AT HOME WITH APARTHEID

University of Virginia Press

Charlottesville & London

. Rebecca Ginsburg

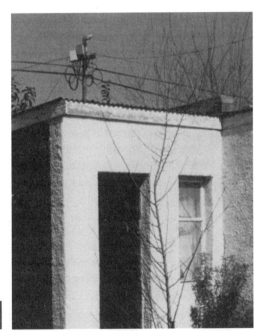

AT HOME WITH
APARTHEID

*The Hidden
Landscapes
of Domestic
Service in
Johannesburg*

University of Virginia Press
© 2011 by the Rector and Visitors of the University of Virginia
All rights reserved
Printed in the United States of America on acid-free paper

First published 2011

9 8 7 6 5 4 3 2 1

Library of Congress Cataloging-in-Publication Data
Ginsburg, Rebecca, 1963–
 At home with apartheid : the hidden landscapes of domestic service in
Johannesburg / Rebecca Ginsburg.
 p. cm.
 Includes bibliographical references and index.
 ISBN 978-0-8139-2888-3 (cloth : alk. paper) — ISBN 978-0-8139-3164-7 (e-book)
 1. Apartheid—South Africa—Johannesburg. 2. Women household
employees—South Africa—Johannesburg. 3. Domestic space—South Africa—
Johannesburg. 4. Johannesburg (South Africa)—Social conditions—20th century.
5. Johannesburg (South Africa)—Race relations—20th century. I. Title. II. Title:
Hidden landscapes of domestic service in Johannesburg.
 DT1757.G56 2011
 968.22'106—dc22 2010051182

To South Africa and its people

Contents

Acknowledgments

I hope to err neither on the side of thanking too few people nor of thanking too many. Long lists of acknowledgments, while generous, often unintentionally dilute the contributions of those most deserving of recognition. Lists too short can slight and leave the impression that an author fails to appreciate the help others gave along the way.

This book came to life at the University of California at Berkeley. I wish to thank colleagues there for providing such a congenial intellectual environment. My advisor, Dell Upton, comes first, for I owe much to him and hope he knows that I know that. Nezar Alsayyad and Paul Groth were also on my dissertation committee and encouraged me along the way. Stella Nair and Don Choi, the other members of my three-person cohort, have been good friends and valuable critics. I acknowledge my interdisciplinary support group, Turbo. (We intended to turbo-charge ourselves out of graduate school.) Its members cheered each other on through the often frustrating days of coursework, exams, and writing. I received an Andrew and Mary Thompson Rocca Scholarship from the African Studies Center at Berkeley, which helped to support my dissertation research. Julio Artiga, Jeff Grossman, and Chris Moffat, my dance partners and friends, helped keep me sane and centered.

In South Africa, I received key assistance from numerous librarians and archivists to whom I remain grateful. Cathy Brookes at Museum Africa, Carol Archibald at the William Cullen Library, and Michele Pickover, the curator of Historical Papers at Cullen, deserve special thanks. Robert Kopecky and Santu Mofokeng were both generous with their photographs. Richie Welch played a key role in this project, as he did during my earlier life in Johannesburg, and I acknowledge his support. I must also thank

here a number of South Africans who helped me better understand apart-
heid conditions, especially from the perspective of white South Africans:
Flo Bird, Clive Chipkin, Harry Dugmore, Stephen Friedman, Sue Gor-
don, and Jennifer Kinghorn. Phil Bonner, former chair of the History De-
partment at the University of the Witwatersrand, deserves thanks for this
and for so much more besides.

To the women and few men who agreed to let me interview them for
this project, I owe my respect and gratitude. It took great trust on their
part to admit me into their homes and share their histories with me. I
sincerely hope that I have done their stories and their struggles justice. It
is a matter of sadness to me that very few of them will be able to read this
book. Indeed, that seems plain wrong. I plan to rectify that situation in the
near future by producing a different sort of work that's accessible to them.
I admire greatly the energy and vision of Eunice Dhladhla and Salinah Vi-
likazi of the South African Domestic Workers' Union (SADWU). Warm
thanks to them for their unstinting support of my research, and encour-
agement as they continue their ongoing struggles on behalf of domestic
workers.

Peggy Twala has been a friend for decades and someone I've relied on
in thick and thin. She's also one of the most intelligent people I know and
as such proved an excellent research assistant. I hope that she feels as en-
riched and nourished by our friendship as I do.

I spent two years as a postdoctoral fellow at Washington University
in St. Louis. Raye Mahaney and Adele Turner, both of African and Afri-
can American Studies (AFAS), were wonderful to me there. The time at
AFAS was invaluable in helping me shift gears from research mode into
book mode.

Since coming to the University of Illinois at Urbana-Champaign, I have
been part of a vibrant Department of Landscape Architecture. I thank all
my colleagues for their collegiality and the historians among us—especially
Dianne Harris, Dede Ruggles, and James Wescoat—for their mentorship
and guidance. Also at Illinois, Sarah Frohardt-Lane, a graduate student
in history, has helped me to put my manuscript in order, and I appreciate
her support. I must acknowledge the good people at the University of Vir-
ginia Press and thank them for their patience, support, and good sense: in
particular, Boyd Zenner, Angie Hogan, and Ellen Satrom, as well as Carol
Sickman-Garner, my copy editor, and Margie Towery, my indexer.

When I started this project, I was a single graduate student living in an efficiency apartment in the flatlands of Berkeley, California. I wrap it up as a home owner living in a large house on a quiet cul-de-sac in Urbana, Illinois. My elder daughter sleeps in the next room; her nanny, an African woman, is not due to arrive for another half hour. Until her death a few years ago, my mother lived with me here in Urbana. We shared our house with a live-in caregiver. Becoming a "madam" has given me increased sensitivity to the difficulties inherent to trying to live fairly and gently with unrelated others who need one another, but do not necessarily love one another. I hope this book is better for my recent experiences, insights, and struggles.

Last, but far from least, I want to thank my family. My father, Norman Ginsburg, financially supported my graduate education more, I expect, than either one of us expected he would have to do. I could not have completed this book without his assistance. Of my mother, Dorothy Rousseau Ginsburg, we can say simply that I owe her everything. William Sullivan found himself, when he married me, thrust into the tail end of a project that he, as a U.S.-based social scientist and landscape architect, had little preparation for. That did not stop him from jumping in and offering wonderfully astute guidance. From the example he provides as a keen, rigorous, and compassionate scholar, I have learned much, and this book is the better for it. I thank him, too, for his support, emotional and practical, during those long weeks when preparing the final manuscript took over my life.

Isabella Joy, Anna Rousseau, and Eamon Sullivan did no proofreading, washed no dishes, and engaged in no discussions about chapter structure. But for helping me to refocus my thoughts about family, home, dependence, and love, and for being their wonderful little selves, I thank them, too.

Chapter 4 appeared in earlier form in *People, Power, Places: Perspectives in Vernacular Architecture*, vol. 8, edited by Sally McMurray and Annmarie Adams, published by the University of Tennessee Press (2000). Chapter 5 appeared in earlier form in *Historical Geography* 27 (1999). Both appear here by permission of the publishers.

AT HOME WITH APARTHEID

Introduction

APARTHEID WAS GOOD FOR NO ONE, but there was nobody for whom it was worse than African women. The government's discriminatory policies weighed more heavily upon them than on any other group, limiting their financial and personal options and leaving most viciously poor. Many women, at some point in their lives, turned to domestic service within whites' houses to support themselves and their families. South Africa's largest city, Johannesburg, was their primary destination, and though most did not qualify under apartheid laws to seek employment there, they made the journey anyway.

"Working in the kitchens" or "working in the backyards," they called it, emphasizing those areas of whites' suburban properties where domestic workers spent the longest hours. Such expressions were misleading, though, because in fact the women had responsibilities throughout whites' houses and even in surrounding neighborhoods. Indeed, domestic workers were ubiquitous in white residential areas. A telephone solicitor was likely to have her call answered by an African voice. White teachers handed their white students off to nannies who walked them home after school, and visitors were greeted at the front doors of middle- and upper-middle class homes by African women in uniforms carrying sleeping white babies on their backs.

African women pushed shopping carts down supermarket aisles while

gray-haired white pensioners walking beside them pointed with their canes at items to be brought down from the shelves. In suburban parks, workers sat knitting on the grass with outstretched legs while white toddlers played in nearby sandboxes; they ran down sidewalks to the front gate at the sound of madam's insistent car horn and opened it to allow her to drive into the garage; and they stood in line at the pharmacy and handed shopping lists written in their masters' hands to the proprietors.

During the years I lived in Johannesburg, in the late 1980s and early 1990s, I encountered women employed as domestic workers at every turn—waiting in line at the post office, strolling through alleys, and sitting next to me on buses. They served at table at some white friends' dinner parties, and I became so used to being told that "the worker will clean it up" that I learned to stop offering to wash dishes when I ate over in the suburbs.

Domestic workers occupied literally all corners of Johannesburg's residential neighborhoods, and as a result, they knew the suburbs intimately and distinctly. Intimately, because their responsibilities drew them into whites' confidences and their private spaces. Distinctly, because although they were drawn into close contact with whites—closer than many of them wished for—the nature of their duties and the restrictions they faced as a result of apartheid's racial policies required them to engage with their surroundings differently than white residents did. Most fought back against the indignity of their positions, but resistance was less likely to mean engaging in open battle against whites than struggling quietly to maintain their composure and spirits in circumstances that conspired to break both. Private struggles became shared efforts, and African women's distinct ways of inhabiting suburban Johannesburg evolved into a world that is the subject of this book. It deserves our attention because the existence of that world compromised apartheid's viability in serious ways. This was not obvious to casual observers of South African suburban life in the 1960s and 1970s, the main period of this study. But then, one lesson we can draw from these women's experiences is that scenes do not always represent what we might think they do.

Consider figure 1. This black and white undated photograph, from a South African museum collection, depicts a two-story stone house sitting behind a stone wall, with the chimney and rooftop of a neighboring house

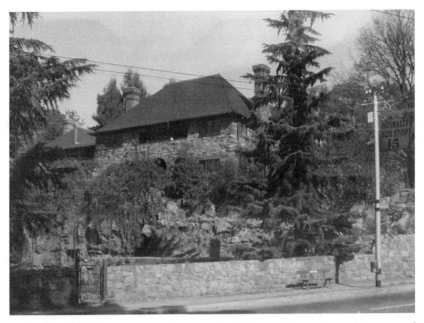

FIGURE I. Archival photograph of a house in Parkview, Johannesburg. (Courtesy of Museum Africa, South Africa)

in the background. A small metal gate admits pedestrians to the property, which is covered in greenery. The area is hilly; the house sits on a higher elevation than the street that runs by it. We can assume that the street is a fairly busy one, though there are no cars in the photograph, because a bus stop stands on the curb.

But how would a domestic worker interpret the scene for us? She might begin by explaining that the photograph shows not a house, but a work site. The front gate is of no moment: African callers and employees were expected to use back doors. The bus stop, a symbol to whites of access and connection to the rest of the city, also held no interest to her or other Africans, since it served white passengers only. African bus signs were black with white lettering, and the stops did not have benches. Indeed, the writing on the bench reads "whites only." The entire picture, then—showing a sturdy wall, meant to control access; an elevated property, conveying distance and stature; and explicitly racist signage—speaks of African exclusion and white privilege. An African woman reading this image might also

bring to our attention items the photographer chose not to include in the composition: the servants' entrance or back alley by which Africans gained entry to the property; any suggestion of labor, such as a washing line; and acknowledgment—through a roof line or a hint of wall—that a woman slept in a detached room in the house's backyard.

We can take the photograph to represent the normative white South African perspective, for the social invisibility of domestic workers implied by the image was pervasive among white South Africans. Many Americans participate in the same gaze as that held by South African whites, the gaze that assumes ownership and control of what it beholds; does not question that a gate is for entering; and understands that the scenes that unfold before us are there for our viewing pleasure and, were we to be present, our use. Of course, though, there is always more than one way to regard any given scene, more than one way to view, use, assess, value, and interpret any single landscape. It is for this reason that we can speak of multiple landscapes—coexisting, sometimes competing modes of engagement with a single site. Domestic properties, because they house people differently situated with respect to status markers like age and gender, are especially likely to contain multiple landscapes. When we consider as well that domestic inhabitants are connected to one another through extraordinarily complex and subtle sets of relations, the potential spatial richness of such properties becomes even stronger. Throw in the added complications of race and class, and we have potential for the creation of what, inspired by philosopher Gaston Bachelard, we can think of as heavily saturated spaces.[1]

The world formed of those spaces can still be found in Johannesburg's Northern Suburbs, the large area north of the city's downtown where most women eventually found employment during the era known as high apartheid. The term *suburbs* is likely to be misleading to American readers, for in the United States the word suggests political entities that exist next to but are distinct from cities and whose governments compete with nearby cities for resources. The mental image the word evokes—again, in the United States—includes rows and rows of near-identical houses, each with a prominent garage, each house occupied by a middle- or upper-middle-class nuclear family that is usually white. Recent scholarship has questioned long-standing American assumptions about the history and

current state of the suburban United States, but of even more importance here is the fact that the term *suburb* has different meanings in other parts of the world, including South Africa. The Northern Suburbs formed part of Johannesburg proper, and with a few exceptions, the suburbs did not have their own local governments. In South African terminology, *suburbs* were, simply, white residential neighborhoods, and *townships* or *locations* designated those neighborhoods occupied by other groups. African townships—which were ruled by an administrative board that oversaw "Non-European Affairs," were located considerably further away than white neighborhoods from the center of town, contained street after street of similar-looking houses, and had a complex and competitive financial relationship with white taxpayers—came closer to fitting the American understanding of suburbs.[2]

To most American readers, the neighborhoods collectively known as the Northern Suburbs will at first sight appear ordinary enough. The initial impression of novelist Allen Drury in the 1950s was that Johannesburg resembled Lawrence, Kansas.[3] A different picture emerges when we regard the houses, yards, and neighborhoods from the perspective of African domestic workers.

The settings encountered by migrant women in midcentury Johannesburg had been many decades in the making and revealed in miniature white South Africa's essential dilemma. From the earliest days of Dutch settlement in the Cape in the seventeenth century, through the arrival of the French Huguenots around the turn of the eighteenth, and then English colonization in the nineteenth, the problem for European settlements had remained the same. Their prosperity, whether based on agriculture, mineral extraction, or commerce, depended on African labor. (Throughout this book, I use *African* to refer to members of any of the Bantu-speaking peoples of the region. They include the Zulu, Basotho, Shangaan, Venda, Shona, and many others.) At the same time, white supremacist ideology insisted upon Africans' exclusion from civil society. This situation was not unique to South Africa, of course. Colonial regimes struggle frequently with the challenge of maintaining domination over subject populations while integrating such populations into their labor systems. Segregation of some form is often seen as the solution, and between 1948 and 1994,

South Africa implemented the most extreme form of racial segregation in modern history. Homeland development, locations, and industrial hostels, all hallmarks of the apartheid system, represented attempts at various scales to keep African workers separate from and yet accessible to whites. Johannesburg's urban middle-class householders had their own solution. Detached back rooms on single-family properties and rooftop servants' dormitories on apartment buildings, as with other forms of African accommodation, allowed whites to own and control the land, but provided a corner for conditional, temporary African worker occupation.

In Johannesburg's earliest days, following the establishment of the town by the Transvaal government in 1886, its principal domestic workers were white women and African men, neither of whom typically slept in purpose-built back rooms. European women with skills and experience, mostly from the British Isles, who ventured to the colonies in search of

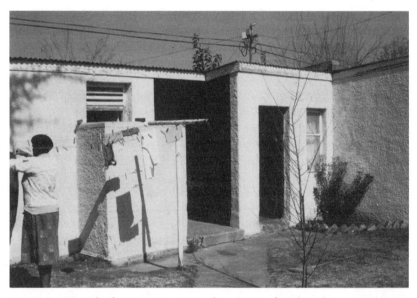

FIGURE 2. Many back rooms were set in the corners of yards and sat, as is the case here, next to storage facilities and outdoor toilets. The door to the worker's toilet is behind the low wall; her slightly larger back room is next to it, connected by the roof; between them is an open closet for yard and laundry supplies. (Photograph by the author)

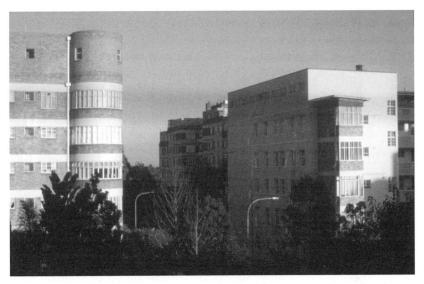

FIGURE 3. The workers' rooms in apartment buildings sat on the roof and were indicated, though barely visible from street level, by rows of small windows. (Photograph by the author)

employment and found it within Johannesburg's wealthiest households, lived in the house with their employers, as they would have expected to do in Europe. Their bedrooms were generally located in the private zone of the house, separated from those of family members by stairs or hallways.[4]

Poor white South Africans, typically Afrikaner farm girls, worked at jobs like nursemaid, cook, or scullery maid, and their rooms were more likely to be located in the service area of a house or even in yard sheds or shanties.[5] Most boardinghouses would not rent rooms to single women, and many of them would not have had the funds, anyway, to live independently of their employers.[6]

Wherever white help could be found, African male servants were also employed, performing those tasks thought to be beneath the dignity of white female employees or requiring great muscle strength. An English nanny or Swedish cook would not be asked to scrub floors, bathe dogs, or care for the horses. Employers expected African men to bed themselves wherever they could find room. Some secured space in the municipal compounds that the city established for migrant workers or within Johannes-

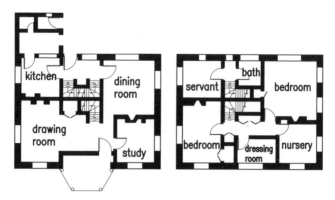

FIGURE 4. The servant's room and the family bathroom in this
1909 house sit next to one another, accessible from the ground
floor by a set of stairs next to the kitchen and from the family
bedrooms by a short set of stairs and a narrow hallway. (Draw-
ing by Cynthia Cope, redrawn from Mark Richard Hindson,
"The Transition between the Late Victorian and Edwardian
Speculative House in Johannesburg from 1890–1920" [M Arch.
thesis, University of the Witwatersrand, 1987])

burg's racially integrated slum districts. If they slept on their employers'
properties, they made space for themselves on kitchen floors or outside in
stable lofts, fowl rooms, or spare outbuildings.[7]

The employment of male African workers and female white workers
did not last long into the new century. In the 1910s, reports of male domes-
tics assaulting and raping their white female employers led to a scare, cyni-
cally exploited and even manipulated by competing employers of African
male labor, known as the "black peril." A 1913 government panel recom-
mended that for reasons of personal security householders dismiss their
"house boys," as they were called, and replace them with female workers.[8]

Around the same time, the era of white female help reached its end.
World War I brought a temporary halt to the work of the immigration
and employment societies. By the time they resumed operations, the de-
mand for white labor had diminished. In any event, the privileges accorded
to white skin in the colonies and, as of 1910, in the newly created Union
of South Africa gave white female immigrants other, more attractive eco-
nomic options than service. These they pursued, leaving the field of do-
mestic service to people of color.[9]

These two trends changed the demographics of domestic service considerably and, as a consequence, the sleeping arrangements associated with it. White employers found themselves with little choice but to replace their deserting white female servants and now distrusted black male workers with African women. They did not always relish the idea, as African women as a group had relatively little experience of urban living and little knowledge of the requirements of middle-class, socially ambitious, English-speaking families. Expectations that they would catch on quickly to the demands of the job were not high, since many whites considered African females feebleminded. Whites also held concerns about the corrupt-

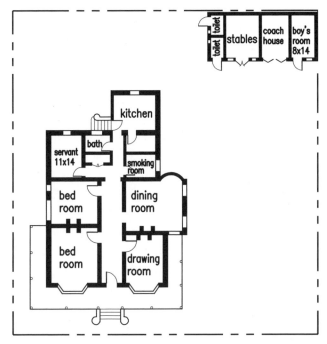

FIGURE 5. The plans of this 1905 house provide an 11 x 14 room for a white domestic in the back corner of the house and an 8 x 14 room for an African worker in the yard, next to the coach house. (Drawing by Cynthia Cope, redrawn from Mark Richard Hindson, "Transition between the Late Victorian and Edwardian Speculative House in Johannesburg from 1890–1920" [M Arch. thesis, University of the Witwatersrand, 1987])

ing influence of the city upon African women's characters. According to one native commissioner, a government administrator with responsibility for African affairs, "in a few years the Native woman in the Transvaal will simply be a prostitute and nothing else."[10] Housewives feared the consequences to their marriages of admitting such women into their homes.[11]

Those concerns notwithstanding, they had little choice. Relatively few Coloureds—the catchall term whites applied to descendents of the Cape Khoisan and to mixed-race people—lived in the Transvaal. The Indian community, consisting of formerly indentured Hindu workers in the Natal sugar plantations and a wealthier, predominantly Muslim business class, was even smaller. Together they formed less than 9 percent of the city's population in 1911.[12] Working-class Afrikaner girls showed diminished interest in working in the homes of the enemy, the Anglo-Boer War (1899–1902) having exacerbated antipathy between them and the English. Urban housewives, then, resigned themselves to employing African women. By the 1930s, for the first time, they constituted more than half of Johannesburg's workers.[13]

In the 1910s, a special committee appointed to deal with African housing in Johannesburg could report that most middle-class households provided separate outside rooms for their African help. While it had been acceptable to allow men to bed on the kitchen floor, contemporary English sensibilities required better treatment for women, even African women. Placing them in rooms intended for white servants or in family bedrooms would be going too far. However, detached yard rooms, which came to be called back rooms, already in use in some households, offered a convenient solution to the challenge of where to place female African domestics.[14]

Automobiles also contributed, indirectly, to the popularity of back rooms. When householders demolished their stables to make room for motor garages, they were simultaneously tearing down what had been many servants' sleeping spaces. It became necessary to transfer them somewhere, and small back rooms fit the bill neatly for those households already accustomed to having their workers sleep in separate backyard quarters. Architects included such detached back rooms in new homes, and the white residents of older houses without such quarters converted structures like fowl houses and fodder rooms for African use or constructed purpose-built rooms.

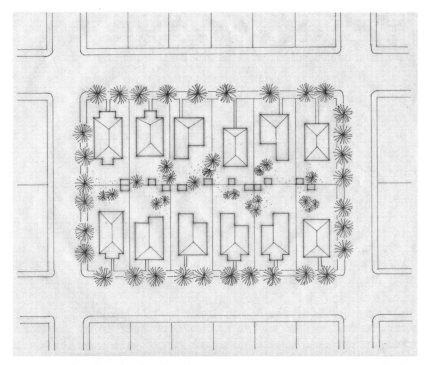

FIGURE 6. For clarity's sake, this plan omits garages, swimming pools, and other features that were common on suburban properties. (Drawing by Sibel Zandi-Sayek)

The most common pattern, which continued to exist in the 1960s and is pervasive even today, was for the main house to sit in almost the middle of the lot. Behind it, or to one side, sat an arrangement of outbuildings, including structures like the garage, garden shed, and workroom. Back rooms were usually located in this vicinity and sometimes attached to the garage or the kitchen. Figure 6 represents a highly schematized view, showing the relationship between the large main house and the outbuildings and the proximity of the outbuildings to one another, albeit separated by fences and walls.

Back rooms varied only slightly in size and plan; by law, they could measure no less than eight feet by ten feet, and they were seldom larger. This allowed little more than a twin bed, wardrobe, and stool. Rooms were almost always constructed of brick and rarely had electrical outlets. A single

door locked with a key, usually held by both the worker and her employers. To protect the privacy of white neighbors, the city planning scheme provided in 1946 that back rooms could not be erected within twenty feet of the door or window of any adjoining property or be designed in such a way as to overlook the adjoining property. This applied to structures intended for white habitation only. It was common to find domestic workers' back rooms within a few feet of one another, clearly within each other's sight lines, on neighboring plots.[15]

In apartment buildings, workers' rooms were placed on the rooftops or, in a few cases, in the basement. Along narrow hallways open to the sky were rows of single rooms, communal toilets, and bathing facilities. Workers accessed their rooms from windowless stairways that led from the uppermost floor of white apartments; elevators did not travel to the roofs.

A back room was seldom so far removed from the house that a person could not see at least some portion of it from inside the house or, at least, from the back stairs. For that reason, home owners usually took care to see that the visible exterior was not an eyesore. There might be some plantings at its door, or its paint color or window trim could match that of the main house. Some had the external appearance of guest cottages or, from a distance, quaint garden pavilions or pergolas. However, the design connection between the rest of the property and the back room stopped at the door of the structure. The back room's interior was another world altogether.

It was my fascination with back rooms that led to this book. They first attracted my attention when I lived in Johannesburg in the 1980s, doing anti-apartheid work. I passed them during my frequent walks through the city, their presence marked by corrugated tin roofs that peeked above the fences and brick walls that encircled almost every yard. They reminded me of slaves' quarters on Southern plantations, in both their size and their relation to the main house. They were, I imagined, the sorts of places my grandparents' grandparents had inhabited back in Georgia and Louisiana.

Although many of my African friends had mothers who had worked as domestics, I never became close to any, in part because I never hired one. Even friends were surprised to learn that I didn't have even a weekly cleaner, but American habits of self-reliance died hard. In all those years,

too, I never entered a worker's room, though I wanted to. They intrigued me for reasons I could not fully explain to myself.

Years later, after returning to the United States and enrolling in graduate school, I found myself back in South Africa conducting field research. It was the summer of 1995, just one year after South Africa's first democratic elections, and I was there to study Soweto residents' alterations to township houses. I lived, as I had previously, in a white neighborhood (by that time it was much easier for me, as a mixed-race American, to find accommodation than it had been previously). I found the pervasive little rooms—indeed, my bedroom window looked out onto a (now unused) back room—as weird and intriguing as ever. "How does that work?" I asked myself as I looked out the window and wondered about the significance of the presence in the white suburbs of thousands of quarters sheltering African women . . . and took out my books to read Soweto history.

Eventually, I allowed my brain to follow where my heart was clearly leading me and started to conduct exploratory interviews with domestic workers about their lives on white properties during the height of apartheid, the name historians have given to the period, roughly, between 1960 and 1976. Those years bookmarked the two most famous uprisings in South African history. The South African government had begun to implement its system of "apart-ness" in the late 1940s, immediately following the National Party's assumption to power. African resistance to political and economic disenfranchisement grew, until it exploded with the Sharpeville Uprising and its nationwide progeny in March 1960. The government responded aggressively, with a series of measures meant to curb further resistance and consolidate its gains to date. It passed new racially discriminatory legislation; banned the two main resistance groups, the African National Congress and the Pan African Congress; put drastic curbs on African urbanization; and reinvigorated the policy of homeland development, whereby Africans were dispossessed of their lands.

On many practical levels, the government's new approach changed little. Discrimination on the basis of race had been the law of the land since Europeans had first entered the Transvaal en masse in the early nineteenth century. There had been little interaction as equals between whites and Africans, except among the poorest classes. It had long been difficult for Africans to enter and settle in urban areas; they had suffered since the ar-

rival of whites from brutality and violence on the part of white citizens and the state; and land dispossession had caused hardships for individuals and entire communities for as long as whites had been raiding their settlements, kidnapping their children, and burning their crops. All this and more had been invisible to middle-class whites in the city. The new slew of regulations simply intensified the hardships that Africans faced and the gap of white ignorance.

Mass popular resistance did not return to the country until the mid-1970s, with increased trade union activity and, in 1976, the student-led Soweto Uprising, which captured headlines around the world. The African youth of '76 accused their elders of complacency and cowardice in the face of the government and saw themselves taking back the mantle of activism. Domestic workers, in particular, had a reputation for conservatism and were often the brunt of youth's derision. I suspected that close examination of their working conditions and personal lives would reveal a situation more nuanced.

For the rest of that summer, and then again in 1996, 1997–98, and 2004, I conducted field research. All told, I spent about ten months in Johannesburg—in addition to the five years I lived there, of course—and collected eighty oral histories, about sixty of which were with Africans, either former domestic workers or family of former workers, and the remainder with white South Africans.[16]

I reached most former workers through the South African Domestic Workers Union (SADWU), a well-trusted organization. Union officials allowed me to make several presentations of my research at their downtown offices during their regularly scheduled general meetings. I explained my status as a university student and my interest in "what it was like to be a domestic worker in those days and to live in the back rooms." I usually added that my African American grandmother had worked as a maid for white people in 1940s Chicago, to establish a point of connection, however tenuous, between my audience and myself, and to help explain some of my interest in the subject. I did not identify myself as an architectural historian. I did not believe the term would be familiar to them, and I worried that, in the course of trying to explain it, I would give the impression that I was more interested in buildings than in people. I did make it clear that

I was a historian, though, and concerned about matters in the past. I was not in a position to offer advice or help for current difficulties, which was the role of the union.

After my presentation, I removed myself to a small office or corridor space. Women who wished to talk to me could approach while the union's regular meeting continued in the main hall. Those who preferred to be interviewed later—whether because I did not have enough time to see all interested people, they wanted greater privacy, or they did not want to miss the union meeting—could make an appointment for me to visit them later in their back rooms or rooftop rooms.

The interviews held at union offices were usually one-on-one. They lasted between one-quarter to three-quarters of an hour. I tape-recorded them with the subject's permission, which she almost always granted. Although I developed a list of questions, this served only as a mental checklist for me. I did not refer to it during the interview, preferring to frame the session as a telling of the woman's life story, with particular emphasis on her years working in the Northern Suburbs and the details of life there. I

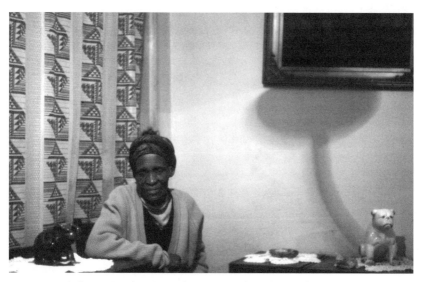

FIGURE 7. A former worker sits in her Soweto living room following an interview with me. (Photograph by the author)

interrupted often with questions and points of clarification. In order to en-
courage openness, I explained that I would change people's names to pro-
tect their identities and that I would not identify anyone in photographs.

Interviews held elsewhere, whether in women's back rooms, rural
homes, or rooftop rooms, usually took place at the end of the workday and
lasted considerably longer, between forty-five minutes and two hours. I
enjoyed these interviews much more because, particularly in the locations
in the sky, as people refer to the rooftop communities, they allowed me
access to an entire community of workers. Often a small group of friends
would ask to be interviewed together, and we would make space for one
another on the bed, bench, and floor of someone's small room. They took
turns telling their stories. It seemed to serve as a form of entertainment
for them, and there was considerable interaction between the women. Old
friends turned to one another for help in remembering events. Someone
would pose a thoughtful or curious question to a neighbor or suggest a
possible line of inquiry to me. Many women seemed to enjoy the idea of
educating me and to relish the opportunity to play teacher that the inter-
views provided them. Several gave me minilectures on matters like bride
price, apartheid regulations, and even cleaning techniques, and I appreci-
ated both their perspectives on such matters and the pleasure they took in
being listened to.

I conducted a second set of interviews in Soweto, the large African
township outside Johannesburg. My research assistant, Peggy Twala, con-
ducted many of the Soweto interviews with me. Ms. Twala was, and is,
an old friend and colleague whom I first got to know when we worked
together at a nonprofit organization in Johannesburg in the late 1980s. She
was the first person I thought of when I decided to engage someone to
help with translation and lining up potential interviewees. I was able to
arrange many meetings through SADWU, but the women I met through
that organization were, by definition, still employed as domestic work-
ers. I was interested in checking their perspectives, as long-term workers,
against those of women who had worked in white homes in the 1960s and
1970s and then moved on to other forms of employment or to none at all.
As a Soweto resident, Ms. Twala was invaluable in lining up interviews
with women who had moved from the backyards into the location. In ad-
dition, SADWU's members tended to be among the most politicized of

domestics. I wanted to interview as broad as possible a cross-section of former workers.

Whenever Ms. Twala joined me on an interview, the interaction between her and the informant was lively and playful. Their memories bounced off one another, and I had the impression of listening to stories that had been shared often between them and that formed part of the social memory of particular groups of friends. When these interviews were conducted in African indigenous languages, Ms. Twala, a native Southern Sotho speaker married to a Swazi (hence her typical Swazi surname), but multilingual well beyond those two tongues, translated orally throughout. In all cases, the interviewees could in fact understand a great deal of English—after all, they had once been employed in English-speaking households—but felt shy or uncomfortable about being able to express themselves adequately in that language. However, they did occasionally correct Ms. Twala's translations or helped her to find just the right English word.

Ms. Twala conducted a few interviews entirely on her own in indigenous languages. She developed a strong rapport with her informants and, after months of accompanying me to interviews, did an excellent job of eliciting information she knew I would find useful. Even more valuably, in these interviews and in those we conducted together, Ms. Twala pursued her own lines of inquiry. Her questions were always worth thinking about and often drew my attention to important issues. For instance, she taught me to be sensitive to issues of African land tenure, a topic of key importance. Unfortunately, the costs of translating and transcribing tapes of her vernacular language interviews—the work performed by University of the Witwatersrand graduate students—proved too high for my research budget, so we were not able to continue having her work on her own.

While it would have made for a provocative interview, at no time did we go back with a worker to her former place of employment and allow her to walk us through her daily life there. The chances of securing the cooperation of an unknown white householder and the risks involved in asking for it—during a period of extreme and somewhat justified white paranoia of crime in Johannesburg—seemed too risky.

The women I talked to were enthusiastic, critical, and proud interview participants. During most of my visits to SADWU offices and locations in the sky, they formed patient lines. Many seemed to approach me with the

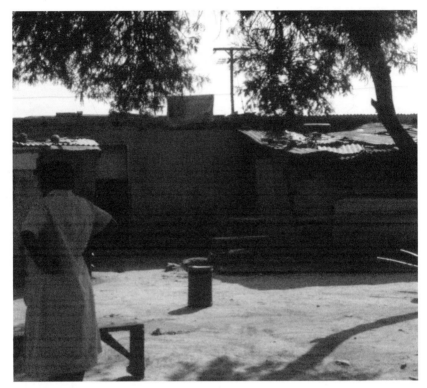

FIGURE 8. Outside the rural home of a former domestic worker. (Photograph by the author)

beginnings of a story already in their heads, one advantage of interviewing women who came from communities with long histories of oral traditions. I had a feeling that I was touching on matters that were important to them and that, from the moment they had heard me announce a desire to interview them, they had begun to consider the structure and content of their narratives. I was impressed by their sharp memories. Several could tell me the exact date of their first being hired in Johannesburg, despite it having happened more than forty years previously. As a whole, they were disarmingly honest about their pasts, and their emotional responses to their experiences remained strong. Tears, and wicked laughter, were common. I heard accounts of cheating spouses and murder. One woman described her rape.

Colleagues and students have often asked me what allowed me to establish such strong rapport with the women I talked to. First, I had an advantage in conducting most of my research during the years of South Africa's Truth and Reconciliation hearings. There was an ethos in those days of telling one's truth, of unburdening oneself of the weight of past secrets and hardships. The women's desire to share their stories seemed so strong that I often felt concern for those waiting to see me. Sometimes I cut short interviews I would have preferred to pursue at greater length in order to be able to spend at least some time with everyone in line. I did not want anyone to go away disappointed. The fact that I had lived previously in Johannesburg and worked for anti-apartheid organizations helped to reassure the women that I aligned myself with worker interests. Years as a crisis counselor gave me some useful skills, including close listening, patience, and respect for the need of each person to approach her story in her own way. Knowing that it can be a powerful and painful thing for people to talk about their pasts, especially when those pasts are unhappy, I was prepared for tears and got many. I held hands, gave and received hugs, and sometimes cried myself.

In some respects, I must have struck the women as an odd bird. I was unmarried and childless (an oddity in Africa, in a woman's thirties) and a confusing mixture of clearly well educated and yet still in school. I was also considerably younger than most of the women I spoke with. On the other hand, I had an advantage in being black. Though my accent, style of dress, cinnamon skin tone, and bearing all identified me as an outsider, I was at least not a white outsider. Many informants seemed to recognize me as a "sister," to use their term, by virtue of our being women of color in a world of white privilege. Though the systems of prejudice and discrimination clearly differed in our respective homes, they treated me as a fellow traveler. One comment that came up frequently in interviews, so that I began to recognize it as an expression workers used among themselves, was "you know how whites are." They trusted that I shared their understanding of the prejudices and vanities of the English-speaking families for which they had worked.

White interviews had a different feel. I identified possible white subjects, both female and male, by word of mouth among friends and acquaintances and interviewed, always alone, two sets of whites, those in their

twenties and thirties who had been children during the 1960s and 1970s, and older whites who had adult memories of the period. Those who had been very young during the years in question were able to separate the children they had been from the adults they now were. They could speak relatively frankly and critically about the attitudes and behaviors they had once held but ostensibly no longer entertained.

Older adults could not distance themselves as easily from their younger adult selves. Recognizing that asking them to reveal the once acceptable and now, in post-apartheid South Africa, unacceptable beliefs they once (and maybe still) held would place them in an uncomfortable and possibly defensive position, especially with a nonwhite interviewer, I altered my approach. Instead of asking older white adults about their own experiences, I put them in the role of social critic or anthropologist. I asked them to explain to me the habits, lifestyles, and attitudes of their friends, coworkers, neighbors, and family. While I started this approach in order to spare them embarrassment and to encourage honest rather than safe answers, I soon saw that it had other benefits as well. People made astute observations about their social worlds. As I began to recognize this, and to trust in their ability to give thoughtful and insightful consideration to aspects of everyday life, I started to use the same approach with some of my African participants, asking them to step back and make observations about their larger social contexts. At the same time, as I had anticipated and hoped, white participants shared generously of their own experiences and household arrangements in order to illustrate their points.

Over dozens of interviews, patterns emerged. The consistency of these patterns made them trustworthy, as did their resonance with the written literature, my own experience of the Northern Suburbs, and, importantly, the physical environment itself. During interviews in their rooms, workers pointed out elements of the interior landscape that they thought deserved my attention or illustrated their points—paint cans that supported a raised bed (under which a person could hide), rain-damaged roofs that insulted their pride, examples of the embroidery they had created to sustain a sense of accomplishment.

We did not walk around the neighborhoods together, as most wanted to keep news of my visits from their employers and other whites. However, they described the larger settings in which they had worked and lived, and

I studied for myself the layouts and landscapes of many properties and neighborhoods that composed the Northern Suburbs, taking hundreds of photographs of extant settings and searching out historic photographs in museums and libraries. I pored over house plans in the city's archives, to ensure that my interpretations of everyday life in the suburbs corresponded with the range of actual physical layouts, and read contemporary architectural guides and professional journals to learn more about the exterior and interior design fashions of the day. In the Johannesburg Public Library, I went through dozens of issues of contemporary housekeeping and women's magazines. Advertisements and articles about home furnishings were my best source of information about décor; stories about family life and letters to the editor revealed contemporary white attitudes and debates about hiring and living with domestic workers.

Two secondary sources were especially useful in helping me reconstruct historical patterns of use and the material settings of domestic service. Jacklyn Cock's *Maids and Madams* (1980) is a sociological study about contemporary relations between employers and servants in South Africa's Eastern Cape region. Based on extensive fieldwork conducted in the 1970s, it contains short quotations and sharp analysis that helped me to draw a picture of white and African attitudes and housekeeping practices. I made allowances for the different conditions in East London and Johannesburg, although in class and cultural background the white informants of our respective studies were actually very similar.

A few years after Ms. Cock's book came out, Suzanne Gordon published *A Talent for Tomorrow*, a collection of biographies of African servants based on multiple, in-depth interviews with twenty-three servants in the Johannesburg area. She includes long excerpts from her transcripts, allowing her informants to speak at length in their own words. These selections were immensely valuable to me, since they contained accounts of conditions at their workplaces and in their native homes and because they revealed, often movingly, worker sentiment. I developed sensitivity for her editorial choices and methods after interviewing Ms. Gordon and three of her former subjects, thus allowing me to engage with her work with greater discretion and confidence.

In the end, I used all these sources—oral histories, contemporary photographs and descriptions, floor plans, extant physical settings, secondary

sources, and professional guides and journals—to reconstruct the everyday patterns of the Northern Suburbs and the variables that bore on whether, how, and to what degree individual households adhered to or altered these patterns. I was most interested in the experiences and perspectives of the African women who had worked there and as a consequence pay relatively less attention in the chapters that follow to the spaces of white children, for instance, or to the guests who visited suburban homes, or to the men who paved the roads and collected the rubbish. They are part of the larger story, of course, and including them would have produced an even fuller, richer, more multidimensional account of the landscapes of the Northern Suburbs, but this book would have been much longer.

One thing that became clear is that the Northern Suburbs were not monolithic. Houghton had huge lots, compared to Parkhurst. The postwar suburbs of Emmarentia and Roosevelt Park contained more ranch-style and split-level homes than the older suburbs closer to town, and larger expanses of turf lawn. Mountain View and Northcliff had hills; Parkview had the park and the lake; into Kensington houses, the dust of gold mine dumps fell. All this had some relevance to the kind of work that women performed on whites' properties and how they conducted themselves on their own time. However, these differences did no damage to fundamental similarities that existed across the Northern Suburbs, similarities that led to the designation among locals of "Northern Suburbs" in the first place and that produced a landscape that shared key characteristics with white middle-class residential neighborhoods across South Africa and indeed, in some details, with elite neighborhoods the world over.

The question that we are prone to ask of any system of social evil is, how could it have happened? The impulses that excite cruelty are poorly understood and seem, sadly, almost an inevitable part of human society. Hope lies not in our ability to eliminate oppressive regimes, but in our ability to fight them. We can learn from those who have succeeded in the past. The challenge is that those who suffer are inclined to resist in subtle ways. Human nature and self-preservation dictate not performing open battle with dominant forces, but bending quietly for as long as possible in the face of repression. Hence, Jews in early 1930s Germany responded to restrictions on the koshering of meat by becoming vegetarian, and African women

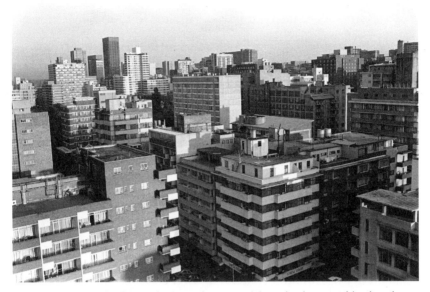

FIGURE 9. Central Johannesburg in the 1980s. The suburban neighborhoods are seen receding in the background of the photograph. (Photograph © Cedric Nunn/ Africa Media Online)

who chafed under the indignities of apartheid utilized what James Scott has called the weapons of the weak.[17]

Covert acts of "infrapolitics" included gossiping about one's employers, stealing from them, and hiding guests in one's back room. Some of these activities would damage apartheid in serious ways in the long term, participating in the broader process whereby racial segregation "rebound[ed] on the system to its discomfort and ultimate demise," as geographer David Smith writes of the apartheid city.[18] However, because they were mostly quiet, hidden practices, we cannot always see clearly what they accomplished, either for the women who worked in Johannesburg or for others. And because they formed part of no explicit, coordinated effort to defeat the system, because domestic workers did not always intend their activities to be expressions of opposition to apartheid, and because white employers often failed to recognize that the activities had taken place at all, they will not fit everyone's definition of resistance. The label does not matter as much as the recognition that, within the labyrinth of interpersonal dynam-

ics and crisscrossing activities that existed in and around whites' proper-
ties, African workers often pushed back against what offended them, but
not always. Sometimes they had good reason not to.[19]

The varied efforts, results, and motives of their actions only give proof,
if any were needed, to the sensitive nature of power relations, especially
those that exist in emotionally volatile settings, and to the need to delin-
eate as precisely as possible the overlapping contexts that shape people's
decisions. Historian Robin D. G. Kelley has called on Americanist schol-
ars to remap the sites of opposition to Jim Crow so that they are more
inclusive of the everyday, unobvious (to white culture) places that African
Americans resisted racial impositions. I take his call to be a plea to all of us
who study people's efforts to negotiate their lives in the midst of oppressive
forces, to approach the subject with a delicate and nuanced hand, recog-
nizing that people always juggle multiple interests and risks and that they
do not always have the freedom or inclination to express their political
opinions openly. We must look imaginatively, deeply, and generously into
the worlds that people inhabited to be able to discern what they did, how,
and why, and then to assess the import of it all.[20]

When we study any site—like the Northern Suburbs, for instance—
what we are really studying is the people connected to it, and when we
admit greater complexity into our study of built environments, what we
are admitting is consideration of more and different kinds of people and
the richness of each. I recall the images of Hurricane Katrina, which re-
main horridly vivid even years after the disaster. The photos that appeared
with heartbreaking frequency on television and in print media depicted
residents of New Orleans who had been invisible in previous mainstream
representations of the city, its poorest and least powerful inhabitants. We
saw the elderly stranded in their nursing home beds, black children cling-
ing to rooftops, and families that could not afford to leave town huddled in
the stench of the Superdome. It was as if the wind and water had washed
away the top layers of the city—the pretty layers meant for popular con-
sumption, the ones used to generate civic pride and tourist revenue—and
exposed what had always been underneath, but too easily ignored.

Ultimately, this book is about the imperative of looking beyond the lay-
ers of environments that flatter and seduce us and peering and squinting

until new, possibly uncomfortable ways of viewing the composition and order of our surroundings emerge. In this book, I squint at the Northern Suburbs. What emerges, first, is the realization that apartheid's planners enjoyed at best uneven success in keeping Africans in their place. Many women refused to allow apartheid regulations to get in the way of their pursuing meaningful lives, meeting their obligations to loved ones, and preserving their personal dignity. They pursued their own agendas, frequently using their intimate familiarity with the suburbs and suburban life to help them subvert the restrictive impositions of that very society. In Patricia Hill Collins's terms, they were the quintessential "outsiders-within," and from their positions as simultaneously marginal and intimate observers and shapers of suburban life, they quietly and energetically strengthened their own positions and those of thousands of others.[21]

Of even greater significance, though, what emerges is proof of our ability to allow new landscapes, different ways of arranging things, and the perspectives of others who may not be like us to come into view. Our imaginative geographies are not fixed, thank goodness, for shifting our point of view is neither a game nor an academic exercise. Good citizenship and basic humanity require the cultivation of a healthy and insistent urge to move from our visual and cognitive comfort zones so that we can engage in imaginative sympathy with others by thinking about what the world might be like for them. The chapters that follow demonstrate not only that sites are divisible through acts of perception and behaviors, such that they hold within themselves multiple layers of significance, use, and meaning. They establish, too, that we can begin to access those layers through careful and creative excavation of the experiences of the diverse groups that inhabited them. The power that philosopher Martha Nussbaum ascribes to study of literature inheres as well to study of the built environment. Through critical, open-hearted, and inclusive consideration of landscapes and buildings and their users, we can develop compassion and empathy.[22] I have every expectation that future studies of other scholars will demonstrate this better than I have here.

Chapter 1, "Getting to Know the Corners," describes women's journeys from rural or small-town settings to the city in order to find kitchen jobs, in the face of apartheid regulations that forbade such travel. They encountered a foreign land when they entered the city and relied on one another

and on the vanities of whites to develop competence within the urban set-
ting. In chapter 2, "The Tempo of Kitchen Life," I look more closely at the
routine lives of African women employed in white households and their
typical patterns of movement in and around their employers' properties.
All such movement, of course, had to be negotiated within the larger con-
text of apartheid regulations that severely limited when and where Afri-
cans could be and popular white sentiment that made interracial contact
in public potentially unpleasant and even dangerous.

Chapter 3 considers the dual worlds in which many women found them-
selves and how they managed to mitigate the effects of being torn between
Johannesburg and home. They could spend years or even decades in the
suburbs, but retained connection through ties of love and responsibility
to their homes. Bonds between working mothers and their children were
especially strong, and some women were able to sustain them by bringing
their children to visit them on white properties, though such visits could
themselves produce considerable problems.

Chapter 4, "Come in the Dark," examines the means by which the
women approached yet another challenge of working in the Northern
Suburbs, separation from friends, especially male partners. Most were de-
termined to sleep with those they loved, so they sneaked their men into
the yards. This involved surreptitious movement on white properties and
in surrounding neighborhoods and took much risk, though the payoffs
could be very high. Ultimately, in housing men and others in their back
rooms, they contributed to the downfall of South Africa's influx-control
measures, one of the cornerstones of apartheid policy.

Chapter 5, "House Rules," continues with the theme of hidden activi-
ties, examining women's violations of white employers' household regu-
lations. Several women I interviewed told me that I was the first person
they had ever spoken to about sitting on the furniture or drinking from
whites' cups. This sort of action, highly disguised and not noted even by a
woman's employers, most challenges strict definitions of resistance, which
require recognition by others of the offending activity.[23] At the same time,
few acts allowed more personal and visceral means of talking back to white
supremacist notions.

Chapter 6 pulls together the lessons of the previous chapters. It demon-
strates that the many forms of use and the multiple layers of meaning that

sites within the Northern Suburbs held produced richly saturated and highly connected landscapes. We can unpeel them, onion-like. At the same time, we can also understand them working together to produce complex wholes through which people variously situated led intertwined, sometimes mutually supporting, sometimes clashing existences. Finally, the chapter examines the women as they left these landscapes and returned at long last to their homes. They took something of the material culture of the Northern Suburbs with them, as they left much of the tension, disease, and fraught nature of backyard living behind. Even in their retirement homes, though, there are complex layers of meaning and use.

In keeping with my interest in the perspectives of multiple users and the necessity of trying to shift our point of view when considering landscapes, I have illustrated this book with a variety of different types of images. I include floor plans and site plans, some hand drawn and some computer generated; historical photographs and photos I took myself in recent years; maps; and diagrams. I hope the range of picture types encourages questioning and querying of how we see and what we see in the Northern Suburbs or any landscape, and who and what lies beneath the surfaces.

ONE

Getting to Know the Corners

FROM BARREN OSTRICH FARMS in the Northern Cape, from small Transvaal towns where a person had to step off the sidewalk when a white adult approached, from crowded resettlement camps where the dispossessed squeezed onto the slivers of land that the South African government had dumped them on, Johannesburg beckoned the women. Various dreams and demons chased them to the city. Most importantly, iGoli, the Golden City, was the source of money for food for children whose growling stomachs could no longer be appeased with watery gruel, but a job in Johannesburg had other value as well: independence from absconded husbands and disapproving in-laws, respite from the racial violence of rural South Africa, and a room to call one's own in the face of a perennial shortage of African housing. The women came from all directions, most hoping to find employment in white family homes. Though each of course had her own story, no woman's tale could be disentangled from that of her country's midcentury experiment with apartheid.

Itumeleng moved to Johannesburg in 1948, the year the National Party came to power, though no one knew then all that its electoral victory portended.[1] She intended to visit only briefly, just long enough to earn some money, and then return home to the Free State: "I did come for a job here. Because [at home] the money is very, very little. The wages is very little. Here it was a little bit better than there. That's why I come here."

She stayed with her uncle in the Johannesburg suburb of Sophiatown while she searched for work. As it happened, though, she never did take a job. Instead, she fell in love with one of her uncle's Sophiatown neighbors and married him. She lived with her husband in his parents' home until the municipality began to evict Africans from the suburb under the terms of the Group Areas Act of 1950, which compelled cities to ensure that only whites lived in urban residential districts: "His people used to have a big home there. And then we lost that home." They moved first to a rented room in the vast African-only district that the city was developing southwest of Johannesburg and, when their names came up on the waiting list, with their young daughter to their own house in another section of the township.

Itumeleng thought that she was finally settled. However, her marriage soured, and in the late 1960s her husband appeared at the township office and, in a spirit of vindictiveness, told officials that he was planning to leave her. He knew the implications of his disclosure: under apartheid legislation passed in the early 1950s, when the male breadwinner moved out of a township house, the remaining, dependent family members had to return to the countryside. Knowing firsthand the poverty endemic to the rural areas, and hoping the township authorities would not be able to track her down, Itumeleng moved instead with her children to the township room she and her husband had rented years ago and supported her family by doing live-out domestic work for a white couple in Johannesburg. When her employers suggested that she move in with them, she jumped at the opportunity. She would have few personal expenses living in, so her wages would stretch much further. Itumeleng took her children and furniture to her parents' house in the Free State, in a location outside Vicksburg, and promised she'd send money for their support. Then she made her way back to the city to start her new life in the suburbs in Johannesburg.

It had been common since Europeans first settled in the subcontinent in the seventeenth century for African men to seek occasional adventure, wages, and a measure of personal freedom in white centers. Female migrancy was relatively rare. However, as the Transvaal's and later the South African government's land policies gradually and steadily reduced the amounts available to Africans for agriculture and grazing, men found that to support their families, they had little choice but to seek employment in

the mines or in manufacturing. Their increasingly longer sojourns in urban areas in order to support kin back home meant their greater susceptibility to city temptations. It took extraordinary self-discipline to make regular remittances, and many rural households became financially stressed as the allowances upon which they depended arrived less and less frequently.[2] Some women decided that the best chance for their families' survival lay in their abandoning their traditional roles and themselves seeking paid employment in town: "Our place is very poor. That is why we come to Johannesburg to work here. Because our place is very, very, very poor."[3]

At the very least, a woman's departure would mean one less mouth to feed.

Kefilwe was born on a white-owned farm in the northern Transvaal, the fifth of her parents' nine children.[4] Conditions on farms varied across the country and within regions, but by all accounts it is fair to compare them to those of plantation slavery. "We earned one Rand a year and every year we received twenty bags of *mealie* [corn] meal," reported one survivor of farm life. "At times we were also beaten."[5] The photographs in figures 10 and 11 suggest the varieties of farm accommodation and its very basic nature. However, the simplicity of the housing tells an incomplete story— after all, many white farmhouses themselves had neither electricity nor running water. Rather, it was the terms of the relationship between white farmers and workers that made life on white farms so difficult. Workers and their families could live for generations on a single farm, trapped in cycles of debt and obligation, held to the land through threats and violence. In Kefilwe's case, her father worked without pay for a white farmer for three months each year in exchange for permission for his family to reside on the land. During the other nine months, he earned cash wages as a migrant worker in Pretoria. Since the landowner objected to his workers' children attending school, Kefilwe spent her days helping her mother in the fields and doing chores around their three *rondavels* (round earthen structures typical of the region).

When Kefilwe was twelve, her father, fed up with the tyranny of farm life, moved his family to the homeland of Bophuthatswana, believing he could live more freely under a traditional chief's rule. About half the Africans in South Africa lived in such homelands, political units formed by the government as part of its cynical program of "separate develop-

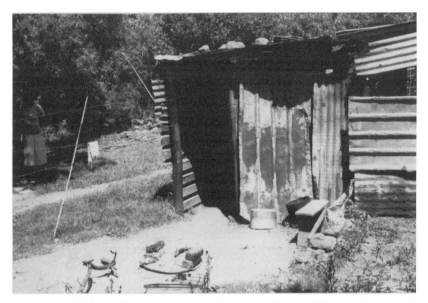

FIGURE 10. These workers' quarters on a farm in Hekpoort, Transvaal, are made of pieces of corrugated tin. Stones on the roof help prevent it from blowing away in heavy winds. As the fire bricks in the yard suggest, there is no kitchen connected to the quarters. (Photograph by the author)

ment," whereby it carved territories from South Africa proper, declared them quasi-independent African states, and then justified discrimination toward Africans inhabiting those lands as nothing more pernicious than differential treatment of "foreigners."[6] Living and social conditions varied across the homelands. Some rural communities that had homeland status imposed on them managed to adapt to the new situation with relatively little adjustment. Other homeland settlements were new, the result of re-locating over three and a half million Africans from areas that had been declared "white" to the new carved-out districts. The map below shows the approximate location of homeland borders in 1971 and suggests the haphazard and chaotic nature of homeland development. These were only ten homelands, but reluctance to cede profitable land to Africans meant that each was broken into several smaller pieces. Few in the international community took the system seriously, and many cried foul over the government's relocation strategies. In these places, people who had lost their

land, houses, and cattle faced the challenge of raising their families and supporting themselves in transit camps that stood on land that could not support even subsistence agriculture and attracted no investment. Sanitation was limited, and typhoid broke out in several settlements.[7]

Kefilwe was lucky to find herself in a homeland town that had a school and finally started her formal education. However, she was the biggest student in her class, and the other children teased her. She soon dropped out and returned to her household chores of collecting firewood, fetching water from the river, cooking, and otherwise assisting her mother.

In 1958, as her father neared retirement age, Kefilwe's family considered how they might best replace his income. Jobs were scarce in the homeland, which functioned primarily as a holding pen for migrant workers' families. With the blessings of her parents, Kefilwe left by train for her brother's house in one of the Johannesburg townships and began to look for a position that would allow her to send regular remittances back to her parents. A friend of her sister-in-law knew of a white family that was looking for

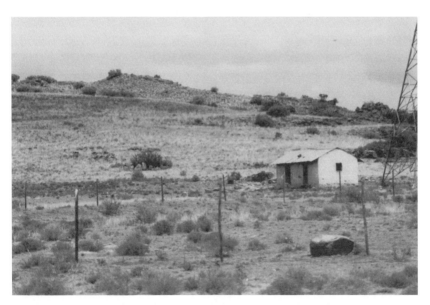

FIGURE 11. Farm workers' quarters could be located far from the main house, in barren surroundings, as in the case of this house on a Northern Cape farm. (Photograph by the author)

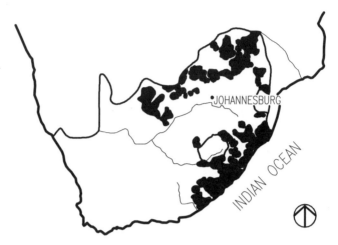

MAP 1. Most homelands were divided into several pieces, the borders of which depended on factors like the resistance of white farmers to ceding their lands. The closest homeland to Johannesburg was Bophuthatswana, the multipiece conglomeration to the north. Map by Cynthia Cope, based on Leonard Thompson, *A History of South Africa* (New Haven: Yale University Press, 1990), 191.

a "girl." Kefilwe trembled when she was introduced to her prospective employer, for she had never exchanged words with a white person before.

As more and more women made their way to the city, the practice of migrating developed momentum. Some went simply because so many others had gone. It was difficult to resist the temptation to see for oneself what all the talk was about: "When you see all your friends your age going to town, you say, 'I can't stay here by myself. All my friends are going to work. I'm also going to work.'"[8] Few intended to stay in Johannesburg forever. Migration was seen as a temporary condition, and the decision to pack one's bags did not necessarily suggest the intention to sever forever ties with the people, land, and grave sites to which women had strong connections and obligations. In this, journeys differed from the almost contemporaneous migration of African American men and women from the American South. Few South African women would describe themselves as "good and gone," in the words of early twentieth-century African Amer-

ican poet W. E. Dancer. Rather, they imagined that, no matter how long their sojourn, they would eventually return home. Especially for women with children who remained behind, to believe otherwise would have been incomprehensible.

Family and friends who had already made the move assured them that they would be able to support themselves in Johannesburg. Jobs could be had for the asking. Women not only listened to their tales but also observed the speakers. Friends visiting from the city wore stylish shoes and dresses of synthetic "town fabrics" like polyester instead of inexpensive cotton prints. They carried with them the life-saving bags of food and clothing upon which so many rural households relied: "Johannesburg people dressed more expensively than we would dress. Johannesburg people, they had a different confidence to the ordinary person."[9]

Said another, "You always think of gold and money when you see Johannesburg. Because, as I say to you, people, when they from Johannesburg, you see they little bit walking tall when they at home. You know what I mean? Then that's why you also feel like, maybe if I go to Johannesburg, I can have the same."[10]

Female migration varied from region to region and over time. It depended on factors like the strength of a community's agricultural base: where not even subsistence farming was possible, there was little reason to stay. Local chiefs could play an important role. Some supported female migration, while others denounced it as unfitting and unnatural. However, environmental disasters like droughts or floods, which could devastate crops and local economies, might overcome any hesitation produced by a chief's or a mother-in-law's disapproval. The degree of missionary infiltration in a given region also played a role. Many women found Christianity's emphasis on individual salvation and denunciation of polygamy appealing and empowering. They started to question the levirate system, common in some communities, according to which a widow was expected to marry her late husband's brother and become a member of his household. Western-style education, introduced by missionaries to the African countryside, encouraged similar ruminations by women on notions of and possibilities for personal autonomy. Although many men continued to believe that "women . . . are like children. We keep them like pets," fewer of their wives were willing to accept such "old school" attitudes.[11] Women's exodus

from the countryside started in some areas as early as the 1840s, and by the 1960s and 1970s, it had touched all parts of the country.[12]

Nomsa was born on Christmas Day 1940 in the African location outside the small Transvaal town of Standerton.[13] Each city or town in South Africa had its own location, essentially a satellite dormitory district without economic bases of its own in which workers who served the nearby white community slept. Conditions could be better in such places than in isolated farmsteads or the homeland camps. Still, African poverty abounded around small white *dorpies*, or little towns.

Kamohelo, who grew up like Nomsa in a small Transvaal location, shared a single room with her parents, five brothers and sisters, her dad's sister, and her mother's sister. The parents slept on a bed, the children on the floor. The only other piece of furniture in the room was a cupboard where they kept any food. They hung their clothes from nails in the wall and sat on sheepskins that her father used to bring home from visits to his parents. The women prepared food outside over coals.[14] Katleho, from another location, lived with her twelve siblings and parents in a four-room house, all of them residing together in the single room they rented from the house's owner: "The same room—it's a kitchen, it's a bedroom, it's a dining room."[15] With the other three families in the house, each of which rented a separate room, they shared two toilets in the yard. Around the same time, Ester was living in a one-room location shanty, also in the Transvaal. Her mother hung cloth to divide the space into a kitchen and a bedroom. The three children slept in the kitchen side on mats that they kept rolled up during the day: "There was enough space in the shack! It was a big one!"[16]

Nomsa, then, did not feel deprived to grow up in a three-room house with her parents and four siblings. The smallest children slept with her father in the main bedroom; the bigger children slept in the dining room. Sometimes the older boys would lie down in the kitchen for more privacy. Her family lived in relative comfort, but the conservativism of Standerton was oppressive, and job opportunities were limited. Nomsa was still a teenager when her eldest sister left the family to seek work in Johannesburg. After she got settled, Nomsa paid her a visit. The younger girl did not see much of the city during her trip, as she had to hide in her sister's room so her employers, who forbade visitors, would not know that she was staying with her. However, she was impressed by the food her sister was able to

secret to her from the kitchen—roast chicken, turkey, and other leftovers from her employers' dinner parties, dishes unlike the cornmeal mush and milk she usually ate at home. She began to consider coming to Johannesburg herself. In the end, though, she returned to the location, got a job in a local factory, and started to raise a family.

The rising expense of feeding her two children eventually turned Nomsa's thoughts back to the city: "When you see people coming from Johannesburg, they've got a little bit of things. . . . Maybe the whites, they give it to them, like old clothes, something like that. Then when you're at home you decide, maybe if I can go to Johannesburg I can also get a little bit for the kids."

She was almost twenty-five in 1965 when she finally made the move, pulled partly by the promise of material goods and partly by the idea of the city, "just, let's say, to be in Johannesburg." Influx control was in full swing by then, so she paid fifteen rands for a forged permit so she could travel the city streets without fear of being sent home by the police. She quickly secured a job in one of the city's wealthiest suburbs, Lower Houghton, joining a household staff of four. Her monthly wage of fifty rands allowed her to recoup quickly her investment in the document.

The National Party had promoted apartheid as a program that would redress the failures of previous, English-dominated governments to recognize and respond to the dangers of what it called African detribalization. A pamphlet distributed nationwide in the late 1940s declared, "The Party appreciates the danger of the influx of Natives into towns and undertakes to preserve the European character of our towns, and to take energetic and effective measures for the safety of persons as well as of property and for the peaceful life of all urban residents. All Natives must be placed in separate residential areas and their concentration in our urban areas must be counteracted. The Native in our urban areas must be regarded as a 'visitor,' who will never have the right to claim any political rights or equal social rights with the Europeans in the European areas."[17] Behind the scenes, the motives and interests that drove apartheid as a policy were varied, as were the competing visions of what apartheid would mean were it actually to be realized. Voters, though, overwhelmingly white, found the rhetoric persuasive, and upon winning the election, the Nationalists kept their prom-

ise by introducing a series of legislation that limited African movement to urban areas generally ("urban areas" referring to the conglomerations of cities along with their associated locations), restricted African residence within cities, and imposed stricter control upon Africans living in locations. The Natives (Abolition of Passes and Co-Ordination of Documents) Act No. 67 of 1952 provided that all African adults had to carry reference books that contained their employers' particulars and specified the conditions under which they were allowed in a given urban area. As of a particular date—1958 for men, 1963 for women—it would be an offense for an African not to produce her book whenever requested by the police, at any time of day or night.[18]

It was primarily through these books that municipal officers policed Africans' comings and goings and enforced their new slew of "pass" laws, the major provision of which, known colloquially as "Section Ten," also passed in 1952. The police enforced Section Ten energetically, and their greedy efforts to seek out and jail (or elicit bribes from) Africans without the proper permits represented one of the greatest hazards of city living. Section Ten, in concert with its subsequent amendments, declared all urban areas in the country "proclaimed" areas and thereby rendered them subject to restrictions on African residence. The restrictions mandated that no African could stay in a given urban area for more than seventy-two hours unless he or she had resided there continuously since birth, had worked continuously for the same employer for at least ten years, had been in the area continuously for fifteen years, was a wife or minor dependent of such a male, or had a work permit granted by the local authorities. Subsequent legislation expanded the government's powers to order "undesirable" or "superfluous" Africans—including professionals such as doctors, lawyers, and accountants who, both in theory and largely in practice, provided services only to other Africans—to leave urban areas and restricted further African entry there.

As expressed by a contemporary South African jurist, "Our racial policy is based on the ethnological fact that one race is not the same as another. Some scientists tell us that the insistence upon territorial exclusiveness is one of the oldest, strongest and most persistent characteristics of many animal species. Mankind has always in the past exhibited the same characteristic. Why should it be any different today? Christ tells us to love our

neighbours and one another, and that the Samaritan, in this sense, is our neighbour whom we must love as we do ourselves. But He does not tell us that the Samaritans ought to live with us."[19]

No matter how well she thought herself prepared themselves for city life, a woman's initial impressions of Johannesburg, the largest city in sub-Saharan Africa, could be overwhelming. With a population of about 415,000 in 1970, Johannesburg was a far cry from the small country towns with which workers were likely to be familiar, where one road traversed the center of town, cars still made way for horses, and all activity centered on the church square.[20] Newcomers encountered an urban environment of a scale and size that was almost literally unimaginable in a land without television and where few movie theaters catered to the rural poor. Most women responded with a combination of awe and fear.

If you look at the big buildings, you're scared.[21]

It was very bright and scary in the evening. It excited and also repulsed me. I didn't know where I was, or the direction in which Phokeng [her hometown] lay.[22]

It was a different world that was new to me.[23]

Johannesburg sat on a series of escarpments almost six thousand feet above sea level that formed what was known as the White Water's Reef, or Witwatersrand. A contemporary account described it as "a sprawling city of low hills [that] reminds you of Los Angeles, with sunlit miles of lush gardens. . . . The light is so brilliant that the shadows look opaque."[24] By the 1960s, dozens of mine dumps, deposits of crushed rock that glimmered golden in the sunlight and resembled low, barren mountains, followed the line of the long-exhausted gold deposits and served as monuments to the city's frenetic nineteenth-century beginnings. Its (white) working-class neighborhoods were south of the city center.

Beyond the hills and green parks of the Northern Suburbs, Johannesburg's metropolitan area continued to expand, incorporating the wealthy municipalities of Sandton, Randburg, and Bryanston. People considered these, too, to be the Northern Suburbs, though technically they were not part of Johannesburg. Further out, beyond where the municipal buses

traveled or a domestic worker was likely to roam, a peri-urban fringe included small agricultural holdings, guest farms, tea gardens, riding stables, and kennels. They gave way to farmlands and, eventually, to the country's administrative capital of Pretoria.[25]

From the large, extravagant homes to the cars in the driveways to the children's play equipment in the front yards, everything about the Northern Suburbs spoke of material comfort and the availability of resources to manage it. Tennis courts, patios, decks, kitchen gardens, flower gardens, swimming pools, and the paths that connected them all had to be swept, trimmed, and cleaned. The labor, of course, would be African, though no Africans—or, indeed, Indians or Coloureds—could rent or buy these houses. The Northern Suburbs were proclaimed white residential areas, so that where, a mere hundred years previously, Sotho settlements had lain scattered among the escarpments, Africans were now unable by law to purchase land.

There was some range in property size and house size, but to women fresh from resettlement camps or squatters' shacks, all Northern Suburb homes could look like mansions. Figures 12 through 15 illustrate the variety that existed within the single suburb of Parktown, one of the oldest of the Northern Suburbs, both block plans drawn to 1:2500 scale (one centimeter on the map equals twenty-five hundred centimeters, or twenty-five meters).

Whether a property was a quarter acre, representing the small end of the range, typical of some parts of Montgomery Park and other post–World War II suburbs that the city had developed in anticipation of settling returning servicemen, or an acre or more, as the largest properties were, they contained the accoutrements of modern, genteel living. This included domestic workers' rooms in the yard.

Each suburb housed at its center a block or two of shops and often a library and post office, making each, in effect, a small self-contained town that was contiguous to and blended into its neighbors. The classic literature on urbanization in the West, then, does not do justice to the experience of the rural women who made their way to the Northern Suburbs. European migrants to the Americas at the turn of the twentieth century and African American migrants to the U.S. North during its early decades confronted and were confounded by urban reserve. Rural and small-town

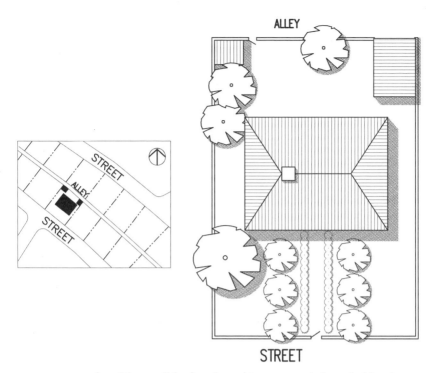

FIGURES 12 and 13. The small backyard on this property is bounded by the garage on one side and the domestic worker's room on the other. It would likely have served mainly service functions. (Drawing by Cynthia Cope, drawn from Andreas Letnick, "A Brief History of Parktown and a Survey into the early Residential Development" [History of Architecture IV Papers, 1990, University of the Witwatersrand Architecture Library])

African women found themselves at journey's end, not in the heart of an impersonal, anonymous city, but in what were in effect insular, sometimes even parochial villages, albeit villages governed by different social structures and material forms than any African communities they might have known. What remained familiar was apartheid, including laws that made them subject to arrest for being out of place, away from their designated place of residence. Such regulations had to be circumvented if the women were going to be successful in their efforts to improve their lives and earn wages.[26]

The challenges started immediately upon arrival. One new migrant,

FIGURES 14 and 15. This huge property included a swimming pool, tennis court, and circle drive. The domestic worker's room here is relatively hidden among the trees and gardens of the backyard. (Drawing by Cynthia Cope, drawn from Andreas Letnick, "A Brief History of Parktown and a Survey into the early Residential Development" [History of Architecture IV Papers, 1990, University of the Witwatersrand Architecture Library])

just eighteen, who had never before been to Johannesburg, made her way alone by train from her home to Park Station, the city's main train station, and from there took public transportation to the suburb of Orange Grove, as she understood her cousin worked there. Zinhle had trusted that she would be able to find her cousin by making inquiries on the streets.[27] However, even after walking for hours and asking the help of the Africans she passed, she was no closer to locating her. Tired and discouraged, she accepted an offer to spend the night in a stranger's back room, but was forced to leave three days later, when the woman's employer insisted that she move on. That night she slept under a tree in a nearby park.

> One day I would find a place, somebody would say, "Come sleep with me." Another day, other people would say, "Come sleep here." Or, maybe you can't find people. You're sleeping out. . . . You'll see people outside and ask them to please give you a chance to wash yourself before their madam comes.

This went on for three weeks. She thought in despair about returning home, but dared not return without money: "The kids want food. Want to go to school." Finally, her luck changed. On her now routine though increasingly desultory walk through the neighborhood, she met some women and asked after her cousin.

> "What nation?"
> "Swazi."
> "Where does she come from?"
> "Ermelo."

They asked Zinhle to follow them, and though she tried not to raise her hopes, she felt herself becoming excited. They led her straight to her cousin: "I was so happy I cried. Oh! Three weeks I'm walking the streets and sleeping under trees."

Zinhle's situation was not uncommon. As another worker explained, "If you come here in Johannesburg, maybe there's nobody you know. Maybe you know me only. Maybe this lady I'm working for her, she don't want anybody in her face. Now, where can you go?"[28]

City hotels, of course, were out of the question. Even if a woman could afford an extended sojourn in a hotel, practically none allowed African

guests. Staying in Soweto was an option only if a woman had family or friends there who were willing to take the risk of hiding her. The township was subject to even more police raids than Johannesburg itself. Besides, the township had many *tsotsies*, or gangsters, and had a reputation as a rough and violent place. Downtown Johannesburg was an alternative, and some managed to stay in abandoned buildings and empty lots amid the small population of the city's white homeless. Epsie tried to spend the night in a tree with her infant daughter strapped to her back. As darkness set in and she realized how sleepy she was becoming, and how much in danger of toppling off the branch, she climbed down, and they slept in each other's arms at the tree's roots.[29]

Some stayed in Park Station, which had the advantage of offering toilets and places to wash up: "A place you must hide. Not in public they must see you. Where they don't think, here a person can sleep, then that's where you're going to sleep."[30] Women found places in bushes, drainage pipes, parks, mine dumps, and public toilets: "We was struggling to hide ourselves."[31]

> You must be sleeping anywhere, under a tree or what, because you have no place in Johannesburg. . . . Sometimes you are scared outside because anything can happen because you are a woman.[32]

The most fortunate newcomers were those with city connections and the ability to plan their journey in advance. They might be met at the train or bus station by someone—perhaps an older sister, aunt, or family friend—already resident in the city. The latter would have received news of the arrival via the informal networks of communication that whites referred to as the "bush telegraph." Really, it was simply people passing word along and in itself spoke volumes about the differences between how urban whites and Africans communicated among themselves. From downtown, the two would travel together by bus or foot to the woman's suburban back room. After closing the door behind them and giving thanks for a safe journey, a newcomer could finally catch her breath. She had arrived in Johannesburg.

First things first. A new migrant needed to secure employment as quickly as possible. Kin and friends could not be expected to provide room and board indefinitely. Besides, family at home needed funds. Self-sufficiency

was the immediate and urgent goal. Luckily, finding a domestic service po-
sition, especially in the booming economy of the 1960s, but even when
the market tightened in the early 1970s, presented little challenge. Almost
all middle-class white households had live-in workers. Official figures
are misleading, of course, given the legal limbo in which so many African
women found themselves in the city and their employers' motivation to
underreport hiring illegals, so it is impressive that during the 1963 House
of Assembly debates, members of Parliament gave the percentage of Jo-
hannesburg households with workers as 93 percent. By all accounts, it was
unusual for a Northern Suburbs home not to have a live-in worker or to be
looking for one. Jobs could be had by walking door-to door in the suburbs.
Personal contacts were another resource. For instance, a friend of a city
cousin might know of a white household that had recently lost its "girl,"
or the madam of the backyard in which a newcomer found herself—not
all white people forbade all out-of-town guests—recommended a position
through someone she knew at church.[33]

The usual protocol was for the prospective employee to appear by previ-
ous arrangement at the home of the housewife looking for help. There was
little bargaining. The employer, after looking the applicant up and down
and asking a few questions, stated a wage, and the prospective worker nod-
ded assent. Then the new hire would return to wherever she had being
staying, collect her belongings, and move into her new employer's back
room.

Anesu, lucky enough to find a job next door to her sister's employment,
had had the presence of mind to bring with her to the city the sheets and
blankets she knew she would need, for bedding and towels were not in-
cluded in a back room's furnishings.[34] Most workers did not move in com-
pletely right away, though. They brought their belongings into the back
room gradually and settled in only after they had decided that they would
stay on the job.[35] As madams, like most employers, usually assumed a fa-
vorable face during the actual hiring process—assuring the prospective
worker that her children were kind and quiet, her pets obedient, and that
cooking responsibilities would be minimal—it usually took at least a few
weeks of actually working with a family to learn the truth of the situa-
tion and decide whether or not staying would be bearable. A housewife
whose previous servant had left unexpectedly might be desperate for new
help and say almost anything to convince the prospective employee to stay.

Workers knew, often from bitter experience, that madams could lie. They knew, too, that if things did not work out, especially if the parting was not amicable, they could expect little help from the police in recovering their possessions should the whites decide to lock them off their property. It was safer, then, not to bring too much in the first place.

Nomathemba was one of those not very enthusiastic about her first position, though it was more because she did not like the idea of being on her own in a white household than because of any warning signals she received from her prospective employer.[36] She secured a job through a *fah fee* runner that her cousin, a domestic worker, knew. These women, making their way through the back alleys of the suburbs to take bets and deliver the winnings of those who played the Chinese gambling game, were well placed to know what openings were available, playing a role similar to that of the independent African American laundresses of the United States, who serviced many households and were an important source of outside news to live-ins.[37] Nomathemba, fresh from the farms, would have preferred to continue living in her cousin's back room. She was, as she says now, "stupid."

To encourage her, her cousin accompanied her to meet her prospective new madam, who lived four blocks away. When they arrived together, Nomathemba found "that woman with blue eyes," who gave her overalls, which were too large. Back at her cousin's room, still apprehensive, she packed her dresses, vanishing cream, sheets, and the money her father and brother had given her into a cardboard box and set out for her new job.

On her way, she remembered that she had forgotten something in her cousin's back room. She placed the box containing her possessions and cash on the wall of the corner house and ran back to retrieve the item. Still fresh from the countryside, she could make no sense of her cousin's exclamations of disapproval when she told her what she had done: "I didn't think somebody can take somebody's things he doesn't know." After her cousin's shock dissolved into disbelieving laughter, they returned hurriedly to the corner to find the box still there. Nomathemba continued to her new madam's house.

During the days and weeks they sought employment, women did not stop trying to learn the city. Humans by their nature crave geographic informa-

tion. Getting lost is frightening on a primal level, and people take pains to avoid the disorientation and loss of self-possession that accompanies it.[38] New migrants were no exception. In addition, they appreciated the very strong practical reasons to become familiar with the highways and byways of Johannesburg as quickly as possible. Influx control, as expressed through Section Ten policing, was the bane of urban Africans and kept them on their toes. If caught in the city without the right documentation, a person could be arrested on the spot. Spending the night in jail wasn't as frightening a prospect as being sent home. Families depended mightily on remittances from urban workers. To lose a domestic job and have to start the entire migration and job-seeking process again was a dismaying prospect. Often a person could get away with a bribe, but that, too, meant money taken from the mouths of children and other dependents. Police represented the possible ruination of a person's best-made plans: "The police were running us. . . . When you go outside, you must watch for policemen."[39] Knowing what routes local policemen followed, where they were likely to be at what times, and what hiding places one could turn to if they were encountered unexpectedly could make the difference between arrest and escape.

Such knowledge was an example of one of the three kinds of competencies that new migrants had to acquire to defeat the forces that sought to exclude them from the city. First—and this is not to suggest sequential learning—they needed to learn the location of things. The objects of their knowledge included both sites and routes. It was important to know not only a local policeman's favorite hangout, but from what direction he was likely to approach it and how he was likely to travel after leaving the spot. The location of bus stops was valuable information, as were bus routes— that is, the path and schedule a given bus followed through the suburbs and into town. Learning the location of things closest to one's sleeping place usually took priority over becoming familiar with items in neighboring suburbs or downtown, as a matter of practical necessity, but migrants' mental maps of the entire Johannesburg region would gradually grow rich and detailed with time and instruction.

Second, the women needed to know how to conduct themselves in the new environment of Johannesburg. Nomathemba's experience with her box was an example of such competency. It also included the mechanics

of urban locomotion. It took experience and reminders for some to ac-
custom themselves to not stepping off the pavement for white people, as
was the custom in small towns. Others were struck by the fact that on city
sidewalks there were no stones or pebbles, as one would have found on a
country road, and so one did not have to pick up one's feet in the same way
when walking.

Using the public transportation system took training as well. One
woman had been told by her farm friends, before she rode her first train,
that trains did not stop. It was up to each passenger to run and jump on
board. It was only after her first visit to a train station that she realized,
with some relief, that they had been pulling her leg. Another newcomer
expressed amazement that the train did not fall off its tracks. The first
time one came toward her as she stood on the platform waiting for it, she
ran away for fear it would hit her. Intraurban travel was just as foreign.
One newcomer relied on her cousin to take her around during her off
time to show her how the city's (African) bus system worked—where the
stops were located, how to pay, and how to indicate when she wanted to
alight.[40]

Finally, there was the problem of urban navigation. The very organiza-
tion of urban space took getting used to, as the layout differed markedly
from the arrangements that pertained in small towns and the countryside.
There, building types were few—churches, stores, houses, barns, and
wells were among the main ones—and a person could see with one or two
glances where most structures in a small town were located. In the city, so
much was happening! Businesses of every type imaginable and unimagi-
nable lined the streets. What was a real estate broker, a travel agent, or
an insurance adjuster, exactly? The functions contained within buildings
were often unclear, which made it difficult to impose an intelligible order
on a scene. To make things worse, the scenes went on forever.

The cityscape was distinguished by its divisibility. Instead of a central
meeting place or a single main street, there were several. Each street had
its own name, and each building, often containing multiple offices or busi-
nesses, had its own name and number. In a recent account of his arrival
from the countryside, an African writer notes that it had never occurred to
him before coming to the city that one could or would want to number a
building.[41]

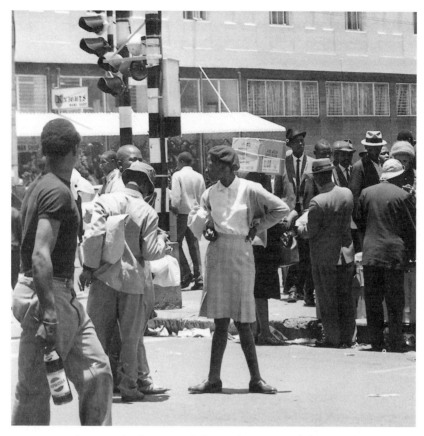

FIGURE 16. A corner in downtown Johannesburg, 1970. (Photograph by Robert Kopecky)

As one woman described it, the main problem was learning to discriminate among the different paths that presented themselves: "If you go this side, you don't know where you're going. If I go that side, I don't know where I'm going. . . . We're scared like that. . . . If you coming in a town, your head you feel dizzy. You don't know which one, this side. If you go this side, where you are going; if you go this side, where you are going. You sit."[42]

Until one had been instructed about the proper order of turns to take to reach a particular destination, like learning the combination of a lock, getting around was a matter of guesswork and understanding, so that this

was an important step in becoming acclimatized to city living. As it was commonly expressed at the time, the task of orienting oneself amounted to "learning the corners." Each intersection—and there were infinitely many in the city—was a point of decision making, made all the more difficult because one could not typically see one's ultimate destination at the end of any given path: "Maybe when the night comes, you must go to Orange Grove. You can't see Orange Grove."[43]

Appreciating the difficulty and importance of acquiring various urban competencies, longer-time residents did not consider their jobs over once they had met a migrant at the train station and escorted her back to the suburbs. They continued to offer aid by helping newcomers learn to get around Johannesburg.[44] Domestic workers walked new migrants through a neighborhood, pointing out bus routes, police hangouts, and neighborhood shops whose proprietors were welcoming of African clientele.

One recent arrival's new city boyfriend developed a routine of showing her a different part of the city every Saturday morning until she was in the position to do the same for her own young friends.[45] During her first few days in the city, one of Sibongile's new acquaintances took her by foot around the suburb where she worked: "You walk, you walk, you walk, you walk. You come back and say, 'Okay, this is Orange Grove.'"[46]

Mastering urban and suburban space in this way could be done only at ground level. Maps or written descriptions, even if rural women had access to or could decipher such things, would not provide the sort of information upon which their livelihoods and that of their families could depend. Urban survival demanded paying close attention to the unique physical details of an area, such as the safest crosswalks for particular intersections, houses where particularly nasty dogs yapped and growled at the gate, and alleys that provided shortcuts and relief from police surveillance. They learned on which corners domestics congregated on their Thursday afternoons off and those where unfriendly white householders discouraged Africans from gathering.

Safe navigation was also a matter of timing. That is, it mattered not only where things were, but also how their condition changed throughout the day. A park that was safe for undocumented workers in the morning because large numbers of Africans typically congregated there, allowing them to blend into the crowd, might become risky after 5:00 p.m., a time

when most location residents who worked in the city had returned to
Soweto or Alexandra and domestic workers were back in their employ-
ers' homes preparing dinner. At that time, an African in the park became
more suspicious to the inspectors. The same park became an even riskier
spot after 9:00 p.m., African curfew. However, by that time a public toilet
that was in heavy demand during the day might offer a convenient and un-
troubled hiding spot for someone looking for shelter. Newcomers learned
of various inspectors, "at this time they are at this corner, at that time they
are at that corner."[47]

Ultimately, the most important landmarks were probably people.
Knowing that "Lydia's mother work in that house," "that madam allows
visitors, but be careful of her husband," or "Mr. Shona is the gardener
there," helped women to know where and when they could secure assis-
tance and where they could run in an emergency.

The success of Africans' networks of assistance depended first on individ-
uals' acquiring urban competence and then on their taking time to share
it with others. A strong sense of mutual interdependence, much as had
existed in the African communities from which these women heralded,
pervaded the networks of aid that workers built for themselves among the
avenues of Johannesburg's middle-class suburbs. This was true in the sense
that they supported one another in learning how Johannesburg "worked,"
and that Johannesburg worked, for these women, to the extent that they
could identify relatively safe spots in the suburbs—usually the back rooms
of other workers—that provided harbor. The cycle of mutual aid upon
which women relied also depended on other factors. They were effective,
in large part, because of how African women's public activities were per-
ceived and interpreted by others. The white people who encountered Af-
rican women on city sidewalks and in neighborhood parks failed to see,
often, what they were really doing there.

Most whites, even if they were immigrants and had not been raised
by African women themselves, paid one to help raise their children. Af-
rican workers prepared their dinners, laundered their clothes, and brought
them tea in bed. They bathed their dogs and their elderly parents. Given
this state of affairs, there were certain things that whites liked to believe
about African women—namely, that they were obedient, trustworthy, and

harmless. They projected these qualities onto all African women, short of obvious prostitutes or beer brewers, such that the common polite form of address that white men, women, and children used when addressing any unknown African woman was "nanny." Unless they worked as so-called garden boys, identifiable by their short pants, African men were rarely seen in suburban neighborhoods. They attracted attention and suspicion. Women did neither. Indeed, although African women had been largely absent from Johannesburg in the town's early years, and the fact that by 1896 they still constituted less than 9 percent of its African population, by midcentury they were the principal users of its public space.[48]

Domestic workers' employment duties required them to spend considerable amounts of time on the streets, sidewalks, and parks of residential suburban neighborhoods, and whites found their presence there reassuring. The sight of an African woman strolling down a lane carrying a bag of groceries, walking a dog, or bringing in the mail served as a reminder of proper and fitting relations between the races. In addition, workers kept their eyes on neighbors' properties and noted suspicious characters in the area. Not only were African nannies indispensible caretakers inside the home; they had a comforting presence outside it as well.

That is not to suggest that African women could walk suburban streets with impunity or confidence. Against the polite greetings one learned to expect from madam's friends encountered at the chemist or the cheerful waves of familiar white children racing by on their bikes, were the barbed comments and rudeness of others. Lower-class whites posed the greatest threat. As store clerks or cashiers, they might delay waiting on an African customer or pointedly serve a later-arrived white first, who did not hesitate to accept such service, as if as a matter of right.

Whites were known to comment if an African seemed to be acting out of station, and concerns about the impact of urbanization on Africans' sense of their social place were rife during these years. One madam complained, "They're coming close to living like us. They're getting cheeky, they want to wear fancy clothes and they don't take their hats off when they speak to you any more."[49]

"You think you're white," a white woman snapped at Phumlani when she, a location resident, pushed her baby in a pram down a suburban street.[50] Downcast eyes, a pleasant demeanor, and submissive gestures helped put

whites at their ease and allowed a person to avoid situations that threatened dignity or could provoke a white to anger. Africans to whom such behaviors did not come naturally learned to adopt them, through what sociologist Erving Goffman called "impression management."[51] One of the few African men I interviewed provided strong evidence that he knew what was expected of him in public: "In those days, when you want to talk to a white man, you have to count your words. You just can't say to him, 'Hey, you, do this.' He will ask you, 'To whom are you talking?' [You must say,] 'Oh, sorry sir, sorry sir,' and *scratch your head*."[52]

A woman new to Johannesburg might dread the indignities she knew she could face even in suburban neighborhoods and be nervous about encountering police on the streets. Nonetheless, she could dare to venture out. The street was filled with other African women. When they were careful not to draw attention to themselves through their dress or their bearing, their ubiquity made them invisible to whites; their positions as family servants made them appear innocuous. While the police, who were both black and white, posed a definite danger, most whites did not. Accordingly, a worker could spend her free afternoon instructing a greenhorn on bus lines or the best hiding places in the neighborhood without attracting as much as a backward glance. The fear that the municipality and government tried to instill in Africans through vigilant and often brutal roundups, hoping thereby to discourage urban migration, was undercut by the capacity of these same folks to take advantage, when the police were not about, of whites' acceptance of their presence. Their relative freedom in the public realm was a function of their status in the private; their social position as "nannies" supported African women's challenge of the state's efforts to control urban space.

TWO

The Tempo of Kitchen Life

At the sound of her alarm, Rose—the name she used in the city, since few whites would make even an effort to pronounce Nkululeko—lifted herself from her narrow bed. She groped for the clock to stop the harsh ringing. There, blessed silence, at least for now. If it was winter and still dark, she might switch on the single electric bulb or light the paraffin lamp that sat on the floor. Her day had begun.

Perhaps it was her first week in this position; or maybe she had been with the family in this very yard for upward of twenty years. There was enough agreement among whites on the appropriate manner of suburban living that African women could move between middle-class homes with relative ease during the course of a domestic career, that white families could accept new employees with a minimum of fuss, and that we can confidently sketch the outline of a woman's working hours. Most white households shared not only a basic technological standard—for instance, the use of running water and electricity—but also a common attitude toward their African workers and a common way of working them. Popularly held considerations, concerns, convictions, prejudices, and interests produced a narrow range of approaches to conducting household business among white Johannesburgers and created a set of fairly predictable and consistent ways of employing household workers.

That said, there *was* a range. There existed important differences be-

tween and sometimes even within Johannesburg's white, middle-class households, where husbands and wives did not always agree on such matters as the proper way to entertain friends or appropriate bedtimes for children, and teenagers and their parents might not agree on anything. Factors like the composition of the white family, their wealth, members' ages, the presence of advanced technologies in the home, pets, the age and condition of the physical structure, and the whites' lifestyle impacted in many ways the decoration of houses, the sort of maintenance required, whites' attitudes toward their things, and the role of a worker within the home. In addition, many households changed their accustomed ways of doing things over time, for instance, when teenagers moved out, a breadwinner retired, or a housewife started working. Events like these necessitated changes within a worker's routine, for better or worse, and the need to produce a new rhythm of working. The worker herself was another variable. Migrants came from a range of backgrounds. A woman raised in the rural homelands was likely to approach chores differently from someone with long experience of modern conveniences. Personal taste and matters of opinion, which were subject to change in the course of interactions with various madams and other workers, also played a part in how an individual woman approached and responded to her work duties.

All of these variables, and more, sketched the contours of what was, to whites, home and, to workers, what one of their number called the "small and very particular hell" of each job site.[1] In her study of Eastern Cape workers, Jacklyn Cock found that of fifty workers interviewed in depth, none enjoyed their jobs. Her informants, all unidentified workers, told her:

I have been a slave all my life.[2]

We are slaves in our own country.[3]

What can we do? We are slaves.[4]

My own interviews confirmed this theme; there were many reasons workers might have felt this way. The conditions under which so many women left their homes to seek city jobs were sufficient, in themselves, to breed indirect resentment toward Johannesburg employment and employers. Long periods of separation from the people and places held dear, caring

for others while one's own kin scraped by on meager remittances—all this could produce longing and dismay, even if conditions in the kitchens were supportive and nurturing. As it was, though, life in the kitchens tended to intensify rather than mitigate one's personal pain. This chapter demonstrates how this was by mapping the contours of domestic work over the course of a woman's days and weeks.

It was still early now, perhaps 6:30 or 7:00 a.m. In the wintertime, Johannesburg was dark at this hour, and before early-morning jogs became fashionable for urban whites in the 1980s, the worker was likely the only one fully risen in the household. Rising from her bed, she took a quick look around "this box they call the maid's room."[6] The small mirror that she had purchased from her savings and placed on a stool, the curtains she'd made out of sheets she had salvaged from her employers' garbage, the photograph of her youngest charge that was attached with tape over the door (few workers had photographs of their own children)—these were the items that were likely to bring a proud smile to a worker's face as she viewed them in the morning light. These objects were hers, and she would take them, along with her clothes and bedding, if she were ever fired and ordered to leave the property. Everything else would stay, not that there was much else. A bed and mattress were standard issue across households, as was an unpainted wooden bench or chair. These items were usually either purchased from stores that sold specially produced back room goods that were cheaper, smaller, and less sturdy than their regular lines or castoffs from the main house. Many employers also included an alarm clock, the white household's version of the factory whistle. The worker could glance at the hour as she silenced its ring and be reminded that while she was on her employers' property, her time was theirs.

What else might a room contain? The Domestic Workers' and Employers' Project, a nonprofit organization based in Johannesburg and dedicated to promoting better understanding between household workers and madams, issued a list of recommended items for back rooms in 1975. It included a door with a strong lock, a window with burglar proofing and curtaining that opened, an electric light with a shade, a mirror, a bed and serviceable mattress, an easy chair, a wardrobe and chest of drawers, a table, floor covering, a heater, a ceiling, a safety bell, and a primus stove. An investi-

FIGURE 17. Employers did not provide much furniture for their workers' use in the back rooms. At 8 x 10 feet, the typical dimensions, the rooms would not hold more than a few pieces of ready-built furniture, such as wardrobes and beds. (Drawing by Sibel Zandi-Sayek)

gative reporter in 1975 reported that not a single room of the "scores" she examined contained all of the items recommended. Rose's Parkview back room contained a bed, a wardrobe, a small table, and a bench.[7] Another worker's skylight room, in nearby Killarney, contained a primus stove, a bed, a wardrobe, and a cupboard for dishes.[8]

Workers compensated for what was lacking in their room, but they spent their energy and money on these places very selectively. Considering their vulnerability, only a foolish person—or one who could afford to absorb the loss—would invest in any goods or improvements that could not be carried out in a large bag. As workers often reminded themselves, "If you call this your home, then you are lost. Because at any time the person you work for can say, 'I'm selling the house. I'm moving.' And then you're in the street."[9]

Being steeled against attachment, though, did not mean that a worker regarded her urban lodgings without a tinge of pride or sense of belonging. Workers found ways to decorate their quarters with minimal risk of loss to themselves. Wooden tomato crates rescued from the alleys of local greengrocers served as cupboards. With a board placed on top, they became

tables. *Mealie* meal sacks, boiled until they turned white, were as good as store-bought fabric for draping over a makeshift table. "You say, 'Oh, Sarah's house is so beautiful!' But you don't know what's underneath."[10]

Those without wardrobes hung their clothes on nails fastened behind the door. Another popular option was to attach a string between two nails and throw clothes over it or hang clothes on hangers from the string. If a worker was lucky enough to have a primus stove in her room, giving her some independence from her madam's kitchen, especially on her days off, she needed to consider how to protect her clothing from its effects. An old sheet draped over the makeshift wardrobe offered protection from dust and the fumes of the paraffin. A hung sheet could also be used as a room divider, separating the bed from the rest of the room and thus providing some privacy when guests called.

Workers also tried to remedy the structural defects of their back rooms, and these were many. Damp-proof courses were not used in older servants' rooms, so the small quarters were invariably musty, despite Johannesburg's arid climate. Bare floors, uninsulated walls, and the absence of ceilings contributed to the cold, leaky, drafty atmospheres of these places. Yet employers rarely supplied fans and heaters, and they were prohibitive for most workers to buy. Because many rooms did not have electricity, and those that did generally had only a single socket, these places were generally dark as well. Some employers whitewashed the interiors annually in an effort to help maintain them, and pale walls could compensate somewhat for the lack of light, but not completely. A worker could disguise water stains by cutting pretty pictures out of old calendars and distributing them strategically along the wall. Homemade rugs, braided from scraps or made of flattened cardboard boxes, made the granolithic paving more bearable. Rolled-up blankets placed at the foot of doors or along windowsills reduced draftiness and cold in winter.

Some decorating strategies were inspired by what workers observed inside the main house. Imported European lace tablecloths, for instance, inspired the use of embroidered sacks, which in back rooms found roles as tablecloths, doilies, and bed dressing, often hiding stains, spots, or holes. Inexpensive to make, and providing the satisfaction that comes from producing one's own handiwork, they were ubiquitous: "When I was working, every night, you know, when I don't go out, then I sit down and when I'm staying in for the [white] children you know, I was stitching."[11] One

worker took several months to embellish an entire twin sheet with a design of red thread. Women also placed embroidered cloths over bed pillows, displaying the resident's needle skill and adding color to the room. Needle-work was especially common among women from the Northeast part of the country, and those from other districts learned it from them when they gathered in parks and other meeting places.

Place of pride in back rooms went to particularly valuable possessions, like radios and cosmetics. Rural African women's cosmetic universes expanded greatly upon their arrival in the city. Where many had been accustomed to washing their faces and bodies with laundry soap and brushing their hair with homemade brushes that resembled small hand brooms, before wrapping it up, as was conventional for married women, Johannesburg presented a vast array of tempting products and new standards of appearance. Domestics heard advertisements on African radio and saw, even if they could not read, magazine pages that promoted hairstyles, creams, and makeup, since marketers by the 1960s were beginning to respond to the potentially enormous spending power of black consumers. Older township women and new migrants—both among the more conservative elements in urban areas—rejected much of the new aesthetic and the consumerism that was such an important part of it. However, even those who opposed the modern look on moral or aesthetic grounds had a hard time escaping all its temptations.[12]

Some cosmetics, like perfumed soaps and hair combs, were common Christmas gifts from employers, who were a second source of ideas for new forms of toilet. Many domestic workers took cues from their madams' dressing tables and listened to the well-meaning advice of the white women who cast themselves as mother figures to maids "raw" from the countryside. Other items workers bought for themselves out of their meager wages. Homemade preparations saved money: "It was the time when we girls used to relax our hair. . . . Straight, straight, straight. People actually used stones. They put a stone on the stove and put some Vaseline on your hair, and used the stone to stretch your hair. It was a terrible experience. . . . Can you imagine the smell?"[13]

Upon rising, a woman might rearrange her bed before stepping outside to pee. The toilet was next to the back room, in a small adjacent stall, which might or might not have a door. In winter, the enclosure could be very

cold. Not all households provided showers in the yard. When they existed, they were sometimes in separate stalls near the toilet and sometimes right in the toilet stall itself. If there was no shower, the worker drew water from an outdoor tap. That was the situation where Rose worked, so each morning after wrapping herself in a blanket in the traditional manner, she stepped outside and ran water into a bucket that she carried back to her room.[14] In some cases, workers had to walk to the white house kitchen for water. If a worker had a coal or paraffin stove, she might transfer some of the water to an aluminum pot and heat it before pouring it back into the tub or into a basin, which she placed on a towel or fabric scrap on the concrete floor. Sponge baths could be quick, and a worker knew that if the air and the water were both cold, the bite of chill could be reduced by wringing out her rag thoroughly before applying it to her body. In the winter, even those with access to showerheads might choose to bathe this way rather than subject themselves to a cold shower.

These bathing practices were not very different from those in South Africa's rural areas, where a well or river might substitute for a tap. There was one difference: in the city she was aware as she threw the dirty bathwater onto the bushes outside the back room door that just a few yards away, hot water was available. Indeed, within the hour she might draw hot baths for white family members. The plumbing system was simply not extended to her corner of the property nor made available for her personal use. Workers knew this, and while there was nothing inherently demeaning about bathing with rag and basin, the coldness of the water took on an insulting aspect, given the unspoken assumptions that underlay the uneven technological relations between white house and back room.

After taking a quick sponge bath, donning her uniform, and fixing her hair under her cap, she stepped into the yard. Johannesburg's mild climate and middle-class whites' abundant disposable income allowed them to maintain beautiful and varied gardens. Many backyards, in size and appearance, resembled public gardens. Granted, in the newer suburbs, a yard might consist mostly of a large expanse of meticulously kept turf lawn with a few ornamental shrubs, as was the "modern" look, but closer to town yards were usually full and lush. Arranged along paths, patios, pools, and clearings, flowering jacarandas and pride-of-Indias burst into vibrant color overhead, and wandering jasmine, trumpet flower, and grenadilla vines

shot forth flowers and fruit. There were roses, of course, as nothing could be more English than a rose, but also proteas, the national flower of South Africa, in their weird and wonderful varieties.

There was often a plant arrangement in front of the back room itself. After all, back rooms typically fell within the sight lines of whites, who could see them from some rooms in the main house and certainly from the back garden or tennis court. Colorful flowers along their front walls or a prettily paved path helped to make rooms attractive visual elements within whites' yards. In the countryside, where rural workers' homes could be a good mile or more from the main farmhouse, things were different. There, workers' houses could become rundown without causing visual offense to whites or their guests. Urban back rooms, though, were less easily ignored. Architects and builders designed them with their visibility in mind, as figure 18 illustrates, and their facades often complimented or set off the larger, main house. They formed part of the setting against which the white family home was meant to be viewed and against which it was to be admired. The few steps from the inside of her room to the pavement in front of its brightly colored wall, then, took a worker from her private, dim world of scarcity and making do, to a lush place of abundance. She locked the door to her back room—that would keep out the gardener, any potential thief who might jump over the back fence, and snooping children—and put the key in her pocket.

As she traveled toward the imposing presence of the white house, a worker could allow neither bitterness over the coldness of her morning bath nor grumpiness about the kerosene smell that she could not remove from her clothes to linger over her face. Instead, she made herself assume the mask of deference that workers wore in the presence of whites. Eyes should whisper submission, and mouths wear pleasant, quiet smiles that signaled dumb eagerness to please. One observant American slaveholder dubbed this submergence of feelings a "house look."[15] The refusal to expose one's real thoughts was more than a protection against accusations of sullenness or "cheekiness" that could cost a servant her job. By holding something of themselves back, workers were able to correct a little the power imbalance in their relationships with their employers. They knew that madams and masters could be frustrated by the "ant-like, noncommittal way in which blacks serve whites."[16] They strategically fed such

FIGURE 18. A back room in Parkview, Johannesburg, with the main house in the
background. (Photograph by the author)

frustration, aware that among other messages, it brought home to their
employers the impossibility of gaining total submission from a worker.

Despite the practiced look of resignation on her face, within her own
heart a domestic was likely to be preoccupied with thoughts of the day
ahead. Was this the morning to ask for that long-promised raise? Was the
colicky baby feeling better? Did she have enough baking powder to make
muffins for breakfast? Many workers found their minds going to the crux
of the matter, the condition that most affected their workdays, the mad-
am's state of mind: "You think, that woman, today I don't know what [she]
will say to me. You can start work. Maybe you come in, you cross with the
woman. Maybe is not cross."[17]

The quality of the work environment depended greatly upon the mad-
am's temper and on a worker's ability to keep her in good spirits. As an-
other worker described it, "I have to fit myself into her."[18] In the half light
of dawn, as they opened the kitchen door to let themselves into their em-
ployers' houses, workers gave quiet prayers for a peaceful day and began
their duties.

A domestic worker ended her walk across the yard—or, in the case of a rooftop location room, down ill-lit stairs—by crossing into the modern kitchen of her madam. For most workers, these jobs marked their first significant contact with whites and their first times inside middle-class houses. Even those who had formerly worked in Boer farmhouses were frequently taken aback by the technologies and material culture of modern urban homes. As Patricia recalled, "Everything in the house was a surprise to me."[19] Ernestina said of her employer's home, "You could get lost if you did not know it well."[20]

The design of white houses differed substantially from that of rural African homesteads. In the city, all domestic functions were contained under a single roof instead of in separate buildings for food preparation, sleeping, and storage. Although domestic workers did not appreciate the fact, the internal arrangement of these spaces, which they could find so confusing, reflected South Africa's particular social history. Unlike houses in turn-of-the-century North America and England, which had "opened up" in response to new technologies and new ideas about sanitation, interior decoration, and family relations, and, importantly, because householders could no longer count on having full-time servants within a changing economy, South African domestic architecture had not undergone such changes. South African households had not experienced a severe shortage of live-in workers or accompanying hikes in their wages. House plans did reflect the removal from the market of white servants with the gradual disappearance of inside servants' rooms. However, the continued use of African labor was evident in the slow adoption of modern technologies into white South African homes; the separation of the kitchen, the domestic worker's domain, from other areas of the house; and the retention of the integrity of individual rooms.[21]

Take figure 19, for example. The floor plan, advertised in a housing magazine, allows us to read contemporary ideas about the role of domestic workers. The kitchen is placed in a central location, allowing the domestic convenient access to key points of the house that require her labor, including the dining room, living room, and work yard. At the same time, walls isolate the kitchen from its surroundings, turning it into an enclosed cell of labor in which the maid must work invisible to white family members. The kitchen has no windows, unless there is one on the back door, and

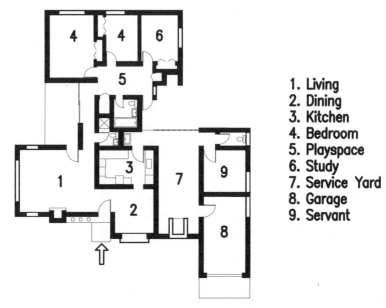

1. Living
2. Dining
3. Kitchen
4. Bedroom
5. Playspace
6. Study
7. Service Yard
8. Garage
9. Servant

FIGURE 19. This house's kitchen, the domain of the worker, is simultaneously centrally located and isolated from its surroundings. (Drawing by Cynthia Cope, drawn from a plan in the *Supplement to Personality*, 20 April 1961)

that would provide view only to an exterior wall. This plan suggests the centrality of the domestic worker to the life of the house and at the same time her intended exclusion from its social life. In this, it is more reminiscent of a Victorian-era middle-class home whose secluded kitchen spoke to the presence of a full-time housewife who occupied an enclosed kitchen whose sounds, smells, and sight did not intrude on other family members than the midcentury modern open homes that were popular at this time among monied homeowners in the West.

The architect of figure 20 has tried mightily to keep current with overseas fashions, such as sunken living rooms and open floor plans, while respecting white South African consumers' desire to separate work zones inhabited by household employees from family zones and entertainment areas. What would otherwise be the dramatic effect of descending from the hall into the lounge, or living room, is sacrificed to the home owner's

perceived need to screen from her family's view and that of visitors the entrance to the kitchen.

From the perspective of the women who worked in them, white houses had too many rooms—a bedroom for each child?—and simultaneously utilized novel and, to some, strange features that ordered these too-numerous spaces, such as stairs that separated upper and lower stories and hallways that ran between rooms. The objects within the houses were also foreign. Curtains and carpets, hi-fi's and electric ovens, children's model airplanes and Easybake ovens, provoked various responses, but all took getting used to.

In the kitchen alone, a worker faced an electric or gas range, electric refrigerator, freezer, toaster, electric kettle, and waffle iron; linoleum floors,

1. LOUNGE
2. DINING
3. KITCHEN
4. STUDY
5. BEDROOM
6. BATH
7. YARD
8. WORK RM.
9. SERVANT
10. GARAGE
11. STREET

FIGURE 20. The text that accompanies the plan reads, "Access from the kitchen to bedroom wing is easy but unobtrusively placed behind a screen wall." (Drawing by Cynthia Cope, drawn from a plan in South Africa's *House and Home* 8, no. 4 [1963]: 42)

sliding cupboard doors, light switches, and electric outlets; sets of stainless steel cutlery, knives, silverware, everyday dishes, fine china, glassware, crystal, and an assortment of pots, pans, and utensils with specialized functions. For those new to the job, it could be intimidating, and seem a little silly, to distinguish a bread knife from a cake knife, a ladle from a serving spoon, or a soup bowl from a salad bowl. Yet many workers not only learned these things but became specialists in table settings and food preparation. Becoming an expert, though, did not render one insensible to or uncritical of the disparities between their employers' homes and those of their own families. A survey of fifty workers in the late 1970s found that all believed there to be a great difference between their employers' living conditions and standard of living and their own and that 80 percent of the workers considered this difference unjust. The sight of a stove that cost more money than her entire annual salary, or a storage freezer that contained enough food to feed her extended family, whom she knew to be malnourished back on the farms, could breed a range of feelings, from sorrow and longing to envy and resentment.[22]

A worker did best to learn to steel herself against too fine a sensitivity toward the unequal distribution of wealth in South Africa if she was going to be able to work in these settings. A healthy contempt for the consumption habits of their employers helped many workers to view the contents of the white house with some equanimity, though responses could be complex, as we shall explore more fully in a later chapter.

Whatever she thought of her employers and their possessions, morning routines had to be performed. In single-family houses, they typically included cleaning and regularly polishing the *stoep*, the open front verandah that welcomed visitors. It made sense to perform the outside chores in the early morning while family members were still in bed and sought quiet in the house. The *stoep*'s place in the day's labors also bespoke its importance to the white household: "The *stoep* is in many ways the most vital part of the whole house," according to a contemporary building guide.[23] It traditionally formed the center of South African home life. Though urban English families were less likely than earlier generations of Boer households to entertain or eat there, a clean and orderly *stoep*, rubbed to a deep shine, remained a matter of domestic pride and neighborhood expectation. The earlier a servant performed this task, the less likely she was to be seen by

FIGURE 21. *Stoeps* came in many shapes and sizes. They were generally raised from the ground, as was the case in this Parkview home. (Photograph by the author)

passersby imposing herself in the picture that composed the ceremonial front of the family's home.

As she faced the leaves and dirt that had collected overnight on the painted cement surface, a worker's back might start to ache in anticipation. The insult occasioned by many householders' reluctance to purchase labor-saving technologies or make them available to a worker made itself felt in stoep maintenance. Most, but not all, white families provided their workers with upright brooms to sweep away debris. However, a clean *stoep* also required washing, and although mops hardly qualified by mid-twentieth century standards as modern appliances, some households resisted purchasing them, on the same principles by which they kept washing machines, dishwashers, electric floor polishers, and other labor-saving tools from their homes. Some employers calculated that it was more cost-effective to have the worker perform these tasks than to purchase such big-ticket items. Others believed—or told themselves—that work done by hand resulted in a higher level of cleanliness.

Old-fashioned labor demanded that workers assume postures of def-

erence. Women without access to labor-saving devices scrubbed on their hands and knees and washed clothes leaning over tubs. They took the conventional pose of the subservient, low to the ground and stooped. In slavery-era America, status was marked in part by the distance of a traveler's head from the ground. Whites rode horses; enslaved workers walked. In the South African home, too, a person's posture was an expression of her role. Even an outline sketch of a house interior could reveal who was who. The white residents would be those sitting in chairs and sofas, backs straight. Domestic workers hunched, crawled on their knees, and bent over dishes and ironing boards and babies and breakfast trays. Not only did these positions speak the language of submission, but they were highly uncomfortable—or, perhaps more precisely, they had come to form part of the language of submission because they were so uncomfortable. Workers complained of their cracked hands, rough knees, and stiff necks, from which access to certain machines would have protected them.

Given the reluctant market and the availability of cheap, unskilled labor, many technologies became popular later in South Africa than in other parts of the world. When they did enter the market, the main target consumer group for modern appliances was households without full-time servants. These were predominantly working-class whites, immigrants, and the few Indian, Coloured, and African families that could afford such goods. Sometimes middle-class households did invest in appliances, but reserved them for white use only: "They never used to have washing machines those days, and even if they had them, they never allowed 'you, kaffir' to use it. No, you must do the washing with your hands."[24]

In another household, according to a contemporary interview, "She does have a vacuum cleaner, but I am not allowed to use it. She said I will break it. I must kneel."[25]

Workers could appreciate to some extent their madams' concerns. After all, many could remember when, fresh from the rural areas, they had not known how to turn on an electric kettle or fry an egg. However, they had learned quickly to use the things they found in white houses. Electric appliances, for instance, did not daunt one worker from a small-town location. She simply read the instruction booklets.[26] In spite of the common white prejudice that Africans were perpetual children incapable of mastering complicated devices, it was clearly experience, not race, that de-

termined one's capacity with technologies. Another worker had to instruct the (white) Afrikaner purchaser of her English employer's home how to use the electric washing machine.[27] Middle-age workers recognized the unstated assumptions behind household rules that made dishwashers off-limits to them but accessible to white teenagers.

The extent to which any given worker reflected upon such matters as she worked depended on her bent of mind. What is more certain is that many struggled to return to their feet after crawling along the *stoep* on their hands and knees and took a few seconds to recover their balance. If a woman's luck was good, she might catch sight of a worker performing similar labor on a nearby property and give a quick wave. Often, though, the size and landscaping of Northern Suburb lots, designed to provide home owners privacy, made it difficult to catch the eye of or even to see people just next door. It was easier to communicate with other workers via backyards than front ones. On cold winter mornings, a woman might rub her palms together to warm them. Then, gathering her cleaning supplies, she moved onto the next job.

The order of the remaining morning tasks varied across households. After polishing the *stoep* and cleaning the outdoor toilets that African staff used, Martha returned to the kitchen to prepare breakfast and feed her employers' young children. After breakfast, she took them to the bathroom and ran their baths.[28] Over in Highlands North, Katherine's routine was reversed.[29] Starting later, at 7:00 a.m., her first priority was to get her employers started on their day. She began by boiling water and preparing two cups of tea and carrying them on a tray to her master and mistress in their bedroom. Returning to the kitchen, she prepared the porridge: "Then you lay the table. Then you call them. 'Madam, baas, *Klein* [little] missus, *klein* baas. The table is ready!'"

"While they're sitting, they're still having their breakfast, you go outside. You go and clean the *stoep*. . . . You sweep it and you kneel down with your knees shining it, every day with the brush and the red [polish]. There's no machine. The machine is your knees."

Younger children required greater care and exertion. Across town, Pauline, who also started at 7:00 a.m., went straightaway into the children's bedroom and woke them. She took them to the bathroom, and as they were unable to perform their toilet unsupervised, she bathed them and

then returned to their bedroom, helped them to dress, and brushed their hair. After they were presentable, their father rose.[30]

Miriam had to be in the kitchen at 6:30 a.m.: "I put the kettle on. When the water is boiling I make coffee, warm the milk, put the porridge on the table. Take the coffee to madam and master in the room to give them. In the bed I have to give them coffee. I have to give the boys their breakfast and make them sandwiches for school. Then they went away to school."[31]

If there were pets, their care had to be figured into one's day as well. Zola's first task upon passing into her employers' kitchen each morning was to feed their two Alsatians. She withdrew their meat from the refrigerator and warmed it in a pot on the stove top with fresh cabbage and cornmeal. She was not obliged to prepare breakfast for her employers. After dishing up the dogs' breakfast and filling their bowl with fresh water, she started to clean house, her mind still lingering, sometimes, on the fact that her madam provided meat for her pets' morning meal, but not for her domestic worker's.[32]

Despite variations, domestics' morning routines had in common that they provided workers access to ostensibly private zones of the white house, like the bathroom and bedrooms, and allowed them to participate in householders' intimate activities. It was often during these early hours, when family members, half dressed, still groggy, and at their most vulnerable or temperamental, revealed most to the worker, wittingly or not. The rooms in which whites felt at their greatest ease, least restricted by social niceties, could be, for precisely that reason, particularly hazardous places for workers. Because whites there were comparatively more relaxed and less thoughtful, the women had to be especially watchful. The sensitive domestic could see at a glance whether there had been arguments between husband and wife during the night or if a young child had been made grumpy by unpleasant dreams: "You'll find that, first thing, she hasn't even said good morning and she's just *bursting* on you. For nothing. So you must know that there was trouble with the master."[33]

The time between workers first entering the white house and white occupants leaving the breakfast table for work, school, or other activities constituted the first shift of the day. The house calmed as school-age children ran to catch the bus, Dad drove off to the office, and Mother, after providing the worker some last-minute instruction, went outside to check

the garden or attend a community meeting. Some workers might oversee the gentle pandemonium that reigned as family members grabbed lunches, double-checked one another's schedules, and sorted through jackets and gloves. Others stayed in the background and kept to their strictly defined tasks. The degree to which she became an acknowledged participant in these interactions, as opposed to a socially invisible observer, depended on things like her personality, her English-language skills, her length of engagement with the family, and the formality or informality of their relations with her and with one another.

After they left, a worker could finally turn to her own breakfast, usually a chunk of bread with margarine and jam that her madam had placed on the kitchen countertop. White madams conferred with friends and neighbors on matters such as servant helpings, validating their own behavior and checking others' by ensuring that no one was spoiling the market, as madams put it, by overindulging her worker and raising African expectations of wages and conditions. If one household offered bread with jam, all others in the block were likely to conform and have similar fare; indeed, that menu was the standard throughout the Northern Suburbs. A worker ate it with a cup of tea sweetened with sugar, two teaspoons a cup being the popular allowance. Whites rarely allowed their African employees to eat from the same plates or silverware that they used. Instead, the worker drank and ate from a tin plate and mug that were sold alternatively as servants' ware and camping goods. She might eat standing or sit out on the back steps if the sun had become strong enough. One worker was required by her madam to eat outside, next to the toilet, "and it smells worse than hell."[34]

Because rations were meager, it rarely took long to finish the meal, but a worker having just, on an empty stomach, cooked a hot breakfast for her employers or stirred up meat for their dogs rarely found breakfast a satisfying experience. One reported that the worst thing about her job was "not eating what I cook."[35] Another complained, "The smell of their food makes me hungry."[36] A worker tried to ignore the aroma of the bacon that she had just prepared as she filled up on the cold cheap bread that she knew her madam bought especially for her. Standing next to the table on which the family's now empty dishes still sat, but unable to take a seat there herself, this was a situation more likely to engender bitterness than a

sense of gratitude or feelings of refreshment. "The smell of meat must be enough for me," one worker observed ruefully.[37] The site that had just been the scene of an energetic family gathering became the location of a very different meal after the whites had left. As she tidied the breakfast dishes, perhaps pinching some leftovers for herself, the worker made the transition from personal maid and cook to housecleaner.

Housecleaning occupied the bulk of a typical day and was, ostensibly, the work for which, unless she served as nanny, a worker was principally paid and most sharply judged. Workers cleaned behind whites, erasing traces of their activities from their own eyes. It was a domestic's job to pick up what they had dropped, fold what they had rumpled, and rearrange the items they had moved in the course of use. Most women tackled the challenge of removing the signs of whites' movements not by retracing in turn the routes of individual family members, but by following cleaning routines that allowed them to respond to the overall effects of a household's regular activities. Daily tasks included dusting, vacuuming all carpeted areas, making the beds, cleaning the bathrooms, mopping entryways, and general tidying and rearranging.

Differences among households regarding standard responsibilities depended in part on employer habits and activities. Smokers meant ashtrays; children, abandoned toys and dirty walls; frequent entertainers, empty wine glasses; and cats, hair. Each season brought its own labors: "Now it's winter they carry a lot of grass with their shoes from outside."[38] Elderly employers often had workers join them on shopping trips, and some servants contributed to their employers' home industries, baking cakes or meat pies that their madams sold at flea markets. As a rule, domestics received no share of the profits. It was part of the job.

The condition of the house was another consideration. Bigger houses meant more work, though smaller homes and apartments sometimes equaled greater clutter and so heavier dusting and rearranging. On the whole, though, apartments were easier to clean than houses. Location mattered, too. Residences nearer the line of gold mine dumps that ringed Johannesburg's downtown were more vulnerable to intrusions of mine dust, small particles that, when the wind blew from the south, entered opened

windows and doors and settled on furniture. Such dust, though sounding evocative, was not only worthless but irritated allergies and asthma and so required frequent cleaning.

In addition to daily duties, workers had regular weekly jobs. Monday was usually washday, although if a household had small children, the worker was expected to clean clothes more often. On the three days each week that Miriam washed, she let the machine run while she went room by room through the house and did her cleaning.[39] Katherine, by contrast, washed the family's clothes by hand, though the home contained a machine. The washer was for madam's use, in case any washing needed to be done on Katherine's day off.[40]

The following day was for ironing, which many workers considered the worst of all household jobs. Two, three, or even more hours, bent over a board, strained many backs. Pauline's employer let her use the washing machine but would not purchase a steam iron. Instead, Pauline used an old-fashioned dry iron, with a little cloth and a cup of water that she used to wet the fabric as she went along.[41] In most households Friday was "spring cleaning," when the worker was expected to move the beds and other major pieces of furniture and vacuum and wash the floors thoroughly.

On the remaining days, there was some variety between households. Where entertaining played an important part, for instance, the worker might be instructed to polish the silver weekly. Some women accompanied their employers to large social gatherings over the weekends, where they worked in the host kitchen and had the opportunity to socialize with other workers. If madam and master liked to get away over weekends, perhaps to the Magaliesburg Mountains or up to Warmbaths for the spas, the worker could relax more on those days.

The religious practices of their employers made a difference to the women's work. In observant Jewish households, observance of the Friday-evening Sabbath became part of workers' regular routines. Most had had no prior exposure to the Jewish faith and found it quite foreign. Nonetheless, because they had to, women who worked for practicing Jews learned the prescribed diet and the intricacies of keeping kosher. Margaret received language instruction from her madam, so she in turn could teach her young charge his prayers in Hebrew.[42]

For Martha, who also worked in an observant household, most Fridays were spent in the kitchen, preparing elaborate dinners.[43] Her employer entertained on Shabbat, and Martha frequently laid a table for ten guests or more. She began by koshering the meat and then preparing chopped liver, herring, and chicken soup. Although she did not understand her madam's insistence, she spent extra time with her work to take care not to mix meat and dairy utensils. During breaks in her cooking, she polished the knives and candlesticks.

Before everyone arrived, and after she had finished the salads and the messy business of frying the fish, Martha carefully set out the *kitke*, or challah bread. Her madam usually made an appearance at this time, at about 5:00, and her arrival gave Martha a chance to retire quickly to her back room to change out of her dirty uniform into a clean black and white one. Then she returned to the kitchen, presentable to her madam's guests, to put the finishing touches on dinner and serve table. By the time all the guests had left and Martha had washed, dried, and put away the last dish, it was often past 11:00 p.m.

A dog in the house usually meant weekly pet baths, a universally detested task for several reasons. Washing a dog, especially an unwilling one, was hard work. It got workers wet and made them dirty. Even more important, it was an outdoor job, and aside from washing the *stoep*, those were usually reserved for African men, mostly day employees. It embarrassed women to wash cars, mow lawns, and do other "masculine" tasks: "I feel so bad when people walk past me and see a woman doing that kind of work."[44]

The issue was less perceived distinctions between "house" and "yard" jobs, than employers' seeming refusal to recognize gender roles, instead treating all Africans, male or female, as interchangeable labor units. Women who spent precious wages on body oils and creams resented being treated like "boys" by madams too cheap to hire men to do men's work.

> A white woman can tell you to move a wardrobe. Because you are black she does not think that you are a woman.[45]

> Your employer looks down on you. You have to keep saying, "Remember that I am a woman too."[46]

Perhaps such considerations would have mattered less had workers cared for their employers' pets, but between domestic workers and dogs, in particular, was usually little love. The animals might wag their tails at the sight of the women who fed and walked them, but no intelligent creature could mistake the grudging manner in which workers undertook these activities for true affection. Africans in general expressed amazement at white attitudes toward dumb animals. "Dogs with names, men without," in the words of writer Esk'ia Mphahlele.[47] In one of his best-known stories, two characters discuss their madam's relationships with her pets:

> These things called white people! he said to me. Talking to dogs!
>
> I say to him I say, People talk to oxen at home do I not say so?
>
> Yes, he says, but at home do you not know that a man speaks to an ox because he wants to make it pull the plough or the wagon or to stop or to stand still for a person to *inspan* it. No one simply goes to an ox looking at him with eyes far apart and speaks to it. Let me ask you, do you ever see a person where we come from take a cow and press it to his stomach or his cheek? Tell me![48]

The fact that many employers appeared to treat their dogs better than their African workers strained credulity and bred great resentment. One worker commented at the time, "I even have to look after the dogs and cats. The employers think more about them than they think about me."[49]

Said another, "The money she spends on dog food, cat food, and the other things she needs for the animals—is more than she pays me."[50]

Pets were usually allowed to jump on the same furniture from which Africans were forbidden to sit. They could spend the night in the white house while Africans slept in unheated back rooms or rooftop rooms. One worker was expected to remove her madam's dog's excrement from the floor each morning.[51] Another was forced to buy her own foodstuffs from her meager salary, as her employer instructed her to give the leftovers from the meals she prepared each night to the family poodle.[52]

One woman had her madam's proscriptions against keeping guests in her back room in mind when she asked her why she kept two dogs. The white woman told her it was because dogs need company. Roberta

retorted, "Your dogs need each other, but you expect me to stay alone. I'm not as good as your dogs."[53] Given the prevalence of such perceptions, and their belief that dumb animals were indeed lower creatures, it was little wonder that many workers took out their resentment against the precious pets, kicking dogs and provoking them when whites turned their backs.

A worker's schedule of daily and weekly tasks also had to accommodate monthly chores. Again, a weekly job in one household might be performed monthly in others, depending on things like standards of fastidiousness and the advice of the latest issue of magazines like *Fair Lady* and *Women's World*. Cleaning the oven, defrosting the refrigerator, washing the walls, and beating the rugs fit into this category.

A worker's days, then, were filled with a combination of great, time-consuming, often heavy tasks, like rotating the mattresses or rearranging the furniture, and small jobs that became unthinking daily habits. It was these little rituals, providing no great sense of satisfaction or accomplishment, that became the stuff of which a worker's days, weeks, months, and years were made, jobs like picking dirty clothes off the bedroom floor each morning, changing the bathroom towels, putting out fresh water for the cat, and emptying wastepaper baskets. While some workers were lucky enough to learn new skills in white houses, like fine baking, the use of modern appliances, flower arranging, and the preparation of dishes that were foreign to them, most found that even these tasks eventually became rote and, besides, bore little applicability to their own home lives or needs. Work, once the initial challenge of learning the task had past, was drudgery, with little opportunity for personal expression or self-direction.

> Every day same thing. Cleaning the *stoep*, cleaning the dining room, the bedroom, the patios. Everything. Every Friday you're doing the spring cleaning. . . . Every Friday. Can't jump a week.[54]

> It's not an interesting job. You don't learn from it. It just makes you tired to think you are going to do same thing everyday.[55]

> It makes you tired and you do the same things every day.[56]

Some workers managed to escape from the mind-numbing boredom of domestic labor, even if only for a few minutes each day. One secretly

borrowed books from her employer's shelf. Though she could not always understand them, they amused and entertained her.[57] Catherine wrote letters and did embroidery, believing that, given the unchallenging nature of domestic work, "you ought to do something to keep your mind growing."[58] Workers' handiwork often sustained them. Not only did embroidery, knitting, and sewing constitute ways of providing articles of clothing for family at home or inexpensively decorating one's room, but there was also some satisfaction in developing one's skills and pleasure in losing oneself in one's needlework. "I love my machine," one worker said, "and I love sewing. I didn't ever learn to sew, it came on me. If I'm unhappy, to sew makes me happy. I'm *very* happy if I sit and sew. I can sit the whole day, talking to my machine."[59]

This worker kept her sewing machine in a room next door to her own rooftop room, which she rented on a monthly basis from her madam's neighbor, who made do with live-out help. Workers had to find space and time to practice their personal hobbies. This presented a challenge, not only because of their heavy workloads but also because of the problem of employer supervision. One pervasive complaint among domestics was the lack of control they had over their labors and their time. Employers preferred to have their servants perform each task on a regular basis, whether or not it needed to be done, rather than trust to worker discretion. As madams explained it to themselves, workers could not be relied upon to judge when particular conditions existed. It was better to have them clean mechanically than to expect them to exercise judgment.[60] This practice had the added benefit, from madams' perspective, of keeping workers constantly occupied. In part to ensure obedience to the prescribed schedule, and in part to check the quality of their work, many housewives followed servants through the house as they performed their duties.

Women complained about and resented the implied lack of respect for their expertise that employer micromanagement implied. "The supervision is killing me," said one.[61] They felt they often knew better than their madams how things should be done, but even experienced workers found they had little say over what tasks they would perform, their order, or how they would perform them. Lucy's employer used to run her fingers along the furniture, checking for dust: "You didn't dust here. Come here. Look." Such behavior frustrated her: "I was getting furious. I was even saying,

'Don't go after me. Why can't you sit down and let me do my job and after that you can come check.'"[62]

Heavy supervision of household work was also expressed through the lunchtime arrangements that prevailed in most households. A woman's lunch rations were usually the same that breakfast had offered, a hunk of bread with jam and margarine and some tea with sugar. Typically, there was not a set lunch hour that she could use to consume this food and otherwise gather herself or spend as she chose. Workers in most households were expected to eat what their madams had left on their tin plates or identified in the refrigerator as quickly as they could and then return to work: "After you finish eating, you just get up. Not to say you are maybe going to lunch one to two or maybe one to half past one. The minute you finish to eat, you just get up and start working. Maybe you can pretend as if you're still sitting and eating. They will call you. . . . 'Aren't you finished eating? The work is standing. It's getting late.'"[63]

Other employers resorted to even cruder attempts to assert control over their servants' movements. Some, if they saw their workers with time on their hands, would request the performance of what workers perceived as useless and unproductive tasks to keep them busy or have them clean items over again. Eunice found that her madam's constant interruptions made it impossible for her to plan her day: "She'll come in and find me ironing, busy [thinking to myself]. . . . At this time I must forget about ironing and prepare the supper. And she'll come and say, 'May I have a cup of tea?' And she'll go back to her bedroom and lie down. You feel like *dying!* Just switch off the iron and leave everything."[64]

One result of constant employer interference with their work was that it turned a woman's day into a tale of timing. This was true not only in the obvious sense that workers had to rely on their employers' schedules in setting their own—for instance, cleaning the bathtub only after madam had finished her morning toilet, waiting until children had left the breakfast table to start washing dishes, or waiting until madam had finished her phone call to complete vacuuming the lounge. It was true also in that workers acquired sensitivity toward timing in the performance of particular tasks, for the way that they "breathed" while working. Domestic service required, to a considerable extent, suspension of control over one's own movements and submission to the anticipated and unanticipated demands of white family

members. An ordinary day was, accordingly, a collage of different paces, composed of rushed periods, impatient delays, the desperate stretching out of tasks, and playing frantic catch-up. Experienced workers measured their exertions as best they could, trying to maintain a steadiness in themselves despite external fluctuations. What whites often regarded as slowness or lethargy was often servants' efforts to pace themselves, to establish in themselves an internal rhythm that could not be disturbed by madam's orders or the children's cries. Managing one's movements in this fashion was one way of compensating for having to hold oneself ever ready for the calls of others, of having to literally wait upon and for whites.

The number of off hours an employer allowed mattered greatly to a worker, as it was during such times that she could reclaim her time, shifting from her outward orientation toward the needs of others to being driven by her own desires and instincts. A woman might use off hours to catch up on sleep, embroider a pillowcase, clean her back room, do her laundry, mend her clothes—or she might take advantage of the time to leave the property. It was during off time that a worker's world could expand far beyond the house and yard. However, the amount of the expansion was limited by several factors. In most Johannesburg households, domestics received half-day holidays each Thursday following lunch. In a private car, they could have traveled to and from many workers' rural homes between early afternoon and bedtime. The nearest pieces of Bophuthatswana, for instance, were only a couple hours' drive away, and parts of Natal just a three or four hours' journey. However, workers were dependent upon public transportation, trains and buses, which did not always keep convenient schedules. Going home was usually impracticable.

A few used this time to visit friends or family in nearby locations, but most live-in workers, hailing from the rural areas, considered Soweto and Alexandra foreign and dangerous territories populated by teenage hoodlums, fast women, and gangsters. Few availed themselves of the townships' meager recreational facilities, like the public swimming pools or sports fields. Besides, there was no direct transportation from the suburbs to Soweto, which had more amenities than nearby Alexandra. To get there, a woman had first to walk some distance to one of the African bus stops, which were spaced far apart, since home owners resisted having queues

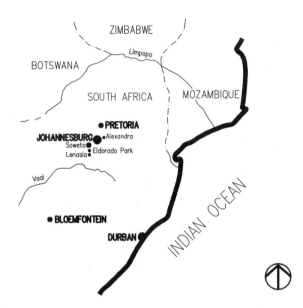

MAP 2. Soweto and Alexandra were the closest African
locations to Johannesburg. Eldorado Park and Lenasia
were Indian townships. Durban is about 350 miles from
Johannesburg. Map by Cynthia Cope.

of African workers outside their homes. From some neighborhoods, it
took older domestics as much as an hour on foot to reach the nearest stop.
There, they would stand and wait, as black buses did not run as frequently
as white buses did.[65]

The bus ride itself could be a pleasure, as the bus was sure to be filled
with other women traveling south to the city. A worker would recognize the
regulars, some of them friends, and there would be opportunity to catch
up on news, commiserate over problems, and share joys. Best of all, the
bus was an African space—with the important exception of the driver—
and, again with the exception of the driver, an almost exclusively female
space, as few men worked in the Northern Suburbs. Conversations flowed
up and down the aisle, with women sharing laughter, advice, and stories
about home and their working lives. They prayed together and discussed
health problems and solutions. Domestic-turned-author Sindiwe Magona
affirmed that it was on the buses that she learned from the experts, more

experienced workers, about white people and their ways and got advice on surviving domestic work.[66]

Unfortunately, the bus trip did not last forever. At Park Station, a woman needed to find a train traveling to Soweto, and again, all aspects of the trip were subject to racial restrictions. Train platforms, toilets, benches, station restaurants, waiting rooms, ticket counters, and staircases were segregated. A passenger unfamiliar with a station had to ask instructions not for "the gate to the trains" but, implicitly or explicitly, for "the African gate"; not "where can I buy some tea?" but "where is the African cafe?" Travelers learned the routes that applied to their race group, even as they

FIGURE 22. Workers waiting for a bus. (Photograph by Robert Kopecky)

might give passing glances to doors, counters, and stairs that were closer, but unavailable to them.

Large urban stations like Park Station brought all South Africans together. While a woman might be able to forget the crudest aspects of racial prejudice while working day after day inside a middle-class English-speaking house, being around working-class Afrikaners and others less delicate in their manners usually brought them home again. Conductors and ticketing clerks could be abrupt and rude, refusing to deposit money in one's proffered palm, making a point of talking to colleagues while serving Africans, or pretending not to understand what they wanted. Passengers could be even worse: "Sometimes you had to pass into the white area of the station to enter the black coaches. They would say nasty things to you, or trip you."[67] Affronts were, or could be, everywhere. At the same time that the hustle and bustle of downtown provided quiet, sometimes blessed, anonymity, it also held unpredictable dangers and multiple indignities: "When you go to town and see a white person, mustn't go next to her. Very scared at that time. . . . We never be free at that time. Be scared all the time."[68] Explained another woman, "You could get 'trespass' just standing on the street."[69]

Pulling away finally from the station, huddled with fellow Africans on narrow wooden benches in third class, a passenger could peer into the windows of a train on adjoining tracks and see white passengers seated comfortably on padded seats in near-empty cabins. The one-way trip to Soweto could take almost two hours, but it felt longer.[70]

Because moving around the city was so difficult, most workers stayed in the suburbs, though there was little for them to do there. Movie houses and coffee shops were for whites only. Shopping offered diversion, but even this activity presented special challenges. Small, independently owned corner stores or cafes, as they were called, mostly run by recent immigrants, had reputations for cheating their African customers: "Maybe they'll make a meat for two weeks and keep putting it in the fridge, taking it out, warming it up, putting it back in the fridge, and when you buy it you can't even eat it, it smells. . . . Also, there were no prices on the things on the shelves and then they charging us more than they supposed to charge. Most of the people who own cafes are really horrible and they don't want to listen."[71]

Downtown shops, especially large chain stores, usually had fairer poli-

cies. Central Johannesburg also contained some black cinemas, though admission tickets cost more than most domestic workers could afford. Many traveled to the city to purchase necessities like food and toiletries and perhaps gifts to send or take eventually to the folks at home. Rural kin were thankful for products that were not available at country shops, like face creams and certain medicines.

Domestics also used their days off to visit one another. Employers looked more favorably upon such socializing if they were acquainted with the visiting servant or knew her madam. Others, threatened by the potential for gossip about themselves, discouraged any tête-à-tête between workers. Many whites, too, discouraged afternoon callers on the "give them an inch" principle. Some explicitly forbade it. Workers learned how to get around such restrictions. In some cases, ingratiating themselves worked.

> There will be a dog barking at the gate. The [white] woman will shout, "What do you want? What do you want?"
>
> First thing you will say, "Good morning, madam. How are you? Oh, my name is Linda, madam, Linda Mdlongwa."
>
> "Oh, where did you learn English like that?"
>
> "At school, madam."
>
> "Oh, I don't allow people to come in, but I can see you are a very respectable girl, so you can come in."
>
> "Thank you very much, madam. Thank you very much."[72]

Hosting friends was not always a comfortable option, even if employers had been more encouraging. Back rooms were too small and narrow to hold more than one or two people comfortably, especially on a hot summer's day: "If one wants to move, the other must sit and wait. If one wants to go out, the other must go out first."[73] Some workers might feel at liberty to put a couple of chairs on the pavement right outside their door or to sit on the grass, especially if shrubbery or architectural features provided them privacy from the main house and neighbors. They would rarely venture further from the back room than that. Even if the backyard was not in use by white family members, Africans were not allowed to entertain their own friends at the pool or on the patio. What served as a social setting for whites was at best a route to the main house for workers and, at worst, another work site.

More appealing was to collect as a group in some public space. It was common to see workers in parks or on sidewalk verges during their off time, sitting with their legs stretched out in front of them, working on pieces of knitting or other handiwork while they chatted. Time away from the white house could be a relief, in any case, for a worker could better relax if she knew there was no chance of a shout from the house calling her in to take care of an "emergency." Young children, too, had a difficult time respecting their nanny's time off, and many ventured to the back of the garden and insisted on the company of the women they loved, regardless of the day of the week. Their employers' homes represented the private sphere for whites only. For the women working there, even during off hours, the properties remained sites where they were subject to control. A housewife might make a point of noting the number and identity of guests and monitoring their noise level. After they left, a housewife might quiz her worker for the latest gossip. In public spaces, on the other hand, allowing for the predictable police checks for passes, there was no one to be accountable to. It was not exactly that public space was anonymous—the suburbs were too insular and close-knit to allow that luxury—but they offered at least relief and freedom from overbearing surveillance. Besides, many women could unwind more easily away from the sight of the washing line and the barks of the dog.

Sunday was another partial day. Workers were free after finishing their morning duties. Most servants were Christian, and for them an important part of the day was going to church, either to conventional Christian churches in the suburbs that held special "maids' services" following those for whites—churches in South Africa, as in the United States, were among the most racially segregated sites in the country—or to open-air services of the Zionist congregations that gathered in the *velds*, the open green spaces that dotted the city. The low sounds of the congregants' singing and chanting were carried by the wind to surrounding houses. However, because workers were not allowed to leave for the day until they had, at a minimum, prepared breakfast for their employers, made the beds, and washed and put away the breakfast dishes, the hour of their departure depended on the time their employers rose from bed. An employer who slept in was effectively sleeping on his servant's time, since he or she prevented her from getting on with her day.

One woman worked for two elderly sisters who regularly stayed in bed

until 11:00 a.m. By the time she had finished her tasks it was often 1:00 p.m., too late for church. Being deprived of this opportunity week after week, feeling the loss of the social and spiritual sustenance her church outings provided her, was exceedingly hard on Catherine: "You feel so lonely, you feel like you are lost." At the same time, she had a remarkable ability to see the sisters' side: "You can feel angry, but you think that they're not young, those people. They're old peoples. They're old, old as your mother. You think of your mother. You can cry, but it won't help you. They don't feel the pain you've got, wanting to go to church, they don't feel it."[74]

Many employers tried to be sensitive and admitted to worrying about the "poor maid" whenever they were, not unreasonably, tempted to sleep in on weekend mornings. However, while frustrations over the maid's dependence on white behavior were felt on both sides, the worker paid the higher price. At such times, she suffered not only from the possible thwarting of her plans but also from the awareness that her employers considered her time less valuable than their own.

On working days, many employers expected their workers to change into a fresh uniform for the evening. A day of cleaning and dusting produced soiled and crumpled dresses. A clean outfit made servants presentable to the adults of the house and erased signs of her labors, further distancing employers from the work of maintaining their own homes. Retiring to her back room to remove her soiled outfit—which she was expected to clean by hand on her own and not mix with the family wash—also gave the worker a chance to take a little break, perhaps splashing her face with water or lying down briefly. Patience used this time to work on her embroidery: "And when they come, they would come in from the front door. I would hear them coming in from the front with their keys and what have you. Then I know that it's time to make tea."[75]

Instead of listening for keys, Miriam watched the clock. At 4:00, she entered the kitchen to prepare dinner.[76] Most madams, even if they did not expect the worker to cook the entire evening meal, requested some help with its preparation. At a minimum, a worker would clean and peel the potatoes, carrots, or squashes to assist the woman of the house in making the English-style meals of boiled vegetables and meat that most middle-class English-speaking whites preferred.

The white husband's arrival signaled the countdown to dinnertime. If

the garage walkway led to the kitchen door, the man of the house might enter the house through that room. However, he was unlikely to linger there long. In middle-class Johannesburg, a white man's place was definitely not the kitchen. Father might stop to kiss his wife and pick up a drink on his way to the lounge. Madam excused herself and followed, while the worker put the finishing touches on the meal and set the table. Men had less contact with the worker than any other white family member, under normal conditions. A white man was more likely to be on speaking terms with the male gardener, a once- or twice-weekly part-time employee, with whom he would discuss matters of house maintenance like clearing the drains of dead leaves or touching up flaking exterior paint. The housewife was usually the one to oversee the garden itself.

Children as a rule played no role in the preparation of dinner or, indeed, any household chores. This caused concern to some white adults who worried about the "mollycoddled" members of the younger generation who would grow up taking for granted the advantages afforded by the current booming economy. Expressing a view shared by many, a woman in 1963 wrote in a letter to the editor, "It's time that 'us parents' were brought around to realize that all the privileges we are forcing our children to accept are ruining their characters and making them lazy, not only physically but mentally as well. They get the fixed belief that the world owes them a living, without any need for effort on their part." Nonetheless, most middle-class parents encouraged their children to keep busy with activities, homework, and sports rather than requiring them to do housework.[77]

As the family finally sat down to dinner, a worker could begin to anticipate her day's end. If she had the energy, she could put to good use the time spent waiting for her employers to finish their meal. Many saw this as another opportunity to do needlework. Some cleaned their rooms or swept the walk leading to the back doorway. In other households, employers preferred the worker to wait in the kitchen, to be available if a salad needed refreshing, for instance, or extra gravy was wanted. If the kitchen was far enough from the dining room that the clanking of pots would not disturb the family, she could begin to wash up. However, it was understood that a worker would not retire for the night without doing the supper dishes. Again, her movements depended on the timing of her employers: "And they don't eat fast. They are chatting and chatting. Oh, you

feel like screaming. . . . You're sitting in the kitchen waiting for them to eat and get finished so I can go and sleep."[78]

Eventually called back to the family dinner table by the ringing of a bell kept on the sideboard or by a call from one of the children, a worker began her final duties of the evening. As whites left the dining room, she entered it, and the space transformed from a site of family gathering to a space of labor. She cleared the dishes, wiped up crumbs, swept the floor, and tidied the centerpiece. Back in the kitchen, the worker washed, dried, and put away the dinner plates and silverware. She would finish by wiping the countertops and mopping the floor. On an early night, she might finish it all by 8:00 p.m. If a family had had company, she might not even start doing the dishes until 10:00 p.m. With a large family, it might take up to two hours in the kitchen to complete the cleaning up.

Workers could begin to look forward to their own dinners as they dried the final forks and knives. For many, this was the only hot meal of the day, and the only one that offered variety in their diet. Many madams dished the maid's portion directly from the family pot onto her tin plate, a gesture that could, with some employers, bespeak gratitude and hospitality, but hinted usually at meanness. After all, madams dished up to ensure that workers did not overhelp themselves: "When she dishes up, so she must pull out your plate there and dish up for you. . . . Even you can cook the food but you can't dish up the way you like. You must wait for them, like a child, and a dog."[79]

If there had been guests to dinner, the extra work involved in serving them was compensated for somewhat by the extra leftovers, some of which were likely to be passed on to the servant, along with the tips of a few coins that conscientious guests often provided. Dinner was likely to be special on such nights as well, a change from the usual meatloafs and boiled potatoes. White food was different from the cornmeal-based fare served in African households, but most found it easy enough to get used to. The more difficult problem came when the white family left little and madam had not thought to prepare the worker's plate in advance. Then she was likely to supplement the thin helping of vegetables and salad tracings with more of the same cheap bread that the worker had eaten for breakfast and lunch. One worker, who found herself constantly facing such a situation, managed to survive by eating at the house of a friend who worked for Afrikan-

ers in a nearby suburb, as they provided, as was their reputation, plenty of food.[80]

Another common problem was that not all of the leftovers were necessarily made available to the worker. Choice cuts of meat might be set aside for sandwiches. Dessert could be put in the freezer for another occasion, and vegetables reserved for stews and soups. Many workers received not just leftovers but the remnants of the leftovers, what otherwise was likely to have been thrown away. Admitted one employer, "I give her what the dogs wouldn't like."[81]

Even those workers who prepared their own meals on hot plates or stoves in their rooms—the minority—felt the degradation associated with receiving inferior food. Whether employers agreed to provide basic foodstuffs or workers were expected to buy their groceries from their wages, the women inevitably ended up eating poorer-quality meals than those they spent hours preparing for the whites of the household. Lucinda's madam regularly gave her meat, but it was of inferior quality. The worker fed it secretly to the dog.[82] Muriel compared the "chops and steak and vegetables" that her madam ate with the "bones" that she was able to afford for herself.[83]

The other problem with having to prepare one's own meals was that it made a long day longer still. Only after she had put away the last dish of her employers' dinner did Molly make her way back to her own room and begin to cook her own meal. She often did not get to bed until 11:00 or 12:00 midnight.[84] Many workers were tempted to skip their evening supper: "To work as a domestic work, it's a tough day because the whole day you're standing."[85] By the time she closed up the kitchen and made her way down the garden path to her own room, traveling again the metaphorical distance from white South Africa to African South Africa, explained another, "You don't feel nothing. You just feel like sleeping."[86] Others allowed their emotions to finally overtake them at night.

> And if you cook, come meal[time], you can't eat it alone. Just think of your children. What are they eating?[87]

> When a woman is alone—alone at night and can't stop thinking about all these problems—then she cries.[88]

It was also in these dark hours of the night that a worker might allow herself to dream. Rachel fantasized about buying a large cream-filled cake and eating the whole thing.[89] The thoughts of others turned to revenge: "One day I wish whites would be forced to live like us. Just for one day. They would die like flies."[90]

Said another, "Go back to school. . . . Open my own business in the Eastern Cape. . . . Look after my own children myself. . . . I'll have money, and then have a big house like my madam."[91]

Others' thoughts turned to their children. Were they hungry? Were they healthy? Did they remember their mother? They imagined their children's future successes, to be accomplished in large part through their hard work in the kitchens of Johannesburg. And they dreamed of seeing their sons and daughters again.

THREE

Children and Leaving

CHILDREN DESERVE THEIR OWN CHAPTER. African or white, present or absent—they, more than anything else, set the stage for a woman's emotional experience of domestic work and colored the way she regarded the things and scenes around her. The subject was a complicated and sensitive one, not least to the women concerned. Children, one's own or one's charges, could be the source of some of the most satisfying aspects of domestic work, but also some of the most frustrating and infuriating. One's own children made the labors bearable, while white children could drive a woman to tears of aggravation.

Others have described domestic workers, rightly, as being trapped between two worlds, their family home and the city.[1] It was primarily their respective attachments to the various children in their lives that held them in that emotionally challenging and financially precarious position. Women had to juggle the strains of the job against the obligations to family, while honoring their own emotional, social, and spiritual needs. It amounted to a high-wire balancing act that many found impossible. When it got to be too much, some women left Johannesburg; others, in response to the stress of it all, elected to stay. Whatever a woman's choice, children were almost always a factor.

Many women found themselves working in white homes in the first place out of love for their children: "The day I stole away from my children

I was so sad that if I had not had those children to get money for I'd have killed myself. They are the only reason I'm still here, the one reason I will go on doing this job that is killing me. At least it is giving life to them."[2] A woman with an absent husband or none at all could expect some assistance from her parents and other family members in raising her children, but among the poor, there often simply were not enough resources to go around. It was the mother who bore ultimate responsibility for her children's welfare—if not in theory, in practice—and she who was expected to make any sacrifice on their behalf. The brutal irony was that in order to provide for her children, a woman often had to leave them. And the work most women found to allow them to keep their own children clothed and fed involved clothing and feeding another woman's child.

Some women were employed specifically as nannies. This became increasingly true throughout the 1960s and into the 1970s, as greater numbers of white women sought work outside the home. In this way, apartheid policy was out of touch even with white people's reality. Influx-control policies became tighter as white South African families' needs for nanny care intensified. Even women who were not hired explicitly as nannies often found themselves engaged in childcare, whether because of household circumstances, their own maternal longings, or a combination of both factors. Molly, for instance, had been hired by her Greenside employers in 1971 to do the cooking, washing, and cleaning. There were two small children in the house, and whenever the madam felt overwhelmed by the demands of the younger, she sought out Molly and had her stop whatever she was doing to take the baby: "She would call you any time, when that child started crying. 'Oh, come and help me. I can't stand it.'"[3]

Many women had similar experiences: "You can never get away. . . . The child will cry and she'll [the madam] shout, 'Flora, Cindy's crying!' She's just lying on her bed or talking on the phone or her friends are visiting. I'm working and she's doing nothing and I must always be there."[4]

As testament to the degree to which African women, whether employed as nannies or in their general capacity as domestic workers, assumed childcare responsibilities within white homes, in a 1968 study an incredible 50 percent of white mothers reported that their social activities and outings had not been restricted *at all* by the arrival of children.[5] While mothers usually set rules regarding tasks like bathing, feeding, and playtime, the

actual work was typically performed by the worker. (Fathers' involvement was more limited. As a rule, white men played little or no role in day-to-day child care, becoming more engaged in their children's lives only after they became older, and then usually through organized activities like school or sports.) Workers were usually the most constant presence in a young white child's life.

As suggested by Molly's example, some workers proved better caretakers than birth mothers, and white women sometimes admitted to learning from the nanny.

> She would talk to my child whenever she passed by, whether she was sitting or crawling. I never did that myself until I noticed her doing that.[6]

> She has given me advice as to handle my child when she's naughty—take her in her room, close the door, and talk quietly to her.[7]

Victoria had been with her employers for two years when, in 1970, an autistic child was born to the couple.[8] The mother, possibly because she had the availability of live-in help, gradually disowned the enormous responsibilities of caring for a disabled daughter, leaving baby Mary in the worker's hands. When she proved slow to develop motor skills, Victoria helped her to learn to sit up and to walk: "In the meantime Mrs. T. was never with Mary, never with Mary, wherever she went she would never like to take Mary with her."[9]

As Mary grew older, her mother found it increasingly difficult to handle the obvious differences between her and other children. While Victoria took the girl on walks to the neighborhood shops and to the nearby Zoo Lake playground, the madam declined to participate in such outings on the grounds that she did not want to be stared at in public. Victoria understood the mother's attitude but did not share it: "I mean the people will be embarrassed, but it's your child—give her a chance to have a play."[10] Neither did she make great efforts to change her madam, recognizing perhaps that the white woman's reluctance to assume parenting responsibilities gave her greater opportunity to be a mother to Mary: "She was just my daughter. I think she was born for me."[11]

For many women, the opportunity to form bonds with white children compensated a little for the absence of their own, and many developed af-

FIGURE 23. A worker with her young charge. (Photograph ©
Paul Weinberg/Africa Media Online)

fectionate ties with the youngsters in their employers' homes: "Especially
when you know that child from a day old, you can never help loving that
child."[12] Sometimes the ties were very intense, almost desperate. One con-
temporary white observer suggested that black women "sublimated" their
frustrated maternal instincts by throwing their hearts into their relation-
ships with white children.[13] Certainly their degree of attachment could

seem extreme even to some workers in hindsight: "I was overfond of Jane. I had too much time for Jane and no time for anybody else. I've always been with Jane, always, except in her sleeping time. I was her nanny, but in between her and me we were more like mother and child."[14]

Warm relationships with white children provided workers with some of their deepest feelings of justification for their years of labor and care. While African women might derive satisfaction from guests' praise of their baking, and long-term workers could grow so bold as to claim possession in the white house of "my kitchen," this provided nowhere near the level of contentment that arose from seeing a child one had helped to raise grow up happy and successful and being able to take some credit for that: "God never gave me any children and those children are mine. They come from the [nursing] sister's hand to my hand. From babies I used to bath them, give them medicine, give them food, everything."[15]

The feeling was often mutual. A white boy who contracted deadly tick-bite fever as a toddler caused his mother great distress by calling, in his delirium, for his nanny rather than for her.[16] "In a way, I think she was my mother," recalled one of my white interview participants of his own nanny.[17]

The problem came as white children started to grow. White parents and domestic workers alike accepted that white children would gradually transfer their loyalty and affection from their nannies to their parents. Successful acculturation into apartheid society depended on white children coming to be aware of themselves as white and on their acceptance of the racial hierarchies that underpinned law and custom. Many commentators have noted the role that the institution of domestic service played in their awareness. From the submissive manners of the worker, her uniform, the nature of her duties around the house, the layout of the family property, and more, lessons about differences between people with dark skin and people with light skin were illustrated and reinforced. Children eventually internalized the principle that people could be and should be classified and that skin color correlated with status and worth. They learned that the wider world, as did their home, operated in terms of racial domination—though most English speakers would have called it racial "leadership"—and that all aspects of life—social, economic, and political—could be understood according to racial classification. Of supreme importance, they

FIGURE 24. This is likely a staged photograph. Nonetheless, it conveys accurately the close relationships that often existed between workers and their charges. (Courtesy of Museum Africa, South Africa)

became able to locate their own places within the structures of apartheid society.[18]

The process of disentanglement from their nanny received guidance from many quarters. White children learned from the off-hand remarks of neighbors, explicit discussions with parents and older siblings, books read aloud, and pictures that hung on walls the respective roles of Africans and whites. One girl, whenever she asked her nanny to come and sit with her at the table, was reminded by her older sister that nanny did not eat with the family.[19] Another remembers being told, "No, don't drink out of that," of the tin cups that her nanny used.[20] The process was usually complete by the age of five, when white children regarded the women they had formerly relied on daily to meet almost all their needs as peripheral figures in the household.[21]

Not all white children acquiesced in this, of course. A white man de-scribed to me the pain he felt as a child in gazing, from his home, toward the back room where his nanny lived, grappling with his new understand-ing that he was no longer supposed to visit that part of the yard. Invis-ible walls began to appear on his property where none had existed before. Some children acted out their pain through tantrums.[22] However, most learned to adopt the values and attitudes of the white world, though the education process could be very painful for the children concerned. For workers, too, it could be a hazardous time, emotionally and financially. Along with events like the death of an employer and a housewife's join-ing the waged labor force, the transition in their charge from affectionate white toddler to racially prejudiced white child marked a shift in the qual-ity and nature of a worker's routine and set the stage for a new set of duties and relationships. Some women found themselves without a job when, in an effort to facilitate the break in the bond between nanny and child, the parents discharged a woman and replaced her with someone to whom the child, presumably, would not be as strongly attached. Those who stayed had to get used to a child's new way of responding to her. White mothers reported on this time:

> When younger, [my five-year-old son] would think of her as a family member. Now he'll tell her, "you're not the boss!"[23]

> When my child has to tidy up, she responds, "Anna will do it; she's just the maid."[24]

Said a five-year-old girl to a contemporary interviewer, laughing:

> When Catherine bathes my brother and me I can see her titties. I try to pull her clothes away. I splash her with water. She gets cross with me so I smack her on her titties. It does not matter. She's just the maid.[25]

The fact that women learned, whether through experience or the stories of other workers, to expect such behavior in their charges did not make it easy to live through it. One woman cried freely during my interview with her as she told me that by the time he was five years old, the white boy whom she had raised and with whom, in his infancy, she had shared her narrow bed during naps had stopped calling her by name and started to

address her as *kaffir*. African American domestics coined an expression
that captured their own experience of white children's predictable distanc-
ing and rudeness as they grew up and reflected their way of handling it: "I
never met a white child over twelve that I liked."[26]

One of the principal occasions during which women employed in the sub-
urbs interacted with older white children was when they came home from
school. If their mother did not work and was available, she might prepare
the early-afternoon meal that children expected then, leaving the maid
to clean dishes afterward and tidy the kitchen. However, if the madam
was employed or engaged outside the home, the worker made lunch for
the children and any friends they had brought home from school. She
watched them eat, cleaned up, and, as the only adult at home, continued
to be responsible for them until their mother returned. Interaction with
children could be pleasant, especially if a woman had once served as their
nanny and if the move away from her had been affected with a minimum
of fuss or trauma on either side. Some children, though, continued to work
through their confused relationship with their former nanny by testing its
bounds and pushing her away. Stories of white children's abuse of domes-
tic workers, verbal and physical, were, and are, legion. We can understand
children's behavior, in part, as an expression of anguish over lost intima-
cies, but even for those women who appreciated the sensitive emotional
and social dynamics that gave rise to cruelty on the part of their former
charges, this behavior hurt.

If the worker was a relatively recent addition to the household, the sit-
uation was a little different. Then an unkind manner served as evidence
not of a child's secret grief but, more likely, of his or her racial attitudes.
Children tended to be more blatant and crude than adults in their expres-
sions of prejudice, and they often behaved in ways that wore on a woman's
nerves and her pride.

> It lowers your dignity to be a domestic. You employer's child can swear
> at you and you have got to laugh. There is nothing you can do.[27]

> The children are rude. They don't count us as people. They think we
> belong to their parents.[28]

Children, of course, could be trials even to their own parents, but at least in such cases there was no question of who was ultimately in charge and no tinge of racial superiority in an angry exchange. Between worker and children power relations were much more ambiguous, and for women who came from traditions in which adults expected to be treated with deference by children, their charges' behavior could be galling: "Especially the kids! . . . You know, this time you close the school [school vacation]. You worried. You worried. All July they stay in the house. If you talk, they say, 'It's not your house. It's my house.'"[29]

Most white adults insisted that their children carry themselves like young masters and mistresses and that they treat their worker with respect, so children were most likely to challenge and provoke a worker when parents were not about. In one household, the children used to ring the front doorbell over and over instead of going around to the back, where they were supposed to enter. They considered it a victory when they could get the worker to finally leave her work and let them in. According to one of the daughters of the house, "There was war between us, really. It wasn't pleasant. Until my father got home, tensions were high in the house."[30] Battles occurred mostly, though, in the kitchen. This was at the same time both the room in which the servant exercised greatest authority and the public room that, unless the house had a family room or playroom, the children were most likely to claim as their own. It was also where the worker was usually expected to feed the children, and they fought especially over food. Requests for extra portions or snacks turned into tests of control over the house's resources.

Her employers' children could be unpleasant company not only by force of their personalities, but also because of the associations they triggered in a worker's mind, especially where food was concerned. Her own family was usually never far from her thoughts or out of her worries. Abie struggled daily to prepare large meals for her employers and their seven children, while receiving frequent messages from her children left in her sister-in-law's care, complaining that they were hungry and unhappy.[31] Another worker observed ruefully that while her madam's children were fat, "my children are hungry."[32] The gnawing hunger pains that the poor know well can be difficult for some Americans to imagine. It's the kind of hunger that

leaves a person weak, lethargic, and feeling stupid. Many women working in the city had firsthand memories of such hunger themselves. During her own childhood, Bertha explained, "We were living on *mealie* meal. There were days when there was nothing to eat."[33]

For those staying on land they were able to cultivate, the living could be easier, and people who kept cattle or sheep were at least able to ensure a steady supply of milk for their children. Unfortunately, apartheid policies had reduced the amount of land available for African farmers and herders and limited sharecropping opportunities, so that such a lifestyle was becoming increasingly rare for Africans, who found themselves moved by the government to relocation camps and homelands in growing numbers. Many workers had been born before apartheid; their children now faced worse conditions than they had in their own youth. Women interviewed in Lebowa, a homeland north of Johannesburg, reported in 1980 that their basic diet was cornmeal, wild greens, and black tea.[34]

> Sometimes there is almost nothing. Only porridge. There are so many of us—five children—so I just mix the porridge with a lot of water. But the kids, they are always hungry.[35]

> The children are sometimes crying with hunger. I feel bad, but what can I do. If there is no money there is no food.[36]

Women thrived on messages that their children were doing well. Reports of illness, truancy, or unhappiness broke their hearts: "When you sleep at night is when you think about your children. . . . There were some nights I used to cry out my heart."[37] Margaret was convinced that her son's death at the age of eight was a direct consequence of their separation. While she worked in Craighall Park, in Johannesburg, her boy, Tebogo, stayed with her mother-in-law. She received a telegram one day that told the news of his death, probably a result of complications with his asthma: "He got sick, and I was never told. . . . She [the mother-in-law] was a terrible old lady, she never took him to a doctor: she was pumping *mutis* [traditional medicine] into him. If I had that boy with me, he would still be alive."[38]

It was clear how much their children missed them, especially in the beginning of their city sojourn, and that in itself produced much sadness.

Ellen's daughter shed tears every time her mother left home to go work in the city, crying, "I don't want to stay with my grandmother, I want to go with you."[39] In time, though, thoughts of children left behind could be painful for the opposite reason, because of the emotional distance that the physical distance created. Epsie was shocked to learn that her sister-in-law, in whose care she had placed her child, had had her baptized and given her a new name: "I cry then and I said, why didn't you ask me that you taking my baby to baptize her in the Church? Why didn't you baptize the baby with my name? You mean to say that you taking that baby? That I give you the baby for a present?"[40]

Especially if a woman left for the city when her children were very young, they were more likely to perceive her as something like a distant relative rather than as an actual mother figure. Not only could personal contact between mother and child be infrequent, but few working mothers were in a position to write letters home. Regular phone calls were also out of the question. Workers seldom had unfettered access to their employers' phones—"She tell me that her phone is not a public phone"—and their children rarely had phones at home, anyway.[41] Often, family members did not even have photographs of one another. It hurt when, as was so often the case, children expressed satisfaction to see their mother leave after a visit home, in recognition that it was only when she was working that their household would receive the remittances upon which it depended: "If I'm not working they get cross because they know they will get hungry."[42]

Women working in the city, then, occupied an unhappy in-between space, unhappy precisely because it was in-between. While the degree of deterioration of their relationship would depend on things like the ages of their children, the distance between the Northern Suburbs and home, and the encouragement that guardians provided for maintaining the relationship between mother and children, it was inevitable that emotional distance would grow with time. When a woman remarked, "The children I work for, I do not see. Soon I will be a stranger to them," she based her prediction on what she saw of other women's predicaments and what they shared with one another privately about their personal sorrows. She knew that she could expect no different and that any bonds between her and her white charges would never be of the sort to replace the lost connection with her own sons and daughters.[43]

These women were in the suburbs because they loved their children; they were in the suburbs loving other children; and there was considerable risk that at the end of the day, they would receive only broken, damaged love from any child.

A scene that took place in Miriam's employers' living room in 1969 encapsulates nicely the situation and its multiple tensions, though it was set in the Southern rather than the Northern Suburbs. Miriam answered a knock at the door to find two inspectors conducting a search of the neighborhood for unregistered Africans. Her papers were not in order, and she pleaded with the men not to report her. "I am working for my children," she told them. "I have not even paid for the school fees [for this current academic year]. . . . I'm working for the kids to go to school," she insisted, tears running out of her eyes. The small white boy she took care of grasped enough of the situation to understand the men when they told his beloved nanny that she wasn't allowed to stay in the city, and he began to cry as well, desperate not to see her go. Miriam was quick to assess the situation. She prompted him to cry even harder, telling him, "They say I must go away." She knew that the tears of a white child would have persuasive powers far beyond her own. In the end, the inspectors did not report her to the authorities.[44]

White children grew extremely close to their African caretakers, for a while; their nannies returned the love, up to a point; the women's own children longed for them, until they didn't; and the women working in the city never stopped worrying about the children who had, in many cases, sent them to the city in the first place. "It's only God knows whether they are going to appreciate it."[45]

To say there was lack of reciprocity in these arrangements would be a mild assessment. As Christina explained it, she was expected to love her madam's children even though her madam did not even like her, Christina, and positively hated her family, including her children, as evidenced (as she saw it) by her allowing them only a few hours to visit her at a time. "But I must be here all the time with her children," she said, "and do everything for her children."[46] Remarked another, "You cannot share the love you give to her kids to your own."[47] What many women observed of white mothers' relationships to their white children introduced another layer of feeling into the already complicated relationship, often provoking contempt:

"They don't like to take care of their children. They are lazy to take care of their children."[48] Molly, who quit her job when her employer became pregnant with her third child, remarked with disgust, "She couldn't even look after her children."[49]

A few employers sometimes allowed their domestic workers' children to visit openly. This was one of the acts most likely to evoke gratitude and affection from a woman toward her employer, for physical contact with the people they loved most was a precious thing. In addition, the favor—and it was very much taken as a favor, not a right—implied recognition of the worker as more than a set of arms and legs. Workers often described themselves as cleaning machines or robots. This was partly because of the nonstop nature of their work, but also due to employers' perceived imperviousness to the women's roles within their families and their obligations to kin. When whites acknowledged that a woman might need her family and that her family might need her, she felt better about her standing with them, a little less like she was being taken as merely a thing.

Of course, domestic workers wanted their family members to be treated well when they visited. When Epsie said of her former madam, "My children can use any cup in her kitchen," she spoke volumes, given the usual white proscriptions against Africans using employers' utensils, plates, or glasses.[50] She also hinted at the tension between worker and children that could result from such visits, when the children, sometimes treated as exotic pets, received better treatment in the home than the worker herself. This was just one of the complications that bringing a child to town could produce. For while such visits could be wonderful and happy events for everyone concerned, they also occasioned their own set of stresses. Neither back room life nor apartheid conditions were supportive of trouble-free visits. Older children, learning that they were coming to Johannesburg, had fantasies of going to the zoo or downtown to see the tall buildings. Women working in the yards had neither time nor money for such excursions, but sometimes they made sacrifices to avoid seeing their children disappointed. Children had to be fed, as well, and that meant either spending extra money for them or sneaking food in from the main kitchen, a tricky operation.

It was when a child was ill that employers were most likely to allow an

extended visit, especially if the child was coming to Johannesburg anyway for doctor visits or for the purchase of medicine, which was difficult in many rural areas of South Africa. However, a working mother rarely had enough flexibility in her schedule to allow her to tend to a sick daughter or son: "You want to give your love to a sick child, but the person is giving you restrictions."[51] Children usually spent the days alone in their mother's room while she worked in the house. Such contact was, in some cases, better than none, but in others, it was so insufficient as to make the pain of separation all the more sharp and poignant. As was so often the case, though, employers could surprise by their ability to act humanely. Molly impetuously asked her mother to bring her son from the farm, where there was no hospital, to her in the suburb of Mountain View after he showed signs of serious illness. She took a risk and, the morning after he secretly arrived, told her madam what she had done. She realized she might lose her job but figured that things would be even worse if she tried to hide the child in her back room and her employer discovered the infant on her own. She held her breath, holding the breakfast tray, waiting for her madam's re-action. "Go wash him now, and I'll have my breakfast, and then we'll take him straight away to the doctor," the woman said, matter-of-factly. Later, her husband picked up the required medicines from the pharmacist and paid for them.[52]

Sophia had a very different experience. When her sick son arrived from the Free State farm where he'd been staying with his granny, her employer refused to let her take care of the boy in her back room. Sophia had to turn him over to her sister, who was staying in Soweto. The thirteen-year-old boy was hurt and angry: "It took me time before I could understand. I used to cry, because at night, there were more things that I need from my mother now. . . . My mother is supposed to be next to me. When you're sick, you need your parents." On those occasions when he went to visit her, he had to stay in the back room and was not allowed even in the yard.[53]

Sometimes affectionate relationships developed between visiting African children and white children. Melanie had permission from her employer to let her son, living in nearby Alexandra, visit her at her job. The white girls whom Melanie took care of used to ask her, "Where is Joseph? Please you must go to try to fetch Joseph because we want Joseph here."[54]

June, now a woman, remembers her anxiety as a child living in the

Northern Suburbs that her parents would send their domestic worker's little daughter away. The young girl had lived with her mother, sharing her back room bed, since her birth. During the day, she played in the main house while her mother worked, jostling with the dogs and, when they were around, the older white children. June's parents, English immigrants with progressive attitudes, never did ask their worker to send her daughter home, but since attending a suburban whites-only school was out of the question, when she reached school-going age, her mother sent her to live with her granny in a township outside Rustenburg, about sixty miles away.[55]

Elizabeth's daughter, Thembeni, became a great favorite of her employers' three sons: "Sometimes she's sleeping and they used to come and wake her up! Jeremy! Andrew! Sean! 'We just want to play with her.' When they come from school I used to have a break because they used to take her outside and imagine how dirty she used to be, playing with three boys!" Thembeni was allowed to stay with her mother in her back room until she was seven years old, when she, too, started school. During her visits to the suburbs during school holidays, she took her meals with the employers' family. Elizabeth, of course, did not.[56]

These playful bonds usually existed between older white children and younger African ones, such that the whites were always in command, thus reinforcing racial dynamics with which white parents could be comfortable. For actual friendships to grow out of these relationships was rare. White children seldom knew any African languages, and few African children from farms or homelands had strong command of English, especially before they started attending school. Accordingly, communication was difficult. There was also the issue of the age gap, which discouraged continued closeness, and the handicap of being, for practical purposes, unable to leave the property together. Sometimes the African children had no permit to be in the city, and their mothers, who did not want to risk their being caught by the police, forbade them to step beyond the gate. Even those with their papers in order were confined in their activities through apartheid laws. Blacks and whites could not eat in restaurants together, could not watch movies together or even ride buses together. "European Only" signage was common around town, and one could not be sure of finding the appropriate toilet for an African child to use on an outing, let alone

a place that would serve her a milkshake or a snack. Michael, visiting his mother at work, once went on a run to the hairdresser with his mother's madam and her son, with whom he sometimes played. It was an excuse to get out of the house and spend some time together, but once they got to the hairdresser, they all recognized the awkwardness of the situation. Michael sat on the steps outside the whites-only salon while his mother's employers got their hair cut.[57]

Differences between the opportunities and privileges afforded the races became apparent at every turn, often when least expected, and made it difficult for children to get close to and accept one another. Walter visited occasionally at the large Ferndale home at which his mother worked. The four white children, around his own age, always welcomed him, and they played together. One day the employer had a new swimming pool installed, and all the children stood with their toes at the edge, excited about jumping in it for the first time. They leaped together, but the fun was shattered by Walter's screams and splashing. It turned out he could not swim. He had been so anxious to join in the fun, he hadn't stopped to think about what it meant to jump into water, and the white children had assumed that everyone knew how to swim.[58]

At the house where Anna worked, the African and white children made little effort to become friends. When Anna's children visited her, they played in the driveway, moving aside whenever a car came in or out. The white children and their friends played, simultaneously, on the large lawn, their shouts sometimes breaking the quiet play of Anna's children, who were limited to skipping and jumping games on the hard surface. The whites ran up and down the yard, playing hide-and-seek and tag. One couldn't invent a more stinging metaphor for the spatial restrictions of Africans under apartheid than that produced by the image of the two groups of children simultaneously occupying the property, separately and in unequal ways. The only time they played together was when the whites' friends were not available, Anna constantly in the background beseeching her children to behave and not cause any trouble.[59]

Everyone—Anna's employers, their children, Anna, and her children—was curious about television when the government finally permitted broadcasts in South Africa in 1976. Though they had formerly been allowed into the house no further than the kitchen, it seemed neither feasible nor kind

to exclude Anna's children from the living room where the new television set was kept. The household had to establish a new etiquette, no rules of which were ever spoken out loud. Anna's children could enter the room, when invited by the whites, to watch a program. White adults had priority for living room seats, then white children. Even if there were a chair or sofa seat available, though, neither Anna nor her children would sit in it. They sat on the floor.[60]

Desmond also grew up in the backyards, as the expression went, and considered his mother's white employers, who treated him kindly, as family. His mother's wages put him through college, from which he graduated as a medical technologist, to the pride of his mother and her employers as well. Upon marriage, he wanted to introduce his bride, a nurse, to his mother's long-term employers. He expected to be welcomed and feted: "And he went to show his wife to these white relatives in some of the houses, and they gave Desmond and his wife mugs of tea in the kitchen."[61] Desmond was deeply insulted, his mother accepting: "You've got to try to forget these things, because otherwise you'll never like anybody."[62]

But a woman could forget only so much; occasionally, the indignity became too great. At such times, she might consider leaving her job. There were, of course, many reasons a woman might quit, most of them related to considerations of family back home. For instance, if a worker's job compromised obligations to kin at a pivotal time—for instance, by absenting her during a family crisis—the temptation to leave would be very strong. Eunice, for instance, quit when her madam refused her permission to take off a few days to see her dying mother-in-law.[63] Domestics rarely considered themselves permanent city dwellers, though they might spend twenty, thirty, or forty years in Johannesburg. Their ties to their rural or township homes carried considerable weight. That meant not only that they had responsibilities to attend ritual events and to nurse family who needed their assistance, but also that they continued to send remittances home.

As the economy slowed in the mid-1970s, largely due to declining gold revenues, money became increasingly a point of contention between workers and their employers. One way that many suburban householders coped with the shaky economic climate was to save money by not giving their employees raises commensurate with rising prices. If it had been a

matter of supporting themselves only, this would not have been much of a problem for women working in the city. After all, they had their housing provided, and most received free meals, in a fashion, as well. Their income mattered because the money they earned in Johannesburg supported children and other kin who were scraping by in Lebowa camps, on Free State farms, and in small Transvaal townships.

Cheapness often betrayed racial assumptions. A Killarney worker tried to justify a request for a raise in 1978: "I said, 'Well, you see, I've got children and I've got to pay the rent [at home] and my children are going to high school.' So they said, 'It's not our trouble if you got children going to the high schools. I don't know why must your children go to the high schools—they know they haven't got a father, they must stop going to school and start working.'"[64]

Another worker, also in 1978, complained that her employers forced her to buy her own food out of her meager wages: "This is what white people are starting to do because they say everything is expensive which confuses me so much because I think in a shop the shop owner doesn't say 'you black, you must pay less, you white must pay more.' It's just the same price. Things are expensive for everybody."[65]

> Some of them will find any excuse to take away some of that money they should be giving to you. End of month, you hear all sorts of excuses from the white women: "This and that is missing. I see you chipped this plate. What did you do with master's blue tie?" Then, you must know; she wants to help herself to your wages.[66]

Workers had little recourse in such situations. There was no question of contracts between employers and employees; workers simply took whatever they were offered. Work conditions and wages were not covered by South Africa's labor legislation. In fact, domestic workers and farmworkers were specifically excluded from its provisions. Knowing that they could not rely upon the authorities to right perceived wrongs within the workplace, workers took matters into their own hands. Complaints were a first step but generally went nowhere: "When you complain they say you are part of the family. It doesn't help to be part of the family when you are in a big oppress and can't even say, 'no, madam.'"[67]

Fortunately, if words proved little help, domestics had other options.

Quitting and finding a new job was the most efficient way to improve one's situation. It also had the benefit of sending a strong message to one's employer; there was nothing subtle about packing one's bags and walking off the property. The continued growth of the white middle class meant that domestic work was fairly easy to come by. Some women openly shopped around for the most comfortable situation, relying on friends and family employed in the city to put them up while they sought a new position. They did not seek perfect jobs—no one believed in such things—but places where at least there were a minimal number of problems to manage.

Yet, while many women marched out of uncomfortable jobs, others chose to stay put. Some employers read in the decision of a worker to remain in a household for years, even decades, high levels of approval and love. It provided status to have long-serving domestic workers. It suggested that a person was a particularly good madam or master, of a certain class and character. Old servants, like old money, supposedly spoke to pedigree and breeding. When whites told their friends, "Martha has been with the family forever" or "Josephine worked for my parents, as well," they spoke with pride, knowing how such long terms of service would be understood.

Many a servant did stay with her employers out of loyalty and love, but love between employers and employees was a messy business; many considerations colored the bonds. Mutual dependencies and jealousies between the parties bred an uneasy and often fragile symbiosis that usually worked to the disadvantage of the worker. Rachel remained through the 1960s and '70s in the employ of a woman whose behavior repeatedly brought her to tears, in part for the sake of the white children: "Always when I'm working for her I say, by the end of this month I'm looking [for another job]. Until ten years, until this year, I keep on saying, I'm leaving, I'm leaving, I'm leaving, and I never left. I pretend I'm not working for my madam now, I'm working for these children because I love them."[68]

In addition, her madam used to drive her at every month's end to the grocery store that the white family owned and then take Rachel to the township outside Meyerton, about twenty-five miles away, with a box of food for her mother. "That person can be bad but you must also think what they done for you."[69]

Apartheid restrictions compelled many to stay in jobs they did not like. While some domestics were willing to take chances and work without the proper permits, others dared not risk it. If they did not qualify under Section 10, Africans needed employment permits to stay in Johannesburg. These permits gave Africans permission to work for a particular employer while they were in the city, but each time their employment changed, they were required to make their way to the Polly Street office downtown and go through the red tape of changing their permit. Many women did not bother and, throughout their domestic careers, worked illegally. Employers often took these requirements loosely as well, disliking the mass of bureaucracy that employing any African required and knowing anyway that a bottle of whiskey could convince many inspectors to look the other way.

Other employers, however, whether because they were conscientious, nervous, or supportive of apartheid regulations, preferred to have things in proper legal order. Christine lost job after job when she and her consecutive employers were unable to fix her pass, and prospective madams proved unwilling to take the risk of a fine for hiring an unregistered worker.[70] "I used to work for two months, three months, and they can't register me. I have to go, they must get another one [worker] that can get fixed up with a pass. . . . So I look for another job and I work for three days, sometimes for two months, three months, like that. It was very terrible; I couldn't get it fixed."[71]

A worker who had had such experiences or whose friends had such stories to tell might decide that once her papers were in order, she would stay put rather than brave again the arbitrary mass of rules and paperwork that constituted South African bureaucracies. One woman, for instance, torn between a madam who refused to let her bring her infant granddaughter onto the property and the fear of being without the proper papers should she leave her employment, since it had taken so long to finally fix her permit book, chose with aching heart to stay with the job, knowing her family relied on her income.[72] Other employers quite openly blackmailed their workers into staying with them: "They say, 'if you don't do so-and-so, you'll go back and starve in the Transkei.'"[73]

In such situations, apartheid appeared in its clearest and sharpest expression. When I asked the women I interviewed to explain apartheid to me, a foreigner, their answers revealed that the denial of free movement

had been at the heart of Africans' experience and understanding of apartheid.

> White man didn't come our bus. We couldn't go on his bus. . . . You couldn't go in a white person taxi that time. . . . Our buses where only black people can go on our buses. We couldn't go on the white people's bus, and the white people didn't come to our buses. Everything there was apartheid that time. I couldn't go to where my cousin's working. . . . When her madam doesn't want me, I can't go in there.[74]

> Apartheid was terrible. It was about oppressing us down. I had to work where I was. Couldn't go to Pretoria. If my boss moved, I couldn't go with him. Just stay where you are. Work where you are.[75]

> When you go to town, you got a train. . . . They tell us, this is for whites, this is for blacks. And when you are in the shops, they tell you, don't enter here, enter here.[76]

> Johannesburg was awful. They got apartheid, on the toilets, in the churches, in the shops. It was terrible in those days. . . . It wasn't that easy to move about in Johannesburg because there was time they say you must walk, there is time they say you must stay in the house.[77]

No less so than when she braved the journey to Johannesburg in the first place, when a woman walked out on a job, she declared herself free of the rules that sought to control African movements to and within the city. Indeed, quitting a job took even more courage, for in doing so, she lost the protection of whites who might, if necessary, fight for her to stay in Johannesburg and under the cover of whose employment she might find excuse for such violations as breaking curfew. She effectively slipped off the grid upon which all African movement supposedly took place and dropped quietly beneath it.

There was little in this that spoke of political conviction or strategy. The worker who lay awake at night in her narrow bed wondering if she should quit her job did so not in response to any call for mass action, nor because she thought leaving her employer might further some cause. Though her efforts to improve her working conditions and wages might place her in direct conflict with apartheid law and policy, her primary intent was

not to challenge the system; it was to get ahead. Few workers attempted to ride white buses, sit on white park benches, use white toilets, or take other symbolic stands. South African history in general is largely, though not entirely, free of those sorts of actions that so galvanized, for instance, American blacks during the civil rights era. Most domestics broke laws of perceived necessity, not as matters of principle. Indeed, they, like other Africans, found that it was near impossible to conduct their affairs without running afoul of apartheid legislation, and so there was little shame associated with being arrested.

Most African adults found themselves moving back and forth between occupying legal space—that is, locating themselves when and where the state allowed—and making decisions about their location according to a different calculus. The urgings of filial love, maternal longing, economic interest, self-determination, desperation, pride, and anger figured into a worker's choices, including her choice of whether to be a worker at all. Housewives' sometimes desperate efforts to monitor the actions and locations of their workers were of a piece with the official white obsession with controlling African movement. There is little evidence that the government recognized the extent to which female migrants in particular undermined apartheid's vision of perfect racial geographies. African women risked arrest, fines, and jail to move themselves and those they loved when and where they felt they had to. As the next chapter explains, most workers broke laws and their employers' rules about such matters on a regular basis.

FOUR

Come in the Dark

DARK, CLOUDY NIGHTS WERE BEST. Or those evenings when the moon was so new it appeared as a tiny sliver against the black sky. Wind, too, was good, because howling and the sound of branches scraping on window panes could drown out other noises, like the squeak of a rusty gate turning on worn hinges or the tread of a man's heavy footsteps on the driveway paving.

He would walk slowly past the side of the house. If master had parked the car in the driveway, its bulky shape might provide a useful cover. Now he could be seen neither from the bedroom window nor, on the other side, by the elderly neighbor whose allergies kept her awake at all hours. Stop. Wait several seconds. Make sure the coast is clear. Rise slowly on haunches and continue past the car into the backyard. Careful not to trip over toys or bikes. The white children often throw their things about. Watch out for dog shit, invisible against the dark grass.

Past the jacaranda. There is just enough light from the stars to faintly illuminate its purple blossoms, shining white now. The scent from the moonflower means his destination is near. Around this clump of shrubs is the back room entrance.

Was that movement in the house? Crouch beside the bushes, quickly. More waiting. But, no, it is nothing. Perhaps madam snores louder than

usual tonight. She is a noisy sleeper, but a heavy one. To be safe, though, he does not rise to his feet, but crawls on the moist ground the remaining few feet to the back room door.

"Meow." Just once, very softly.

He does not wait long. She opens to admit him, and the aroma of the dinner she has placed on a tin plate in the corner greets him, along with her relieved smile.

Hours later, as they lie together on her narrow bed, they hear a faint whistle carried by the wind from a cluster of trees on the other side of the brick wall that backs her employers' property. They smile knowingly at one another in the stillness. Another couple is about to be reunited.

Such scenes replayed throughout the Northern Suburbs during the apartheid years. As the government undertook drastic, often violent action to protect cities from the incursion of "superfluous" Africans, men, women, and children continued to quietly make their way to South Africa's cities. The cracks and fissures through which they eased themselves into urban life consisted not only of the legal loopholes and lapses in policing that gave many opportunity and grounds to stay. Rural migrants also achieved their toeholds in urban society by literally squeezing between bushes, ducking under benches, and flattening themselves against the sides of houses. Their goals were domestic workers' quarters, the single most important stations on the underground railroad—a fitting image—that carried tens of thousands of African migrants into the city.

The stream of migrants who insinuated themselves, singly and in small groups, into Johannesburg's crevices and established themselves within its growing economy did so thanks to the actions of thousands of others who abetted them, knowingly and unknowingly. A symphony? A dance? A river? The ideal image acknowledges that many anonymous individuals, in pursuit of goals both private and shared, created the multiple openings—physical, perceptual, emotional—of which migrants availed themselves. The principal actors were domestic workers, who participated, mostly in full consciousness of the risks they took and the price they would pay if caught, but they operated within a wider context of regular, routine, predictable, and messy urban activity that they exploited for all it was worth.

They listened and watched and identified the fissures and gaps and located the opportunities and in the process conducted thousands of undocumented Africans into the city.

Workers had good reasons to secret people onto their employers' properties. Domestic service was hard work, not so much because it required muscle as because it was tedious and thankless. A single servant might be responsible for preparing meals, serving them, baking, cleaning house, child care, washing and ironing, tending pets, and sometimes caring for elderly parents as well. Days were long, often more than twelve hours, and many employers expected in addition that their workers would be "on call" during evening hours. The conditions under which many African women performed this labor increased the weight of its load. In some households, white employers slapped their servants. Yelling and harsh words, including racial slurs, were common. Domestic workers were pained also by the indignities of their position. Being forbidden to eat off their employers' plates humiliated them, as did being fed separate food that butchers sold as "servants' meat," while some employers bought the even cheaper "dogs' meat" for their workers. Many servants had even their consumption of tea rationed.

Domestic service was not an unmitigated evil. There did exist some decent labor conditions, and in some households there were affectionate ties between employers and employees. On the whole, though, the job was an unpleasant one, and one of the things that made it so was the loneliness and boredom that workers encountered on a daily basis. The women who slept at the end of the gardens and on the rooftops spent most of their waking hours inside cleaning, cooking, dusting, and polishing. If she was the sole employee of a household without small children, a woman passed much of her days in relative isolation. The habit of some employers of locking their workers in the house to ensure they did not leave, in addition to being a dangerous practice, accentuated the women's feelings of being removed from others.

If, on the other hand, madam was a full-time housewife, a worker had to adjust to a pair of eyes following her around the house, checking on her work, and offering running commentaries on everything from the neighbors' affairs to her own deficiencies as a worker. Such "companionship" tended to heighten rather than diminish one's sense of loneliness.

Nighttime could be even worse. For many, life among strangers on the rooftops was alienating and frightening after the accustomed order of their rural communities. Fights and drinking were common in these places. The environment in the back corner of the yard, though it offered less threat to personal safety, could be equally grim in its isolation. One worker described the emptiness of sitting on her bed with nothing to do but count the boards of the ceiling over and over.[1] Another cried in her room at night, unused to the solitude and afraid to sleep alone.[2]

Books offered little companionship to the illiterate majority. Women from the northern Transvaal used to keep busy with their needlework. One young teenager, come to Johannesburg to help support her widowed mother, played her battery-operated hi-fi all night long to keep herself company.[3] At such times many workers' thoughts turned to those left behind. "I used to cry for my children," said one.[4] Some considered returning home. But "you think, 'If I go back, what can eat, my kids? My kids, what can dress my kids?'"[5]

Given the workers' social isolation, all interpersonal relationships assumed great value. The conversations they struck up with the next-door worker over the backyard fence, friendships with the part-time gardener, and the collegiality of fellowship with other workers who congregated in neighborhood parks on Thursday afternoons off helped considerably. "You'd meet plenty of people taking the white children to the park. 'Where do you work?' You tell her your address. Just like that. Now she's your friend."[6]

African prayer groups proliferated largely in response to such need. Workers also used their off days to visit relatives and others from their region who had also journeyed to town. None of these efforts, though, went far enough. Women desired and sought more intimate relationships. This usually meant opening their rooms to others and sharing their lives, especially with someone they loved. This could not always be managed, but each and every one of the dozens of domestic workers I interviewed had, at some point, housed overnight guests in her back room or rooftop room. Several of them seem to have run virtual boardinghouses: "You'll find that in the rooms, we sleep like the sardines."[7]

Not all of a woman's guests would have been illegal, though most of them were. To workers, though, their visitors' legal status was not the issue. It

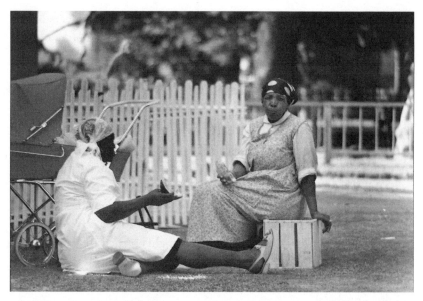

FIGURE 25. Domestic workers were a common sight in city parks, which offered a safe and relatively comfortable meeting spot. (Photograph by Robert Kopecky)

was their relationship to them that was relevant, and they accordingly identified four types of visitors. The first were "homegirls" or "homeboys," people they were connected to through their rural communities. These were folks, sometimes family, who spoke their mother tongue, knew the hills and valleys of home, and might even be age mates or old school friends. Sometimes such arrangements were made in advance. A worker hanging wet clothes in the yard might see someone beckoning quietly to her over the back fence. Checking to ensure that madam was nowhere in sight, she would place her laundry basket on the ground and approach. The stranger—or perhaps it was a recognized face from her village— would exchange greetings and news and then deliver instructions to meet a certain cousin or family friend or neighbor of her grandmother's sister at a particular time at Park Station. Sometimes the woman waving over the back fence would be the guest herself, and the worker would quietly admit her into the yard. Such guests might plan to stay in the city for a short time only, perhaps seeking medical treatment or visiting friends. Others

intended to migrate, with the stopover in the domestic worker's room constituting one step in that long and uncertain process.

The second group of visitors was children. A contemporary survey found that when a woman worked further than a few hours' travel from her home, she was likely to be able to visit only once a year, during her annual leave: "When you get home, your child does not even know you. She says to the granny, 'Granny, when is this woman going to go?'"[8]

Said another, "I've lost touch with my kids. I don't know them. . . . When I go home, I don't know them. And I've got to spend a little space of time to communicate with them. And I can't really know them at all. And what about at my retiring age? Will I expect same love from them?"[9]

These women, who once negotiated a break with rural society, found themselves caught between traditional expectations of support during old age and modern notions of independence, which they had, after all, once claimed for themselves.

During school breaks and whenever other opportunities presented themselves, workers sent for their children. It was forbidden under apartheid legislation even for minors to spend the night in Johannesburg without proper documentation. In fact, in parts of the metropolitan area, migrant workers were obliged to sign a contract undertaking never to have their children join them on the property as a condition of employment. Yet such visits were fairly common, especially during school holidays, and though they were usually painfully brief, they offered one of the few opportunities that domestic workers had to become acquainted with their own sons and daughters.

The third class of guests was female strangers, those already established in the city often lending assistance even to complete strangers whom they encountered in local parks or wandering the sidewalks in the early evening. Many of them, after all, had benefited from earlier being some other worker's illicit guest. The necessity of lending others a hand seemed to many beyond question: "But they have to hide. You must hide them."[10] Or, as another simply said, "You are suffering like me. Must give help. Until you find work."[11] At a minimum, workers could offer a stranger a place to wash and rest.

I wondered how common romantic relationships were between workers or between workers and female friends, but every time I raised this

question, my participants denied that such things existed. "African women don't do that," they told me repeatedly. I did not force the issue.

Male lovers, though, the last group, were very common. Indeed, there was no shortage of African men looking desperately for lodging. African men had a long history of employment in Johannesburg. Some had city roots that stretched back for generations and, accordingly, well-established rights to live in government-provided township units. Others were more recent arrivals, considered illegals, and ineligible for such housing. Other men fell somewhere between these two extremes of having secure urban rights and having none at all. Whatever their situation, men had many motivations to seek a place in a domestic worker's room.

The undocumented migrants who arrived in the city without proper papers and without a job in hand were in the least favorable housing position, as they qualified for none of the official African housing in townships or workers' hostels. In a similar position were those employed by small white-owned businesses that had not bothered to regularize their workers' status. Lacking access to public accommodation such as boardinghouses and unable to rent or buy property, African newcomers had to rely on their ingenuity in finding a place to live in the city.

Men housed in workers' hostels or industry compounds had at least bunks to call their own, but hostels were notoriously brutal environments. One Johannesburg-area mining hostel, the subject of a contemporary study, housed about 3,700 men who slept sixteen to twenty in each room. They worked, bathed, ate, and drank together. One resident, using a metaphor that would have resonated with others from agricultural communities, suggested that the problem of violence in these places was not the number of men per se, but the lack of social order among them: "When you span oxen to a wagon, you must choose the correct number sufficient for pulling the load, and select particular beasts to work best in front, rear, or on the side. If you disregard the size of the load, and the ability of individual animals, then oxen will horn each other, strain, and break from their leashes."[12]

Disease was another hazard of hostel living. Beri-beri, pellagra, and scurvy flourished, due to the poor diet, as did high blood pressure. It was difficult to keep one's personal belongings secure in these places, and theft was a perennial problem. Many men turned to witch doctors, or *sango-*

mas, for assistance. Others tried to help themselves. One resident of a city hostel painted a window at one end of his concrete bunk in a twenty-man room.[13] Others made literal escapes from these environments by moving in with domestic workers.

Some men who had township houses slept instead in the back rooms with their girlfriends. Men defended these arrangements as part of African polygamous tradition, dismissing wives' objections to their kitchen lovers as evidence of their capitulation to "white" values. Township women, understanding that divorce would mean eviction from the urban area—for them and their children, not their husbands—usually tolerated the other women and their husbands' frequent absences from home, even while they might complain bitterly to one another about old-fashioned husbands who refused to recognize modern, more equitable forms of union.

One attraction for all men of relationships with domestic workers was the backyard. Far from the dirt roads of the townships or the noxious noises of industry, back rooms sat in green gardens in quiet neighborhoods. Birds nested in fruit trees, and cats curled up in flowerbeds that were often meticulously maintained by gardening staff. One could reach up to pluck an apricot from a low-hanging bough or reach down to pick a strawberry from the ground. Compared to other housing alternatives, and even in its own right, the back room offered a pleasant spot to return to in the evenings. The physical setting of the back room was matched favorably by its amenities. Beds, though possibly the rejects of the employers, were an improvement over the concrete slabs of the hostels. Some backyard bathrooms had hot and cold running water, unlike either township houses or the compounds. And the toilet was shared by only two or three instead of ten or two hundred. A few rooms even had electricity.

The domestic workers themselves were practiced in the arts of making a clean and comfortable home. Many were accomplished cooks and bakers. They were valued as well for the access they had to the things of the white house, to valuable commodities like butter, white sugar, tasty jams, and biscuits, things too expensive for most Africans to purchase on a regular basis but that workers might, with a little skill, be able to convey secretly back to the room at night. According to an African male interviewed in the 1970s, "Most of the men like to go and sleep in these comfortable rooms in town, in the private houses where his girlfriend is working. You know,

some whites provide good rooms for their servants. . . . The man knows he is going to be well looked after. . . . When it comes to cooking the domestic girls are better than the educated nurse or teacher or social worker. Even in etiquette they are better."[14] Overall, these rooms were about as comfortable a home as a working-class African man could hope to secure in the city. Besides, what were the alternatives? One man who lived on the streets during the summer months told a contemporary researcher that every year when the cold set in, he found himself a domestic worker who could provide him free shelter and board for the season.[15] Not all male guests, of course, were as mercenary in their approach. While pragmatism, loneliness, and a desire for comfort could underlie women's and men's decisions to pursue relationships, love was often another factor, or at least a result. However, the forms that love assumed in the back rooms were not traditional ones. In these settings that they controlled, women insisted upon new modes of relating.

Deciding to harbor an undocumented houseguest, whether for a weekend or on a semipermanent basis, was only the first step. Once she chose to break her employer's rules and civil trespass laws and, possibly, to abet the violation of the government's influx-control regulations, a domestic worker faced a host of practical challenges. How could her guest avoid detection by unsympathetic white employers, apartment managers, and nosy neighbors? How could her guest evade the police during the municipality's frequent raids for illegal Africans during this period?

Challenges were different for different kinds of guests. For instance, a person who had come to the city to seek work needed to be able to travel suburban streets and avenues during the daytime, knock on doors, and check in regularly with any possible job contacts. Since it was when entering and leaving a property that a person was most likely to be noticed by whites, she generally sneaked off very early in the morning, perhaps 5:00 or 5:30 a.m., and returned after dark. Family or close friends, on the other hand, who came to the city primarily to visit the worker, could avoid these hazards altogether by never leaving the property at all. In that case, the greatest risk came in being seen, for example, through a back room window or when going to the toilet. There was also the danger, in keeping a guest locked in one's room for days or weeks at a time, that the person would become bored and miserable.

FIGURE 26. Moving a guest from the public street onto the private property of a worker's employer posed considerable challenges. Fortunately, the heavy urban forest of much of the Northern Suburbs afforded hiding places for visitors and their possessions. (Photograph by the author)

The solutions to some of these problems lay in clever and judicious use of suburbia's built environment. A woman's ability to hide the presence and movements of her guests and to camouflage her own behaviors associated with caring for them—for instance, opening a gate to give them entry or declaring that "I'll take my plate and eat in my room tonight, Madam"—depended on the domestic worker's knowledge of and control over the spatial and temporal orders of white neighborhoods.

The first task faced by the domestic worker who sought to shelter a guest was bringing the unauthorized tenant onto the property without alerting the police or her employers. Each household had its own set of rules. Although some white householders might grant permission for certain types of visitors—for example, allowing close family of the domestic, daytime guests, or sleepovers on the weekend only—most workers found even these arrangements, where they existed, too restrictive. Even women who worked for relatively liberal families found themselves eventually secreting people back into their rooms. Accomplishing this was largely a

FIGURE 27. The back room sits at the end of a garden path, beyond the open wood gate and on the other side of the washing line. When family members were sitting out on the *stoep*, of course, this would not have been a useful route, but it worked well when they were occupied on the other side of the house. (Photograph by the author)

matter of timing. Her knowledge of the family's comings and goings, combined with an intimate acquaintance with the layout of the house, guided the worker's judgment of when in the day her employers were more or less likely to be alert to activity outside.

There were special challenges in those suburbs that had no back alleys or in those homes where back-alley doors were kept locked in fear of thieves, because that meant that guests had to pass by the main house on their way to the back room, as illustrated in figures 27 and 28. Mealtimes often presented opportunity: "When the employers are busy eating at supper time, then you'll run and open the gate for [your friend] to go in."[16] That could work if conditions like those in figure 27 existed, where one path to the back room led a person underneath the bedroom wing of the house, which would be unoccupied in the early evening. But perhaps the guest needed to travel along the driveway to reach the back room, as in figure 28. If the dining room overlooked the driveway, it made better

sense to wait until the family members had left the table for the evening. Strategies depended greatly upon house layout and family habits of use. One worker, for instance, knew that it was safe to move her friends if her madam was sitting in the living room. She would tell her guest in the back room to wait while she crossed the yard and stepped into the white house kitchen. From there, she could survey the living room, while at the same time attracting little attention to herself. A quick hand gesture at the back door signaled her guest, if madam was indeed settled into the living room, to make a quiet run for the gate.[17]

In other households, due to either the location of white house evening activities or their unpredictability, it was safest to wait until the whites had retired to their respective bedrooms. Lovers and other guests would let themselves in through the gate and come around to the locked back room: "In the middle of the night he will knock slowly on the window so that you can walk like a cat inside."[18]

FIGURE 28. On many properties, a person had to pass by the house to get to the back room, the door of which, on this property, sits behind the large wooden door that separates the front yard from the backyard. The vents above the back room door are visible in the distance. (Photograph by the author)

Dogs always posed a problem. Even if friendly, they were likely to bark and alert their owners. Workers developed a wide range of ruses to assure the safety of their guests. One woman's boyfriend used to approach her back room by walking onto the premises backward. If detected, he would claim to be leaving anyway.[19] Another, whose employer allowed female but not male visitors, had her gentleman lover wear a dress when he came visiting at night.[20]

Until the hour it was safe to enter the property, a guest had to wait outside, and this was where intimate acquaintance with the geography of the neighborhood proved invaluable. Sometimes it was possible to linger on the streets. A guest who had received instruction about which of the African bus stops the police usually targeted in their pass raids or which corners they frequented was well placed to wander without being caught. After the 9:00 p.m. curfew, though, even informed wandering carried substantial risks. Then visitors were better off knowing which parks offered sufficient foliage to shelter a person or where friends with less strict employers lived, so that they could visit them for a few hours before going "home."

Just as her guests, with her assistance, developed familiarity with its surrounding geographies, the worker became an expert on what happened within the house itself. Knowledge of the hours madam and master rose in the morning, when and for how long they were in the bath, the time they left for work, when the children came home from school, the schedule of regular shopping trips, and the hours for bedtime allowed a worker to make informed choices about the timing of her own activities. The white family's movements formed the basis of her guest's, in an inverse manner, and it was the domestic's strategic position as overseer of the one that allowed her to plan the other.

In an apartment building, white employers did not control entry; the white superintendent or African watchman did, patrolling even the servants' entrance. Sometimes they could be bribed, as could the police on occasion. But "the watchmen were not the same."[21] Some were more sympathetic, others more greedy. Servants had to learn who worked the various shifts and make their plans accordingly. Sometimes, none of the guards could be trusted, and then a worker would have to sneak the visitor into the building after dark. If the circumstances were such that the risk of detection ran very high—perhaps the guards were particularly hostile or

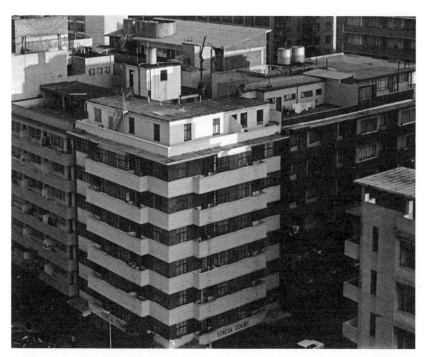

FIGURE 29. Above the floors that whites inhabited were the locations in the sky, clearly visible from the street and the destination of would-be visitors. (Photograph © Cedric Nunn/Africa Media Online)

nearby white neighbors overly nosy—she would confine her visitor to her room for the entire duration of his visit, not allowing him to leave until the final departure date.

This was a possible hazard of back room visits as well. Alice was so afraid of detection by her madam's son, who she believed disliked her, that when her elderly mother and ten-year-old daughter came to town for a two-week visit, she confined them to her back room for their entire stay: "My mother she stay there, but my missus and the *baas* they didn't know. Ah, they will chase me [away]. It's not nice to stay there all day long in the room together and my mother ask me, what I do when this little girl want to go to the toilet. I tell my mother she mustn't go. I've got a chamber pot but this little girl didn't want to sit in. It's very, very hard."[22]

Getting their guests inside was not the end of the challenge. Domestic workers also had to plan for the eventuality of a police raid or surprise visit

by their employers. According to one study, workers were more likely to lose their jobs over boyfriends than because of pass trouble.[23] It was essential to keep knowledge of a lover's presence from unsympathetic madams. The challenge was hiding not simply one's visitor, but also any personal effects that might suggest a male presence. The fact that employers often provided their workers with crude and cheap pieces of furniture worked to their advantage. At any given time, domestic workers were forced anyway to pile, stack, and squeeze their belongings into overly small spaces. Their rooms were often crowded with garments hanging from nails, bags jammed under stools, and pillows stuffed with personal effects. An extra person's things were often difficult to identify in such seeming clutter. One resident of a Killarney skylight room, for instance, kept her boyfriend's clothes in a box that she kept covered with cushions. Though it was large, it did not attract attention in her crowded room.[24]

Inspectors made frequent rounds of suburban neighborhoods, searching precisely for undocumented workers and unregistered urban visitors. Knocking on the front gate, either during the course of a random check or because of a specific suspicion, perhaps due to a neighbor's complaint, the officer in charge would demand to be taken to examine the back room quarters. Hearing the ruckus, perhaps warned by the barking of a dog or the master's footsteps on the path, a worker would spring into action. Some domestics laid out specific escape plans for their guests, the apartheid version of earthquake or fire preparedness. One worker, for instance, had an understanding with her lover that, in the event of a raid, he would jump out of the window of her skylight room onto the ledge beneath. She would hand him his shoes, and he would run quietly down the corridor to the stairs, where she would meet him once the coast cleared.[25]

Guests could crawl into wardrobes and hampers and under tables. Beds' legs were raised on bricks or empty paint tins. The dominant white view of the practice was that superstitious Africans did this in fear of the dreaded *tokoloshes,* mythical creatures that attacked unsuspecting humans in their sleep. Several informants chuckled at this idea. While they did not disavow the presence of *tokoloshes,* they pointed out that there were other advantages to this arrangement. Not only did it increase their storage space, but it also created room for hiding a guest's things and, if need be, the guest him- or herself.

FIGURE 30. Rooms were crowded, dimly lit, and packed with possessions. Here, a worker hangs extra clothes that will not fit into her wardrobe from the wardrobe's door. Boxes and bags also sit on top of the wardrobe. (Photograph by the author)

It was Emily's preferred hiding place: "Under the bed I will hide you, and put the boxes and blankets in front. Sometimes they [the police] don't pull [the blankets]. If they pull, I'm in trouble."[26]

The semidarkness of these rooms lit only by candles or paraffin lamps also provided an advantage. One woman remembers her aunt hurriedly

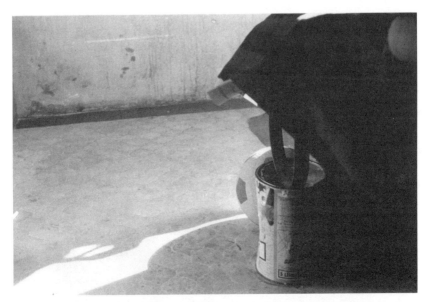

FIGURE 31. A bed leg raised on an empty paint tin. (Photograph by the author)

directing her to the cupboard one night when the police paid a surprise call during one of her own early visits to the city. It was so crowded with things that the officers could not see her, even after they had opened the door and looked inside. She managed to evade arrest, but only at the expense of her heart dropping to her feet. She never dared to visit her aunt again.[27]

Margaret's mother also took advantage of the crowded, seemingly confused conditions of back rooms to hide her children: "And one day, it was early in the morning, I think it was six, and my mother came running to the room and just pick me up and take all the washing out of the washing box and put me in there, put all the washing on top of me and I couldn't breathe. Inspector came. Inspector looked under the beds, everywhere. He pulled the box and I was inside the box and he just pushed it under the bed again and left. And so my mother came and called me and I came out and she said, 'The inspector is gone.' I was shivering all the time."[28]

There was clearly much that could go wrong with these arrangements. Being discovered was the greatest threat. One new arrival to the city wrote of being caught while staying with her sister in Orange Grove: "My sister had taken her usual Thursday afternoon off, and she had delayed some-

where. I came back from work, then waited in the park for the right time to go back into the yard. The white people always had their supper at six-thirty and that was the time I used to steal my way in without disturbing them or being seen."[29]

After sneaking onto the property, Gcina realized that her sister had not yet returned. Unable to let herself in the locked back room and afraid to risk walking past the house again to leave the yard, she decided to sit on the ground in front of her sister's room. She thought she could not be seen: "I was trying hard to concentrate on my reading again, when I heard the two dogs playing . . . and then, there they were in front of me, looking as surprised as I was. For a brief moment we stared at each other, then they started to bark at me. I was sure they would tear me to pieces if I moved just one finger, so I sat very still, trying not to look at them, while my heart pounded and my mouth went dry as paper."[30]

For those who kept friends, children, and lovers in skylight rooms, there was also the perennial fear that someone would fall off the roof. The skylight locations offered uneven, treacherous landscapes. Buildings had terraces, balconies, protruding stories, and fire escapes. Some windows looked onto rooftops, while others had sheer drops of six, seven, or ten stories onto the pavement beneath. For children restricted to the rooftops, who could not easily be kept from playing on the flat expanses, there was the danger of a careless move sending them over the edge.[31]

The chances of such accidents increased during police actions. Permit raids, and the attendant tumult and confusion they wrought, saw people running from back rooms in various directions in an effort to escape. Unfortunately, the impulse to jump out the window apparently existed, at least according to urban legend, even when the ledges did not: "When we first come to Johannesburg, we were suffering with the reference book. White people was chasing us, running, run away. . . . They scared of police. Then you open the window. Then the man jumps outside. Sometimes he jumps, there's no wall to hold him. He goes down, he dies."[32]

The practice of hiding people held many rewards for workers. At the most basic level, it provided them with human contact. These women worked alone under difficult conditions. They received meager rations and harsh words. At the end of the day, their bones and muscles were weary. And

"when we get upstairs, we've got nobody to talk to her."[33] Having a room-
mate—man, woman, or child—offered "somebody . . . to sleep by you at
night."[34]

Clearly, though, once a person made a commitment to hiding someone,
for a weekend or for months at a time, she found that the comforts of com-
panionship carried a whole host of problems. Would the dogs bark? Was
the new watchman bribable? When would the police next raid? Thoughts
like these seem to have occupied many a woman during her working hours:
"You'd be working in the daytime, being happy. But if you think, what's
going to happen in the night? My man is going to come and wait for me
outside. Sometimes it's cold, in the cold. Sometimes he doesn't come. You
don't know where he is."[35]

A range of possibilities could present themselves to the worried mind:
arrested and jailed by the police, threatened away by a passing white neigh-
bor, in the arms of another woman. Many workers seem to have lived with
omnipresent stress and tension over their arrangements.

We didn't sleep that time.[36]

It was terrible, I don't want to remember it. . . . Now I can talk about it,
but at that time, really, it was terrible.[37]

Nonetheless, it was partly just because there were so many pressures
associated with hiding others that the practice provided meaning on a sec-
ond level. It gave workers the satisfaction of taking control of their lives
and making bearable hard conditions. As one explained, with more than
a hint of pride in her voice, "If you suffer, you must have a lot of plans."[38]
There was pleasure in designing a room to accommodate secret visitors,
plotting escape routes, and devising schedules of entry and egress. To suc-
cessfully hide a guest, workers needed to establish and then implement a
series of steps, from collecting empty paint tins to finding ways of occupy-
ing the dog in the kitchen, that required short- and long-range planning.
Part of the delight of engaging in this activity may have been the intellec-
tual satisfaction it provided. Many workers were frustrated by their em-
ployers' heavy-handed supervision. They resented not being able to decide
for themselves how best to perform their various tasks and in what order.

The challenge of keeping secret visitors could compensate somewhat for the often mundane routine employment of domestic work.

In addition, these schemes allowed women to put one over on their employers. Whites had a habit of saying their domestic workers were part of the family. Workers usually experienced their relations differently. Breaking the explicit rules of the household, lying to madam's face about whether one had guests, and then stealing bread from the kitchen to feed an extra mouth could provide a pleasing sense of undermining unjust authority. These practices allowed domestic workers to resist individually and privately what they saw as unfair labor practices, at the same time that their menfolk were organizing into trade unions and engaging in collective action to assert themselves within their own employment spheres.

It was in their role as *women* that the practice of hiding people, especially male lovers, perhaps held most significance, and it is on the basis of the gendered nature of this practice that it is most strikingly distinguished from similar historical examples, such as hiding escaping African slaves in the United States or Jews during the European Holocaust. Apartheid laws and traditional African social structures assumed and demanded female dependence on men for housing and support, so that one reason for making one's way to Johannesburg in the first place was the promise of financial and personal autonomy.[39]

Once in the city, a woman quickly learned how relatively favorable her position as a domestic worker was, compared to other city women. Township women needed husbands to register for a township house. This requirement, first introduced in the 1930s and strongly reinforced by the apartheid regime in the 1960s, cut against women's efforts to set up house on their own. To the contrary, many township women found themselves deeply compromised in their relationships with men as a result of their efforts to hold on to their rights to urban residence. Some tolerated cheating, abuse, and cruelty rather than raise the ire of their men, as it was not uncommon for husbands who quarreled with their wives to go to the location superintendent's office and cancel the leases of their houses without warning, leaving their families on the street.[40] Others who found themselves abandoned quickly established new unions to preserve their right to a township home.

Women did everything to save their houses. They went to witchdoctors, married their own cousins or relatives, or even men they did not like.[41]

There are many cases I could tell you of where women just got themselves husbands just to save their houses. . . . There were those who were forced to marry for fear of losing their houses. Those marriages were all the same: no love was involved.[42]

The alternative to township living, squatting, or homelessness was domestic service. Indeed, many who lost their rights to township housing through divorce, desertion, or the deaths of their husbands entered domestic service precisely in order to stay in the city.[43] While township women needed men to secure housing, domestic workers did not. In fact, many suburban employers preferred that a worker be unattached.

This gave workers one advantage over their township and country sisters in their shared efforts to create what they called "modern" relationships. Their direct and intimate exposure to white families gave them another. It helped to broaden their vision of what marriage could be; encouraged them to consider new options for themselves; and, perhaps most important, provided them a model to assert against their partners for negotiating purposes. For what were often the first times in their lives, many workers began to explicitly challenge the assumptions of their most intimate relationships and to redefine their terms.[44]

Take the case of Linda, who worked in a building of flats. Her boyfriend, hired by one of the many city employers who hired illegal Africans without bothering to regularize their status, had no urban accommodation. Without her madam's permission or knowledge, he began to sleep regularly with Linda in her skylight room. Linda was an ardent Christian, and the couple began eventually to argue about her commitment to her religion: "He didn't want I must go to the church. He made me cross." Under other conditions, Linda would likely have found it advisable to acquiesce to his demands that she spend more time with him. In the back room, though, he held little persuasive power. She told me how she put a swift and efficient end to his nagging: "I kicked him out."[45]

For men who believed that the old rules still applied—that "when I get to my house . . . I must feel I am being welcomed and everything is done to make me feel back home—a husband feels he should be appreciated

when he gets home"—life in a back room could prove a rude awakening.[46] Sally's husband also experienced such a shock. Originally from Soweto, he lost title to his family's township house. He thought his housing problems solved when Sally secured a domestic position. He moved in with her. Given her familiarity with her employers' hours and habits, she felt it necessary to set the rules of the household: "You have to give your husband orders. To get here this time, not this time. Behave like this, not using too much water." He eventually left her, she said, because he could not accept her placing restrictions on him.[47]

There were frequent cases of domestic abuse in the servants' quarters; women did not have absolute power there. But even this violence may have been less a sign of men's continuing control over their women than a symptom of its disintegration. Rural women, who had shown such courage and perseverance in making their way to town, found conditions in urban areas that allowed them to continue thinking of themselves as autonomous and resourceful people.[48] They came to develop a new sense of themselves as independent and dignified. In the rooms that they controlled, and by virtue of the fact that they controlled them, African women were able not only to provide places in the city for their loved ones but also to create new social and personal roles for themselves.

Domestics' need for companionship, employers' desire to exercise control, and the state's imperative to command the movement of rural migrants, to be realized, all depended upon particular ways of moving over suburban grounds. Paths and intentions clashed and occasionally supported each other, sometimes in ironic ways. For instance, women could learn to navigate urban space in the first place in part because the same whites who complained about African urbanization smiled mildly at the "nannies" they passed on suburban sidewalks, giving instruction to greenhorns on the locations of favorite police checkpoints. Whites might discuss news stories about African "detribalization" over the dinner table, never suspecting that two "extra" Africans were secreted in their backyard, hungrily anticipating the meal's leftovers. In fact, though, it was because so much of the movement that undermined the intent of apartheid's planners took place on private property that it could happen to the extent that it did.

South Africa in the 1960s and 1970s was in many ways a police state.

The extensive security apparatus maintained strict control over public order. African areas, in particular, were heavily patrolled and monitored. Early-morning raids on Soweto houses were commonplace, and because township homes were government property, residents had no recourse when officers banged on their doors and demanded an accounting of everyone present. White houses, by contrast, were privately owned. On these properties, master and madam ruled supreme, not the state.

Most English-speaking whites, even if they disagreed with the government's position on African influx control, did not relish the idea of boarding African families in their backyards. They made vigorous efforts to ensure that their servants were not harboring guests. However, what many disliked even more than illicit lodgers were the rough intrusions of police—most of whom were working-class Afrikaners—onto their properties. Employers tried to assert the privileges and rights of home ownership according to the liberal traditions of which they considered themselves heirs. Some posted homemade signs, "No Police Allowed," on their front walls.[49] Many argued vigorously, and somewhat disdainfully, with white "hairyback" officers—the derogatory term for Afrikaners—who tried to push themselves past private gates to search for undocumented Africans. On principle, they refused to cede their rights to control entry onto their lots. The police had to turn away unsatisfied when an angry madam threatened to turn the dog on anyone who tried to step past her, or when master swore that he would take the officers to court if they ever again disturbed his dinner.

Employers had other interests as well in keeping inspectors from their yards. African worker registration was a complicated affair. Some employers avoided the bureaucratic red tape involved, while others made sincere efforts to regularize their servants' status and failed. In either case, if they continued to employ an undocumented worker, they were subject to a fine, in addition to losing her. Fear of detection, and the concern of losing a possibly trusted, certainly necessary employee—especially likely to be the case if she was nanny to their child—led some whites to collaborate with their workers on avoiding inspectors. One instructed her worker that if the police should ever come while she was away from the home, she should go into the master bedroom and hide in the closet. Another used to rush to

the back room at the first sign of an inspector visit and warn her domestic, "Look! Tell the children to go and hide away!"[50]

Another madam received help from her neighbors. According to her worker, "You have to hide yourself in the house. You won't go out. Or if the dogs are barking you don't go out, you just hide yourself. You close the curtains. And the other madams help the madam. They see the one who have got the girl not with the right pass and they telephone and say, here are the inspectors, they were here to me, you must take care, don't open the door, don't move."[51]

Other white householders resisted state efforts to control African movement between rural and urban areas on even higher principles. For some, the right of Africans to maintain familial ties was a principle worth fighting for. A small minority felt so strongly opposed to the government's influx-control policies that they chose to practice civil disobedience, fighting apartheid as it appeared literally at their doorsteps. Precious's madam not only allowed her children to visit during school holidays but put them up in her own guest room, in the main house.[52] Another worker's employer went to jail for fifteen days in protest of apartheid policy, rather than paying a fine for illegally harboring an unregistered worker.[53] Such courage, though, was rare. Most home owners did not align themselves with the interests of their workers and would gladly have evicted unauthorized guests, had they known of their presence. They had their hands full with uncouth police and labyrinthine apartheid regulations on one side and misbehaving workers on the other.

The state, through municipal authorities, struggled to enforce legislation that it hoped would gradually decrease the numbers of urban Africans. "Nonproductive" and "unfit" Africans, in apartheid terms—which included those fresh from the rural areas who as yet held no jobs—were the primary targets of removal. The suburbs were a firewall, and apartheid bureaucrats and police tried hard to prevent newcomers from leaking into the city via the back rooms and gardens of middle-class homes.

Workers, meanwhile, continued to sneak family, friends, and virtual strangers onto whites' properties. Even those employers who allowed some visitors into their backyards had at best only vague ideas about the actual volume of traffic that passed through their gates or about its nature. One

householder spoke contemptuously of his next-door neighbor, whose do-
mestic worker managed to run the neighborhood *shebeen,* the local term
for speakeasy, under his nose in her back room. What the first did not
realize was that the shed on his own property served as the *shebeen's* store-
room.[54]

Whites were not totally ignorant about their properties. The typical
adult could recite facts like the size of the stand, the price paid for it, and
the amount of its possible appreciation in value. Gardening enthusiasts
knew what was planted where and could predict when shoots would begin
to appear in one corner of the yard and flowers' blooms to fade in another.

Information of this sort was inconsequential to most domestics, who
worked to familiarize themselves with a different set of details. The hours
of madam's naps held more interest than the bulb-planting schedule. Dis-
tinguishing the sound of master's car tires from his neighbor's was more
useful than knowing the specifications of the garage. The success of work-
ers' plans depended not only on their memorizing details of whites' lives
that whites themselves did not know; it relied also on whites' oblivious-
ness to workers' activities. Often, white ignorance was born of prejudice.
Many a child was saved from detection because whites saw in raised beds
a "primitive" fear of *tokoloshes* rather than a hiding place. Linda found that
the "Welcome to Jesus" signs she posted on her rooftop door deflected in-
spectors' suspicions, since it seemed to identify her as a conservative, law-
abiding African. One police officer actually returned to her room directly
following a raid to discuss the Bible. The notion that she as a Jesus wor-
shipper might also be a lawbreaker apparently did not fit his conception of
African religiosity. As they chatted, she prayed that her boyfriend hiding
in the wardrobe would not cough.[55]

Certainly whites often knew more than their domestics gave them credit
for. Experience in such matters, suspicious natures, sharp eyes, or workers'
carelessness might alert an employer to the presence of illicit activities and
tune her in to the rhythms of the network that ran beneath the surface of
things. Workers could be caught, and their guests thrown off the property,
as a way of restoring whites' sense of proper order on their properties.

At times, an even greater sense of control could be gained if a white
householder did *not* come forward with what she had detected. To some,
having illicit guests was not too high a price to pay for the satisfaction of

knowing that which a domestic was trying to keep secret and of watch-
ing her continue, in vain, to try to disguise it. Power lay in penetrating
the layer under which illicit activities lay and exposing it to one's view. It
existed, also, in observing useless efforts to remain hidden that revealed a
domestic and her guests as blunderers and so reinforced notions about Af-
rican mental inferiority. From Amy's kitchen, she and her family could see
the workers' friends sneaking onto the property. "We'd hear the gate creak
open," she said. "They'd just slink along the back way." Amy did not try to
stop them.[56]

Workers, employers, and police inspectors would all probably claim the
upper hand in knowing and exercising command over these properties.
Depending on a person's perspective, there was some truth to the claims
of each. After all, the police made frequent arrests, so that the number
of African migrants to Johannesburg did fall during this period; madams
prevented the entry of many an inspector; and all workers hid at least occa-
sional guests, with varying degrees of success and trauma. Yards and back
rooms were not the only sites caught up in struggles to claim comforts and
assert privileges. Inside the white house, too, domestic workers and their
employers fought undeclared wars over the occupation and use of urban
domestic space.

FIVE

House Rules

White South Africans had a problem. Middle-class Johannesburgers depended on African labor to give them practical help and social status by maintaining their homes and looking after them and their families. To do their jobs well, workers needed to get inside the head of each white family member, anticipating their movements, intentions, and wishes at any given moment. "Just like that. We knew one another just like this, the insides of our hands. In and out," as one worker said of her madam.[1] The intimacy that could exist between household members cannot be overstated. Indeed, in many cases the best word to describe it would be *love*—the fractured, conflicted, pathological, self-doubting love that often exists among family members in a dysfunctional household, but love nonetheless, including fondness for, knowing of, and dependence upon another person. Workers also needed a high degree of intimacy with the home itself, learning the corners, crevices, and ceilings of each room. Where did the dust catch? What polish worked best on which of the living room tables? Which way did the rug have to lie to hide the wine stain on the floor?

At the same time, dominant white attitudes and a rash of other considerations led whites to try to keep Africans at a distance. The back room was one means of doing this, of course. Whites also responded to the challenge of keeping a "white house" whose maintenance depended upon black

hands and black intelligence by employing house rules, conventions that sought to control how Africans comported themselves in and with the white house. House rules were a set of understandings passed from parents to children, neighbor to neighbor, and through the occasional advice column in the ladies' section of the newspaper regarding the appropriate behavior of one's domestic workers. House rules supported whites' efforts to situate themselves comfortably within their homes, their neighborhoods, and even globally during a period of great social stress for white South Africans. Domestic workers responded to the indignities of their employers' regulations with routine, circumspect behaviors of their own.

House rules divided the white house into two coexisting, though intermingling, spheres, one of domesticity (the white sphere) and the other of labor (the African sphere). The African sphere was not a separate room or collection of rooms. However, as much as if walls had been erected, house rules relegated domestic workers to a different social zone within the shared physical space of the house. The two zones were distinguished primarily by what happened within them. In the white sphere, mothers knitted, children did homework, fathers read, and Spot and Rover frolicked. In the African space, domestic workers swept up loose threads, tidied papers, put away books, and vacuumed dog hair. House rules allowed all these activities to take place within a single room without white family members feeling vulnerable, exposed, or distracted. The worker was present, but she was never an audience, only a stagehand. Servants had no right to acknowledge and comment upon the scenes played out in front of them, only to repair the props.

One way to think about house rules is in terms of invisibility, a condition that workers in the Northern Suburbs shared with other domestic workers the world over.[2] Social convention required that white people pay little regard to the comings and goings of their domestics, who occupied a lower social level and so existed, as it were, beneath their lines of vision. House rules supported whites' efforts to ignore the everyday, routine activities of household workers by demanding that they comport themselves so as to avoid drawing whites' attention.

On certain points there was little ambiguity. Domestic workers were expected to use the back door to enter and leave the house, while white adults had the option of entering through the front. Inside, they were supposed

to move through spaces quietly and inconspicuously. One housewife, interviewed during this period, said her biggest complaint of her worker was that "she insists on wearing shoes in the house and I find the noise very irritating."[3] Servants were not allowed to sit down inside, although some were given their own chairs or stools in the kitchen. Essentially, they were expected not to use the comforts or technologies of the house for their personal benefit, only to service them for the benefit of others.

Invisibility did not apply with equal force throughout the house or to all members of the white family, as figure 32 illustrates. The ease with which whites could choose not to acknowledge an African woman's presence depended on the respective parties' perceived roles and status within particular rooms. African invisibility pertained most strongly in ceremonial spaces where the white householders enacted rituals of family life for private and public consumption, like the living room and the dining room, labeled here as rooms 2 and 8. The most highly prized servant was one who could serve and wait table without attracting attention to herself or dust in a corner of the room so quietly one would not know she was present.

Africans were also expected to be invisible in the front exterior of the house. A servant on her hands and knees applying the red polish that gave the *stoep* its distinctive shine was permitted, although employers hoped that this task would be performed early in the morning. It was ridiculous, however, to think of a worker sitting on the front steps during her break in the middle of the day, hoping to catch a bit of sun.

In very private spaces where personal dignity was implicated, such as bathrooms and toilets, the servant would rarely be present with other adults, and so literal invisibility pertained. Intermediate areas such as a child's bedroom, where a worker who served as nanny had some limited authority over her charge, allowed a greater degree of visibility. Among other things, that meant that white people there were less likely to talk about a worker or racial politics as though she were not in the room and that she could openly listen and respond to their remarks.

Typically, the only room where a domestic worker could be unapologetically present and acknowledged, pulling herself up to her full height and breadth, was the kitchen, labeled in figure 32 as room 4.[4] Usually located at the back of the house, the kitchen was the worker's point of entry into the white house. Anything that could be called hers—a bench, if she had one;

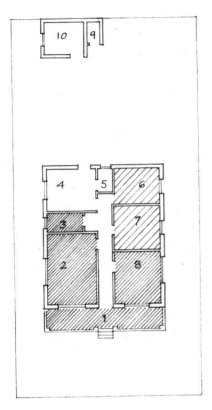

FIGURE 32. This 1915 house plan, though small by Northern Suburbs standards, helps to illustrate schematically the typical areas of greatest African invisibility by room type. Degree of shading corresponds to degree of invisibility:

1. stoep,
2. living room,
3. bathroom,
4. kitchen,
5. pantry,
6. bedroom,
7. bedroom,
8. dining room,
9. outdoor toilet,
10. worker's room.

(Drawing by Sibel Zandi-Sayek)

her tin plate, mug, and spoon—was kept in this room. Here she prepared the frequently requested cups of tea, fed the family's pets, did her baking, polished the silver, and ironed—in addition to preparing three meals a day, washing dishes, and cleaning.

The kitchen was the room in which she was likely to spend more time than any other and where she often exercised an acknowledged expertise. In some households, the worker might even manage to gain nominal control here, so that others excused themselves when entering and using it— "I hope I won't disturb you if I get myself a cold drink" or "I just want to grab a knife, Lucy. Don't let me get in your way"—or perhaps referred to it as "Mabel's kitchen." However, such control was never absolute. White children and, especially, the madam had interests in preserving access and authority in a room that served also as a rainy-day play space and as the

housewife's symbolic domain. The worker's position here, then, was subject to frequent testing from various sides.

The convention of invisibility depended also on which white family members were present with the worker. Fathers normally had little contact with the maid. If the two of them were alone in a room, he might greet her—though many would not—but rarely engaged in conversation. She would continue her dusting, working quietly so not to draw attention to herself, as he engrossed himself in his newspaper as if alone. Children were more likely to engage freely with her, especially if they had long-standing ties to the worker. However, children could also be guilty of cruelty, sometimes due to their clumsy efforts to detach themselves from her as they grew older. For instance, they might make a point of ignoring her in order to declare their independence from her affections. At many times, though, children probably did not acknowledge the presence of their family's workers because, having trained themselves to not see them, they were genuinely not aware of them.

Madams, who assumed responsibility for the worker's labors and for the appearance of the house, tended to pay close attention to the women they employed. Some followed them about when the two of them were alone during the day. In social situations, though, or during family evenings, the lady of the house turned her attention away from her servant. Like the other members of her family, a madam could show a remarkable ability to ignore the presence of someone working only a few feet away. Nevertheless, of all white household members, the madam was least able to completely ignore the worker when she was present. Many managed to mentally track, perhaps almost subconsciously, the activities of their domestics.

Most middle-class households required domestic workers to wear uniforms, typically a smock-type dress with matching cap, and the use of uniforms in the white house further supported whites' efforts to mark the separate spheres of home and labor. By donning her uniform, the domestic turned herself from a woman living at the bottom of the garden to a worker. The dress declared her relationship to the property and implied her responsibilities and limitations there. It served to remind both parties that, as much as the uniformed African attendant who checked the oil at the neighborhood petrol station or the uniformed African bag checker at

FIGURE 33. In her uniform, this woman was expected
to mute her personal feelings, toward the dog, for in-
stance, and become a depersonalized working unit
within the house. (Courtesy of Museum Africa, South
Africa)

the grocery store—for uniforms were ubiquitous dress among Africans—
the African worker's role within the white house was to serve.

The very fact of the worker's being African, of course, would have been
sufficient to distinguish her from family members or guests. After all, it
was rare for Africans to enter openly white properties for any reason other
than to serve the people who lived there. Friendships and even professional
relationships between the races were uncommon, so that it was highly
unusual to see an African guest at a Northern Suburbs dinner party, the
restrictions against serving alcohol to Africans serving as additional dis-
incentive. The uniform, however, not only spoke to differences between
white householders and African staff but also emphasized the difference

between a householder's domestic worker and other Africans. Uniforms helped to distinguish domestics from Africans who were either unemployed or who worked in less affluent households that did not provide uniforms.[5]

According to the myth of disorderly detribalization that informed apartheid ideology, it was "superfluous" Africans who posed a social danger. Africans who held city jobs, who were under the control of white employers, and who therefore fit within the smoothly running machine that supposedly was Johannesburg, held considerably less threat. The women in white, pink, or blue aprons who chatted under trees at the corner or carried bags from the greengrocer were, to whites, Africans with places. The uniforms marked Jane and Emily as "the Smiths' Jane" and "next-door Emily," black women under the command of whites who therefore slotted neatly into the system. In fact, their uniforms made them extensions of the households for which they worked. They stood for "the Joneses" or "the MacIvers," and their orderly presence on suburban streets marked the reach and power of those homes into the public domain.

The use of uniforms helped whites to make sense of their world. They made visible and reinforced the popularly understood—or at least desired—differences between the races. Whites did; Africans assisted whites to do. Whites dressed according to taste and fashion, and Africans' uniforms marked them as an uninvolved, depersonalized accoutrement of those superior lives. An early twentieth-century observer remarked, "The native servants were looked upon as so many automatons, there to perform their tasks as silently and expeditiously as possible without obtruding themselves unduly on the attention of their superiors."[6] This relationship stood unaltered at midcentury, and uniforms abetted whites' efforts to visually order their society according to this scheme.

Part of a uniform's power lay in its communicating that the person who donned such dress knew her place. "When they [whites] saw them clothes they knew how you'd be acting," according to a African American maid who worked in Washington, D.C., in the early 1900s.[7] In South Africa, as well, domestic dress indicated a black woman who had placed herself ready and available for service to whites. On South African farms, uniforms had not been necessary. Racial relations and social roles were unambiguous in the oppressively conservative countryside. In the more liberal and chaotic

urban environment, though, people needed help figuring where others stood. Uniforms offered reassurance to whites that some Africans, at least, could be relied upon to play their proper parts.

That it was a uniformed *African* woman dusting in the corner made the fiction of invisibility easier to maintain. It is difficult as a rule to enforce invisibility between social equals, bound by mutual obligations of acknowledgment and regard. Between whites and Africans there was no such compact. Not only apartheid, but also the entire history of the subcontinent, was testament for whites of the social inferiority of Africans. Some whites even regarded Africans as biologically inferior. "They've just come out of the trees. I mean, they are at a lower stage in the evolutionary ladder," were the words of one housewife.[8] Most had more charitable, but equally confused ideas about race. For example:

They're not inferior. But they're not equal to us.[9]

They're black and we're white. You can't compare us.[10]

House rules did more than inform the quality of Africans' movements through various parts of the house; they also restricted their interactions with the objects of the house. That is, they helped whites to handle not only the presence of Africans but also their traces. After all, it was not just the African in one's room who threatened one's privacy; it was also the African who had just left. Prior presence was felt, among other ways, through the medium of objects previously touched and handled. Workers were not supposed to use the things of the house for their own enjoyment, not to stop to admire paintings, to read books, to eat from the plates, to use the telephone, or, certainly, to use the white people's toilet. The people who made these rules understood at some level that it is in part through the nature of our interaction with particular material things that our status is achieved. Africans polished chairs; whites sat on them. Africans made beds; whites slept in them. Their respective relationships with the things of the house helped to distinguish the family from the worker and so further delineated the separate, unequal, but coexistent spheres of white home and African workplace.

Things played a critical role in another respect as well. The blurring of social distinctions and the loss of privacy were not the only things

whites feared. Popular ideas about hygiene and "Black germs" also justified practices like the use of separate plates, outdoor toilets for the staff, and proscriptions against workers sitting on the furniture.[11] Leticia's madam, admittedly extreme even by South African standards, required her to wear gloves when she prepared food. If Leticia forgot, her madam refused the meal. She would protest, "But, madam, I had a bath. I have no boyfriend," but her employer stayed firm.[12]

At the same time that racial attitudes reinforced house rules by making servants easier to ignore, they demanded them, by positing Africans as possible sources of contamination. House rules were a response to the visceral uneasiness many whites felt around Africans. When Africans interacted with whites' objects in their capacity as servants, washing or dusting or cleaning them, and thereby counteracting any polluting effect, the physical contact could be tolerated. However, when Africans engaged with whites' objects as equals, using them in the same manner as whites did, it was a challenge to the social order and an almost physical affront. Whites were uneasy about the prospect of whites and Africans coming together over things in intimate and uncontrolled ways. House rules enabled whites to rest assured that the forks they ate with had not been licked by a African's tongue or that a black bottom had not been the last to touch their favorite armchair.

As in matters of raising children or training dogs, there was room for disagreement among reasonable white people over the practice of house rules, both within households and between them. Differences between white households were most pronounced along class lines. Relations between workers and family members were typically warmer and looser in poorer homes, which tended to be Afrikaner or immigrant households and not located in the Northern Suburbs. In low-income homes, the worker was likely to be fairly closely integrated into the total life of the family, and the rapport between worker and employer tended to be better. The closer social distance between madam and worker and common experiences of urban migration and rural roots facilitated the development of warm bonds. So did the frequent presence of at least one common language. Many newly urbanized white women had learned African languages from farm laborers as children, while African women from rural areas had often had

more exposure to Boers than to English speakers and so had better com-
mand of Afrikaans.[13]

The relatively small size of lower-income whites' houses and properties
also helped. Because the worker was thrown into closer physical proximity
with the white household and because working-class family members and
friends were likely to congregate and socialize in the kitchen, the domestic
worker's terrain, relationships could be closer and more genuine. Although
working-class whites were likely to express strong anti-African attitudes,
in practice their personal relations with individual Africans were stronger
than those of more liberal homes.[14]

As early as the late nineteenth century, observers noted differences
in treatment toward servants between longer-term white South African
residents and those newly arrived in the colony.[15] Mid-twentieth-century
commentators found the same thing.[16] White South Africans were aware
of the differences between themselves and more liberal immigrants and
tended to construe any dissimilarities to foreigners' disadvantage. Middle-
class whites considered household management a craft, and many scorned
the inexpert efforts of newcomers to exert firm and judicious control over
their staff.

Whites who had grown up with servants, according to those who held
this opinion, knew how to give instruction and manage staff. This was in
part class-based snobbery. New white immigrants who arrived after World
War II tended to be of lower socioeconomic status than those longer set-
tled in the subcontinent. South Africans couched their opinions, though,
in terms of their expertise with "the natives." Personal knowledge of Afri-
can traditions, manners, and sometimes even languages supposedly made
whites of several generations' residence in the country better employers
than newcomers who, out of ignorance of South African ways, tended to
pay higher wages that "spoiled" the market and failed to observe proper
relations between the races. Much as Southern American whites claimed
superior knowledge of and attachment to "Negroes" than Northerners,
established English-speaking white families believed themselves just and
caring protectors of Africans' interests. Many Afrikaners, having even lon-
ger ties and closer connection to Africans, argued the same point, to En-
glish speakers' disadvantage.[17]

Many immigrants themselves admitted to discomfort with their Afri-

can employees and found negotiating relations with live-in workers to be a delicate, self-conscious affair.

> Even after many years in this country, I am still unable to cast off the idea that there is something feudal, if not actually immoral, in having a domestic servant at all. I was brainwashed into this belief while I was still young, and I suppose I shall always be assaulted by vague pangs of guilt when hearing the whine of a vacuum cleaner which is not being operated by me.
>
> Of course, I tell myself that having a servant leaves me free to do sewing and all sorts of things for my family which I should not otherwise have the time or energy to do, but that does not help.[18]

A few chose the route of going servantless:

> It has always been a source of wonder to me since I arrived from England, thirteen years ago, that so much fuss is made about servants here. Women in England have coped for generations without domestic help, regarding it as their proper contribution towards the efficient running of their homes. In any case, I wouldn't care to have an uninterested stranger cooking my family's meals, and wandering about among my hard-won possessions.[19]

For their part, many Africans found conditions in foreigners' households, as a class, more to their liking. Maria's remarks were typical. "There was no bathroom, there was no nothing," she said of the back room she inhabited while working for her American madam. "And she [the employer] was also complaining that she had no money. But the treatment, let me put it that way, it was different from the whites of South Africa."[20]

Foreign employers' attempts to treat their African employees with fairness usually involved some disintegration of the boundaries that ordinarily divided black and white spheres within the house. Maria's madam allowed her to entertain her visitors in the main house, even making tea for them when she prepared a cup for herself. "I used to sit with her at the table and used to talk, talk, talk. Everything. . . . When my children they came from home, with my grandchildren, they came inside, watching TV. In and out."[21]

Maria was never able to accept all of her madam's gestures. "She would

say, 'If you want to come inside and have a bath you can come and have a bath.' But true our apartheid in South Africa was heavy for me to come in right there and have a bath. You understand what I mean. But to her it was all right."[22]

Middle- and upper-middle-class foreigners, likely more sensitive than locals to international condemnation of apartheid, probably struggled mightily in their efforts to be "nice" to those Africans they had relationships with. Coming from countries that denounced apartheid, they may have made efforts to prove to themselves that they were different from South African whites. Indeed, they probably were. They undoubtedly had a difficult time balancing the advice of their neighbors to draw firm lines with their desire to avoid being "racist."

About preferences between English speakers and the rare upper-middle-class urban Afrikaner, workers were less unanimous.[23] Some swore that English speakers were kinder and less fixed in their racial attitudes. Others disliked what they perceived as English coldness: "They . . . didn't shout at me or anything, but treated me like something . . . something not human you know. It's appalling. No greeting at all in the morning. I think the Afrikaans people are much better, they are more human."[24]

While the treatment of servants on Boer farms was notoriously rough, Afrikaners who had moved to the Northen Suburbs had reputations for having preserved their honest plainspokenness and discarded their brutality. They were also generous with food: "The English people they always eat one spoon of pumpkin, one spoon of rice. The Afrikaans make the plate *full* of food."[25] Conventional wisdom among workers was that one never went hungry in an Afrikaner yard.

Conscious of their social positions, and ever anxious to draw distinctions between themselves and Afrikaners, most middle- and upper-middle-class employers aimed to strike a balance between, on the one hand, the crude familiarity with one's workers that supposedly marked working-class and immigrant households and, on the other, the rudeness and violence associated with Boer farms by genteelly ignoring their workers. Whites' dignity was best preserved when a woman's efficient and inconspicuous movements through a house did not compel them to pay attention to her. Workers' attempts to comply with house rules, along with Northern Suburban residents' predispositions not to acknowledge their activities and

presence, meant that African domestic workers were, in effect, hard to see. As one of my white participants said of the workers in white houses during this period, "They were never a feature. [Or], if they were, they were a silent sort of feature ironing in the corner, if anything."[26] Or, from another, speaking of his family's domestic worker when he was a child, "To me she was sort of part of the furniture. She just belonged there."[27]

The conceit of African invisibility—and assumptions about African women's intellectual capacities—sometimes lured whites into assuming equivalence. If they did not notice her, went the unspoken assumption, then the domestic worker presumably got along in her day without reflecting overmuch on them, either. Many householders convinced themselves that their workers were deaf to and ignorant of much that happened in the house. Most spoke unguardedly in front of them, as if they were not present. When one white American, newly arrived in the country, commented on this during a particularly candid conversation over a family dinner table, his host reassured him, "They're not interested in what we say and do. They don't even hear us." The maid, serving dinner, winked at the visitor.[28]

The most effective way of maintaining two spheres—of ensuring that workers behaved as workers, in other words—was, ironically, through surveillance.[29] This was the madam's job, and as a consequence, many white housewives followed their workers through the house as they performed their duties. Surveillance allowed white householders to make sure that their workers were indeed behaving as they wanted them to and, in the process, reassured them they were getting their money's worth from their employees, a matter of economy and of pride. They feared being taken advantage of by women purposely not performing up to par, and they feared being taken for fools, laughed at behind their backs. These concerns would have been matters of interest for employers at any time, but they held special interest for white women during this period. Their roles in the home and beyond had become subject to ever more public debate during the 1960s and, especially, the 1970s. Proving themselves efficient and competent home managers became a matter of urgency for many.[30]

Until midcentury, most middle-class whites held conservative views about family life, believing that the husband's role was to provide and

the wife's was to supervise the home and raise a family. Married women customarily identified themselves by their husbands' names and devoted themselves to supporting their careers. A study in the late 1970s found that 35 percent of white women did not even know their husband's income and that in over half their marriages the husbands made all financial decisions in the households.[31] "The husband is the breadwinner. Therefore it is right that he makes all of the decisions about money," was a typical comment.[32]

Beginning in the 1960s, however, the white middle classes became aware of the feminist revolution under way in North America and Europe, so that only 14 percent of female respondents in the same Eastern Cape study could say that they had not heard of the women's liberation movement.[33] While the movement never made significant inroads among white South Africans, many white women could not avoid considering the issues that it raised. Women's revaluation of their social places and personal ambitions, reflected strikingly in the lengthy discussions on such matters conducted in women's magazines, became common. One of the most contentious topics was whether married women should work outside the home.

It had long been acceptable for young, middle-class white women to hold jobs between the years of graduation and marriage and perhaps even during the early years of marriage before children came. After that time, they had been expected to devote themselves to home life or, at least, to activities that did not compromise their duties there and possibly enhanced them, like part-time volunteer work. However, the notion that the workplace was no place for mothers was increasingly under assault. This, and the economic slowdown of the 1970s that pinched families trying to survive on a single income, meant that during the period of this study, the numbers of employed white women rose.

One argument used to oppose women's outside employment was that white women who worked were forced to leave their homes in the hands of domestic workers. As one letter to the editor expressed it, "A woman's main reason for marriage is her love for a man, and a desire to raise a family in a home of her own. Why then, once they have achieved this goal, do some women hand it all over to a servant? A servant can never take the place of wife or mother, no matter how faithful or efficient she may be, and I am sure it was definitely not the intention of the husbands concerned that their children's characters should be formed by the servants."[34]

Critics of working white mothers expressed skepticism and disdain of the latter's motives. Women who sought outside employment to purchase luxury goods were materialistic and greedy. Many simply sought to escape the challenges of homemaking. No matter their particular moral failings, though, all working mothers, according to the critics, created dangerous situations in the family home, because a white woman's absence meant an unsupervised domestic worker. African women who did not have constant monitoring would damage one's prize possessions or steal items in the home. Improperly attended children, cared for exclusively by the domestic, were more likely to become delinquent.[35]

At the same time, white women who elected or were able to avoid paid employment were provoked to question their place. Although homes did not boast many labor-saving devices, the maintenance of a household was in many ways a simpler affair than it had been even fifty years ago, before the advent of frozen dinners, instant foods, vacuum cleaners, and electric stoves.[36] Some women found themselves feeling superfluous. One young woman expressed the frustrations of many:

> The most important woman in my husband's life is his secretary. And I don't mean that they're having an affair. But she's with him all day. She's in on what he's doing and thinking. She shares the crises. She's on the spot to celebrate the achievements. He relies on her. He was more distressed when she was away for three days with 'flu than he was when I had to rush away for three weeks to a dying mother.
>
> It's quite simple—without her, his routine, his output, his very existence were affected. Without me—well, *the maid has been trained to run the house and children quite adequately.*[37]

It was easy to feel trapped in a no-win situation. If a white woman sought personal fulfillment through outside employment, she faced the shame of "deserting" the home, but those who remained as full-time housewives in a society where at least one full-time domestic worker was the norm found themselves hard-pressed to explain exactly what functions they fulfilled in their own homes. Performing their own housework was not a serious solution for most. However, overbearing surveillance of workers' efforts answered the bill. Whether a white woman left the house during the day or identified as a full-time housewife, by heavily supervising and minutely

controlling workers' activities, she mitigated her guilt, appeased her wor-
ries, and justified herself.

Some white women invented tasks, trying to ensure their workers had
no time for leisure. Madams who had to absent themselves from the house
during the day had other ways of letting their presence be felt. Some threw
money under the bed or left coins on the dresser. These were in part tests
of honesty, which savvy workers passed by leaving the money exactly where
they found it or making a conspicuous show of turning it in to master
or madam. Whites knew that most workers would understand the loose
change to be a check and that the Africans would realize as well that their
employers knew that they would take it that way. The money's real mean-
ing lay within these webs of mutual though unspoken acknowledgment.
The money spoke to the worker, in the voice of her madam, "I'm watching
you." And in the time it took the worker to crawl under the bed, retrieve
the coins, and place them on the nightstand in an obvious position, the
madam had succeeded once again in controlling her movements and keep-
ing her occupied.[38]

On the surface, the house rules of Johannesburg's suburbs resembled em-
ployer expectations around the world. Rules against taking breaks in the
living room and requiring use of the back door were fairly universal and
protected the same employer privileges in other countries as they did in
South African homes. For English-speaking whites, though, house rules
also formed part of a much larger political picture. Although still the most
economically powerful population in the country, this "ethnic" minority
within a racial minority considered itself under siege. On one side lay Afri-
kanerdom. Many English not only felt shame at having lost political power
in the early twentieth century to a group deemed inferior but also worried
that the latter's culture would swamp them. One writer speculated in 1968,
"It is becoming painfully apparent that English-speaking South Africa as a
cultural and political force, and even as a group, is on an increasingly steep
and slippery slope which can only end in the black waters of extinction."[39]

In language that is striking today for its naïveté and paranoia, a prize-
winning high school essay published in a national journal called upon
English-speaking whites, subjugated by Afrikaner censors who "have been
given the power of deciding what the English can read at home or see at

the cinema," to "insist on their freedom, not as a privilege but as a right granted to all citizens in every democratic land."[40] No mention was made of the conditions faced by nonwhites. Far from being dismissed as juvenile patter, the essay was celebrated as evidence for hope that the younger generation would continue to fight for English values and traditions.

At the same time, the English-speaking community was painfully aware of the condemnation that South Africa's racial policies were receiving overseas. Many traveled under dual passports in order to avoid snubs at international customs desks. The newspapers and radio broadcasts that regularly announced the world's outrage over apartheid found their way into their dens and bedrooms. Starting in 1952, the United Nations' General Assembly began to produce regular resolutions condemning the South African government, and in 1973 it declared apartheid a crime against humanity. In 1961 the country was effectively forced to resign from the Commonwealth. Some of the bitterest international denouncements, for sports-loving whites, came from the athletic community. An invitation from the International Olympic Committee (IOC) for the country to send a team to the 1964 games in Tokyo was withdrawn when new domestic restrictions on interracial sport made South African compliance with international standards impossible. South Africa was invited again in 1968, and this time other countries threatened a boycott if it participated. In 1970 the IOC withdrew recognition of South Africa.

A host of books published during this period defended the country's policies and maligned its critics. Asserted one, employing popular rhetoric, "It is no secret that Communist China and the Soviet Union, for example, have been training guerrillas and other military personnel in several Black countries in Southern Africa. And it is also no secret that such armed forces are not being trained for the defense of their own land but rather for the invasion of a foreign land. First they must take over in Rhodesia and then they can aim for the brass ring—the number one prize—The Republic of South Africa."[41]

And, declared another, "In the past thirty years double-standard treatment and selective indignation has characterized most of the pronouncements and actions against South Africa in the world at large. There is one standard for South Africa, another for the rest of the world; one morality condemning real and imaginary wrong-doings in South Africa, another which tolerates gross sins elsewhere."[42]

Most of the liberal whites who lived in Johannesburg's Northern Suburbs scorned the Afrikaner government's crudest racial pronouncements. However, as South Africans, they felt the sting of international condemnation and its practical effects. Many feared Communism and the prospect of invasion. General principles of racial segregation and paternalism had a long and respectable pedigree within the English-speaking community. Many whites felt their position on such matters to be under assault.[43]

The institution of domestic service, by placing whites in close and often intimate contact with a few, particular Africans, helped them to feel competent to judge for themselves the rightness of apartheid itself, or at least of the premise of white superiority. House rules served as self-fulfilling indicators of "cultural difference," thus helping to justify a system in which more "advanced" whites held almost total power. Through eyes that needed to see an inferior in the person of her African worker, a white household member perceived just that. In the words of one white person I interviewed, "Emotionally, mentally, you psych yourself out that a black person is inferior to a white person."[44] Whites depended on their workers staying literally and figuratively in their places to reinforce and justify their ideas about their own superiority and their positions in the social order.[45]

The paternalism that was so often noted as a component of white attitudes toward workers had its source in part in whites' needs to see Africans as children needing the guidance of a benign ruling class. The way housewives referred to their domestics constitutes some of the strongest evidence for this attitude. White women sent letters to ladies' journals, hoping to collect a fifty-cent prize, detailing the supposedly amusing exploits of their African staff. These letters characterized domestic workers as well-intentioned but slow-witted children whose misadventures were worth a chuckle or two.[46] They bring to mind the Sambo personality in popular American culture, which served a similar purpose of quelling whites' anxieties.[47] The myth of the foolish, infantilized worker allayed fears of the dangers posed by strangers in the family's nest. What many white women feared especially was sexual competition. Whether or not housewives believed the stories about African women's hypersexualized natures, painting servants as uniformed and therefore unindividualized, slightly retarded, childlike creatures served to desexualize them and reduce them as threats.[48]

As is true of children, the most damning accusation one could make of

a domestic worker was not that she was lazy, untruthful, slow, wasteful, petty, dishonest, or unreliable. It was that she was ungrateful.[49] Ingratitude represented rejection of the white madam's role as protector, teacher, and mother figure. And ingratitude was felt primarily through a worker's refusal to obey the rules of the home. One contemporary observer called madams' obsessions with monitoring their workers' observance of house rules a neurosis.[50] Their suspicions that Africans were transgressing the limits of their acceptable engagement with the house and its things caused housewives to peer around corners, set traps, and ask neighbors if they had evidence of rule breaking.

Did their suspicions have any basis in fact? Of course they did. The discussion so far has considered some of the factors that led white women, in particular, to take house rules so seriously. From workers' perspectives, whites' obsession with how they performed their jobs was suffocating and insulting. The women resented greatly their treatment within white homes and the heavy-handed supervision they faced there: "But if she's not working, she's with you whatever you do. Whatever step you do, she's there. She's watching you, . . . like a snake. . . . You can't rest. You have to work, work, work. You can't ever rest."[51] Even if the madam disappeared for a brief period, "after five minutes you see her, she's there. She wants to see, 'Where are you? What are you doing there?'"[52]

One worker found that her madam's controlling presence forced her to time herself in all her tasks, "and still, you don't have enough time in between. There is always something to do, not a lot of relaxing time." Many were forced to squeeze in a bite to eat or a chance to rest at any opportunity. As another woman described it, capturing nicely both the tight schedules under which many women worked and their knack for fine-tuned organization of their time, "You used to drink tea walking."[53] Back and forth within a room or between rooms, often the only opportunity to take nourishment was on the run.

> You didn't fold the carpet back to sweep beneath it. . . . You left the washing outside too long; you'll have to damp it now before you rinse it. . . . Did you rinse these glasses? You must always rinse dishes otherwise we are eating soap with our food. And another thing, you didn't get the

eyes out of the potatoes you cooked last night. Use the back of the potato peeler, the pointed end, you know? That's why it's there.

Madams who micromanaged left workers feeling that no matter what they did or how they did it, their efforts would never be rewarded and their employers never satisfied.[54]

It was not that the work was difficult. Ironing was a special story, of course, but regarding most of the other routine tasks, if a person cleaned every day, the house never got dirty enough to require hard work to keep it looking nice: "It's simple, the housework. . . . I finish the house I go for the windows. . . . I finish the windows . . . perhaps I do the rubbing of the silver. . . . Tomorrow the same thing on the same spot. So how much can you rub? Or dust?"[55] The tasks were basic, the house in no danger of becoming a pigsty. The most obvious explanation for white supervision was white distrust of Africans.

Many attributed white house working conditions to whites' hardened racial attitudes. Most, it seems, had no more hope of changing the nature of service than they did of dismantling apartheid itself. "I thought that was the way it was supposed to be," said one, echoing the sentiments of others who also reconciled themselves to their situation without believing in its rightness.[56] "I was feeling sore, but now what can I do? Because I don't know what to do," another explained.[57] Complaining could get you fired: "Whites refused even to let you talk."[58] If lucky, a woman would find that the money she earned as a worker allowed her to justify to herself the abuse she took at the job. Often, it did not. "The money I earn will never do even half of those things I came here to work for."[59]

Many women kept their grievances and their pain to themselves or shared their true feelings with one another over garden walls or in parks where they collected on their off days. Mutual commiseration was a natural response to their unhappiness, and while it was not intended to ameliorate their situation, talking to others did help. There were other activities, too, that formed part of no plan to dismantle the political system or to remove the prejudices of even liberal whites, but made workers feel better about themselves. Quitting a post, as we have seen, was one option. Another was violation of house rules. The degradation attached to whites' attempts to control workers' bodies in their homes could be met effectively

through violation of the spatial and bodily etiquette that whites imposed on them.

Most workers found it relatively easy to get into the habit of breaking house rules. In Cynthia's case, for instance, her employers forbade her to drink from their glasses, which were kept, as was typical, in an overhead kitchen cabinet. A servant-issue tin plate, tin mug, and spoon were kept under the sink for Cynthia's use. She may or may not have considered the way their relative placement reflected social hierarchies when one day, instead of stooping down for her own mug, she reached up and took one of their glasses for herself instead: "Something is pushing you to do it . . . I don't know what it is." She never told anyone what she did. "But you know yourself, I did that."[60]

"I don't know what happened in my mind," another worker said, trying to explain her own rule breaking. Six months into her position, she began to drink from her employers' glasses, even bringing them into the living room. "I used to sit and"—emphasizing the position of leisure that she would assume—"cross my legs. . . . I used to sit in this very house and have my lunch."[61] Eventually, she became even bolder. In the afternoon, after finishing her tasks and before either her employers or their children returned home, she would turn on the radio, which was forbidden to her: "I listened, and it was the music that said, 'Stand up and jive,' and so I would stand up and jive, because I was alone."[62]

Despite the great risks she took, there were some activities this worker shied away from. Although she could not explain why, she never ate from her employers' plates. Cynthia used their plates, but she did not sit on the furniture. In the home where Brenda worked, "the whole house belonged to us when they were not around."[63]

There was no fixed standard of rule violation that applied across households. Figure 34 illustrates the circumstance-specific nature of African rule violation. Physical conditions such as the position of a tree or the height of a wall could determine where women broke rules (indicated by shading). In each example, the kitchen (upper-left-hand corner room) also provided the necessary privacy for breaking rules.

The worker's control over and familiarity with the room in question was another variable. She needed to consider also the temperaments of her employers, their different schedules, and the layout of their house in taking

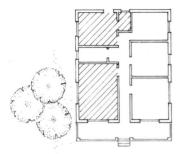 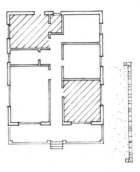

FIGURE 34. Physical conditions such as the position of a tree or the height of a wall could determine where, in two otherwise identical houses, workers were most likely to break rules (indicated by shading). In each example, the kitchen also provided the necessary privacy for breaking rules. The floor plan is the same as that in figure 33. (Drawing by Sibel Zandi-Sayek)

such risks. The view that madam had of the kitchen from her bedroom, for instance, what could be seen by a passing neighbor from the street, and the possible reaction of the family's temperamental poodle to her forbidden behavior all formed part of the complex equation of whether a particular rule could be violated with impunity.

Given the greater degree of comfort and control that workers experienced in the kitchen, it is not surprising that they were most likely to break the rules there. In her Mountain View job, a worker regularly helped herself to that room's facilities: "Even when I used to have tea, I will switch on their kettle and use the same cups to drink tea. Thereafter I will wash it and take it back to its place with no marks."[64]

Some women invited their friends into the house, to chat and to help them with their work. They rested on whites' beds, used their washing machines to wash their own clothes, and took baths in their tubs. Jacklyn Cock found that 98 percent of the workers in her study used household items they had been forbidden to handle, such as the telephone.[65] The fact that workers were responsible for maintaining the house—for washing dishes, for example, cleaning bathrooms, and vacuuming away footprints—meant that they were in an ideal position to literally cover up their tracks. When Janet's madam found her missing party dress in Janet's room,

she demanded to know what it was doing there. "I was brushing it," Janet said. That was believable enough, so her madam let the matter drop.[66]

Just as the establishment of house rules spoke to multiple interests on the part of employers, so their violation was telling as to the position of domestic workers on several levels. First, the use of white people's forbidden things offered physical comfort. Sofas offered rest for weary bones accustomed to secondhand mattresses. China plates were a welcome change over the tin saucers that conducted heat uncomfortably to the fingers. Glass was pleasant to the lips. Many servants found their regular rations small and unappetizing: "It was really bad. Because, let's say, in the morning, she's giving you tea in a tin. You know these tins for jam? She give you tea with that. And a plate, really, you couldn't stand for that plate. . . . And she would put a big jam on top of that bread, and that's your breakfast. And lunch—! It's really disgusting. [But] at that time, there were no words to say anything. You have to say, 'Yes madam, yes madam.'"[67]

Terry, too, was nauseated by the breakfast her madam provided her, slices of bread dipped in bacon fat. She was afraid to complain.[68] To prepare hearty meals each evening for their employers and then be sent to their back rooms with "dog's meat" rankled feelings and stimulated appetites. Many workers refined the art of skimming slices from cheese logs, scraping butter trays, and rearranging fruit bowls.

They also had other, less tangible, longings. Unlike some American domestic workers, who tried to assert the values of a rationalized workplace within highly personalized settings, African South Africans wanted and expected personal, even paternalistic relationships with their employers.[69] The history of African-white relations, especially on the farms, helps to explain this attitude, as does the isolation of domestics in the white suburbs. Many depended greatly on emotional bonds with their employers to satisfy their need for human contact. When one worker received as a Christmas present from her madam an old, used sweater with no buttons left on it, she ran to the next-door madam, with whom she had a much warmer relationship, and broke down in tears. "What have I done wrong?" she cried.[70]

Some interpreted unkindness, restrictive rules, and harsh controls as indications of personal mistrust or lack of caring. For those women who gave their affection and care to white family members, such lack of reci-

procity could be bitter indeed. There was little they could do to change white hearts, but they could take revenge. Breaking house rules was "payback" time. By secretly upsetting employers' expectations, a worker might at some level feel avenged for perceived injustices in the workplace—for attempts to push her away from the heart of the family, for low wages and cheap Christmas presents, and for food that couldn't begin to fill a hungry stomach. Like bringing unauthorized guests onto the property, rule breaking allowed a worker to feel the pleasures of retaliating against unfair treatment. Perhaps envy also played a role. It was an unusual woman who would not note the wealth of her employers and compare their lifestyle to that of her own, often impoverished, family. There could be considerable satisfaction in "showing them," even if master and madam never learned of the infraction.

Violating rules produced even other benefits. Servants placed considerable amounts of their own physical and emotional energies into other people's households. Many were proud of their work and aware of their madams' occasional envy of their ways with the children or the successes of their baking. Many desired to see more of themselves reflected in surroundings of their own making. There was no confusion about the white house being theirs, but by carrying themselves with a stronger sense of propriety, by lounging on the sofa or eating from the silverware, they could at least express a more intimate connection to the spaces and things over which they exerted their backs and their pride.

House rule violation also allowed workers to reclaim their own time. Pervasive employer presence and their attempts to manage their workers even in their absence meant that a woman was constantly "on call," ever ready to respond to the orders or wishes of white family members. When workers broke house rules, they broke their stride. They stopped working. Their breaks interrupted their employers' clocks and allowed servants to reclaim control over their movements and their pace.

Finally, workers sought to establish, if only to themselves, the absurdity of the assumptions of white superiority implied by some house rules. Unless they caught a worker in the act, whites could rarely detect that a violation had occurred. "There was no difference," Brenda noted, in whether you drank from their cups or not, used their bath, or even rested your head on their pillow.[71] They could not tell. Whites' attempts to create insulated

lives for themselves against the supposed threat of African contamination revealed them to be not princesses resisting the proverbial pea, but emperors without clothes.

Domestic service was a difficult and often thankless job. Workers had few resources at their disposal and many sources of unhappiness. Breaking house rules did not begin to solve all their problems. However, for women who were poor, ill educated, and unorganized, these little transgressions allowed them to assert their self-respect. Simply by engaging the white house and its things in particular ways, a person, through her person, could challenge white authority and make her own claims about her place in the world. When whites were around, a prudent worker carried herself with the reserve and deference that she knew they expected of her. She kept her eyes focused on the work in front of her, her hands busy, and her steps quiet. But women knew that there would be a time when they could "take back" their bodies. The same arms and legs and head and back that she trained to move quietly through rooms and hallways could be used to assault whites' notions of superiority and undermine their attempts to keep her down.[72]

Of course, it was not always so easy. Rule breaking was not always a voluntary, autonomous occurrence. The white wife's greatest fear was not that her worker would place her feet on her ottoman or that she would raise her black lips to her glasses; it was that she would sleep with her husband. And some women did. Sexual liaisons between master and servant ranged from genuine relationships of affection to what are better described as cases of rape, but veered mostly toward the latter. Sometimes such encounters took place in the servant's back room, sometimes in the main house, and there, it seems, predominantly in the worker's spaces such as the kitchen, laundry room, and pantry. There, after all, the master could be most assured of privacy from the rest of his family.

For a woman, having sex with her boss might provide some sense of power, but my interviews with domestic workers whose friends had had sexual relations with their employers—for no one would themselves admit to such relations—suggest that they mostly found these affairs shameful and degrading. If, in the words of so many who were employed in the kitchens, being a domestic worker amounted to being a slave, there was little freedom to resist such encounters. When employers violated what lit-

tle space in the house one could reasonably claim as one's own, they turned cruelly those few rooms that otherwise operated as safe havens into little prisons.

As whites saw it, they could not relax house rules without undermining their own, increasingly tenuous positions in the house and in the world. African women could not accept house rules without surrendering their self-respect. Both sides had much to lose, and as a result, many whites and their workers resorted to a high-stakes game of sneaking, snooping, hiding, and watching one another's behaviors and whereabouts. As white house inhabitants sought to situate themselves with respect to the spaces and things around them, and found they could do so only in the context of opposing claims, the house, with its contents, became not just the site but itself the object of some of the most bitter and heartfelt racial negotiations of the apartheid era.

SIX

From Homes with Apartheid

IMAGINE A MIDDLE-CLASS HOUSE in the Northern Suburbs in the 1960s. Place nothing extraordinary in the scene, no unusual architectural features or exotic pets or idiosyncratic art hanging on the walls. The house can be either one-story or two-, on perhaps a quarter-acre lot that has a well-tended flower garden in the front, a one-car garage at the side, next to the domestic worker's room, and an above-ground swimming pool in the back. A large sliding-glass door connects the family room to the backyard, and from our vantage point we can see most of that room, the kitchen beyond it, and much of the yard as well. As luck would have it, at the moment the entire family and the worker are at home. By observing their activities, their interactions with the home and one another, we can glean some understanding of how various residents might collectively contribute to building a multilayered landscape within a given property and beyond it.

Because the father is present, we can assume it is a weekend afternoon, and because the boys are playing in the pool, it is likely summer. The house appears midcentury new, judging from the absence of any detailing on the ceiling or moldings, the wall of sliding-glass doors leading outside, and the kitchen opening directly into the family room. Its furnishings are stylish. Low armchairs with sleek lines, matching coffee table, portable record player, and a shiny new car reinforce this image, as do the built-in cabinets and tiled wall in the kitchen. Given the spate of consumption that

coincided with South Africa's growing economy during this period, homes filled with such items would have been unremarkable among this class of whites.

Several other details also mark this as a middle-class home that supported a comfortable lifestyle: the pet cat, the fish bowl, the swimming pool, art on the walls, books in the credenza, and matching canisters full of pantry items. In fact, each of the family members is engaged in an activity that locates this household squarely within a normative middle-class South African urban lifestyle. The eldest daughter, lying on the family room floor, is studying, probably for either high school or university courses. University education was the preserve of the elite, and the fact that her family can afford the tuition and do without her contribution to the family income is one indicator of their wealth. Even if she is in high school still, she appears to be a senior student and so formed part of the minority of scholars nationwide, if we consider both white and nonwhite populations, who were able to matriculate.

The mother sits outside in a lawn chair having tea. Afternoon tea was an English custom, and its observance distinguished households that could afford and had the freedom to take time away from labor for refreshment and socializing. Two cups and saucers—not mugs—on the small round table suggest that the father has either recently finished his tea, or that a friend has come and gone, and the teapot and creamer suggest the leisure of ceremonial serving and pouring and the time for multiple cups. The woman of the house reads a newspaper, and a pile of magazines lies beside her, hinting that she has been able to spend some time relaxing in the sun with light, recreational fare.

Father shines his car while smoking a pipe. It may have been that he previously washed it with the hose that the boys now use to spray themselves, but it is unlikely that a middle-class white man, unless a car buff, would wash his own car. Even if he did not have a gardener to do the job for him, male African day labor was readily available for such tasks. In any case, his white shirt and pipe suggest that he is engaged in a hobby of love, not a chore.

The boys play in the pool. Most suburban yards were large enough that they could easily support laughing boys waving water hoses, fathers waxing cars, and mothers quietly reading, without one set of activities disturbing

the other. The youngsters are not engaged in household tasks, since yard work would likely be taken care of by a gardener and indoor responsibilities, of course, by the female domestic worker. We can see her through the open kitchen door.

The female domestic wears a plain dress covered with a matching cap and apron set. She is, not surprisingly, the only nonwhite person in the scene. On a weekend afternoon when everyone else is engaged in recreational activities—even the student manages to listen to music and eat cake while studying—she works. It makes sense to imagine her in the kitchen, since that is the room in which workers spent most of their time.

While the kitchen could be a lonely place for workers, let's not imagine her there by herself just now. The youngest child, a girl, keeps her company, and together they are preparing a cake. The girl appears to be helping her nanny, rather than simply running into the room for a taste of the batter, since she wears an apron, which is much too large for her. Her participation in such household activities would not have been considered beneath her position. White women, even those with full-time help, were expected to learn the basics of baking and cooking, and the child's desire to "assist" nanny would probably have been taken as affecting and cute.

Informed imaginings allow us to speculate further. What sounds would a scene like this produce? The occasional shouts of the boys would figure prominently, as would the music from the turntable, probably playing a foreign singer. Elvis Presley? The Beatles? The scholar might remonstrate softly with the cat as it strolled over her papers, the father hum a favorite tune between his teeth. In the kitchen, the worker is probably giving instructions to the small girl and answering her barrage of "whys" and "how comes."

If the telephone rings, the young woman, if she has any consideration for the worker, is likely to answer it. She will appreciate that the domestic will not want to leave the little girl unattended on a tall kitchen stool and that her hands are probably covered in flour. At any rate, the phone is unlikely to be in the kitchen, as that would be an inconvenient spot for family members to take their calls. Accordingly, the student is probably the closest person to the phone and, if she is a typical teenager, probably assumes that the call is for her anyway.

A visitor would bring different responses, depending on the door at

which he or she appears. A white adult guest would park in front of the house, walk up the path, and ring the front doorbell. A family member might respond to the bell if they see the worker otherwise occupied, since the caller is likely to be a family friend or business caller. Africans and other nonwhites were expected to knock at the back door. On a Saturday afternoon, an interruption from that part of the house was likely to be a work seeker or deliveryman. A servant could handle such matters. Besides, the back door—as opposed to the side sliding doors—would be located in the kitchen, and so she would have easiest access to it.

Children's friends, if well-known to the family, might ride their bikes right into the yard and announce their presence in that way. In a house like this one, if no one was about, they would be more likely to put their heads in at the open sliding doors and shout than to venture around to the kitchen door, where they knew there was only the domestic working. The sliding doors operated as the informal entrance of the family and those close to its members, and the rear entrance, much as in an apartment building, was for Africans and tradespeople.

There might be conversation as well. Requests from family members for service would likely be heard throughout the afternoon. "Flora, will you please bring me another soda pop?" was likely to be met with a disapproving look from the mother, who would instruct her daughter to get up and help herself. However, if madam required another pot of tea, she would probably acquire it by asking the same young woman to please instruct Flora that she was needed on the terrace. Father might have forgotten his tobacco in his study desk drawer. In that case, the worker might beseech the littlest daughter to be an angel and run and give Daddy what he was calling for. "Will you please—," "I hate to bother you again, but—," and "My girl, just one more cup, please" were likely to punctuate the afternoon and keep the worker on her toes.

What might these various characters be thinking as they engaged in their respective activities? What would be their feelings of connection to the places where they entertained themselves? We can gather some of this from the nature of their activities. The three oldest children engage in behaviors that carry high potential for accidents or mishaps. Water might land on the newly polished car. Horseplay could overturn the pool and flood an area of the garden. Inside, soda pop could spill on the wall-to-wall

carpeting or crumbs fall into its nap. Yet they carry on with these activities, apparently unrestricted by their parents. The presence of domestic workers allowed children to take much of the risk factor out of their consideration of what they did. After all, if a mess was made, the worker would clean it up. As Barbara Ehrenreich argues, growing up in a servant economy produces in children a sense of "a certain magical weightlessness and immateriality. . . . You drop the socks, knowing they will eventually levitate, laundered and folded, back to their normal dwelling place. The result is a kind of virtual existence, in which the trail of litter that follows you seems to evaporate all by itself."[1]

While this is the children's home, they know it at a certain level only, as actors who move through and have freedom within these spaces, but not as caretakers of its floors, walls, and windows. For them, it serves as a container of their activities. They are players on a set that accommodates their routines. If it does not, they are reasonably free to alter the set as they see fit. However, they are divorced from the physical shell. It may be too strong to argue, as Ehrenreich does, that this breeds callousness and solipsism.[2] No doubt, though, they experience a degree of disconnect among their bodies, their surroundings, and the results of their actions, that will result over many years in difficulty in seeing and calculating the physical repercussions of one's acts and others'. When this young woman rises, for instance, we can imagine that if she leaves any crumbs on the floor, she will not notice them.

Whites were not without opportunities to develop appreciation for their environments. A well-educated person could discern the difference between cashmere and its imitations; choose a good bottle of wine; and identify teak, cedar, and yellowwood. This young lady might not see her crumbs, but she could probably describe in some detail the oil painting on the wall behind her and knows the name of its artist. She could identify the species of fish in the tank and explain their natural habitats as well. She might even have responsibility for feeding the fish. However, what she knew and saw around her were the things she had been trained to see and that established her as a person of a particular class. They were facts that called for no response, for no raising of the arms and pushing back of the sleeves. She regarded her surroundings and enjoyed them, and they presented themselves to her for her pleasure.

The father, alone among the whites in this drawing, is engaged in activity that provides tactile engagement and care for his environment. Even he, though, approaches his task more like a connoisseur than a laborer. We can imagine his satisfaction in reacquainting his eye and hand with the lines and curves of his automobile, in erasing unwanted marks from the paint, shining the chrome, and polishing the leather seats. There is a joy in physically maintaining the things we love. Indeed, one way of expressing attachment is to "care for" a thing or person. The mother might have a similar relationship with the corner of the garden in which her favorite rosebushes stand. We can easily imagine her spending hours pruning, tying them back, weeding, and even talking to them. She might know each plant by heart and be able to spot at a glance a new bud or diseased leaf. It is highly unlikely, though, that either parent exercised the same degree of attachment to the upkeep and maintenance of the house and its furnishings. The only person who regularly laundered the drapes, dusted the countertops, washed the floors, vacuumed the carpet, and cleaned the sofa did so with little if any affection toward the objects of her labor. The worker would not know a Turner from a Picasso, appreciate that the tea set had been the wedding gift of an old friend, or care that the cabinet had been bought on installment and was not yet paid for. But she saw the tears, nicks, stains, and scratches in them, and put her back as a matter of course into fixing such things, so that her employers might continue to enjoy them.

Not only do the spaces of this house contain, at the moment we are imagining, layers of different experiences and different views, but the nature and composition of such layers are likely to change over the course of a day. After the cake is in the oven, for instance, the worker might walk from the kitchen door across the den's carpet with the little girl in hand. They will chatter loudly and attract quite consciously the attention and delight of madam and the older daughter. Alternatively, the worker might cross the same path with an empty tray on which she plans to quietly place used plates, cups, and saucers. She will try to make little noise, to avoid interrupting the readers' concentration. If the two white women notice her, they may pretend not to, not from impoliteness, but simply to let her get on with her work.

Later in the evening, as the family sits at dinner in the dining room on

the other side of the hall, the worker might return with a vacuum cleaner and tidy the room more thoroughly. She can pull herself taller now, as her visual presence threatens no one in an empty room, but she will continue to make an effort not to disturb the white inhabitants by making unnecessary noise. The following day, when she is alone in the house, she may take her tea on the sofa and raise her feet onto the coffee table.

Awareness of a worker's different ways of inhabiting a single room makes us sensitive to the fact that there are many ways of traveling across the earth, of taking up space. We do not always meet each other squarely. People move not as pieces on a flat grid but, rather, irregularly—floating, oozing, slinking, marching, prancing, hiding, and sloughing their ways through the landscape. Their respective manners of moving and being are, among other things, functions of their relationships to one another and to the particular spaces in which they find themselves. They point to the unevenness of the landscape itself and the necessity of figuratively squinting and peering around corners to discern its use and significance.

What people see in their environments reflects their modes of engagement with them. Could the whites step out of time and gaze into the scene we are examining, they might see in it a naughty cat, a plant that needs watering, a lost record hiding under the sofa, photos of a favorite cousin, and room for another figurine on the coffee table. Their description of these rooms would reveal them as surveyors of the domain. The worker would notice other things. Her eye was attuned to objects that required care and, especially, situations that called for her hands and back. In looking at a scene like this, she would project into the future. She would predict where she would be needed and what she would be expected to do.

The rag, after father finished with his waxing, would have to be picked up from where he was likely to leave it on the terrace and put away with other cleaning supplies. If he wanted to return the car to the garage, he would ask the worker to open the door for him as he drove in and then to close it afterward. She might check the terrace floor, after the car had been removed, for any signs of oil to be scrubbed away.

The hose would have to be put back and any other items the boys disturbed during their play, like balls or pool toys, restored to their proper places. The housewife would rise from her tea when she was ready to move on to her next activity, perhaps a bit of shopping with her daughter or

visiting a friend, and leave the cups and magazines where they lay. The worker would bring a tray from the kitchen and collect the dirty items and return them to be washed. She would pile the magazines and find a place for them in the bookshelf or on the coffee table. If the chair and table outside needed to be rearranged, she would carry them to their preferred places.

When the scholar rose, she was likely to place her empty bottle, plate, and apple core on the coffee table and carry her paper and books back to her room. There would be records to put away, then, and the worker would pick up the plate and make sure it had not left a mark on the table underneath it. She would check for crumbs and if she found any either vacuum them up or, if that technology were unavailable to her, use a hand broom.

This sort of activity might be boring to the little girl, who was likely to find washing dishes and sweeping less interesting than baking a cake. She might run and join her sister in her bedroom or beg her brothers to be included in their next game. In two hours' time, then, this scene might contain only the worker, walking back and forth, collecting items to be cleaned, restoring things to their places, stooping and lifting, perhaps humming softly to herself.

What might most strike a family member looking upon this scene, though, could well be neither the house nor its furnishings, but the people depicted therein. Whites at home could look about them and see their families, the people upon whom they could, one hopes, call upon for material and emotional support and to whom they could complain about others they encountered "out there" in the wider world. For the worker, though, this scene represented the wider world, or some version of it. She beheld an affectionate girl whom she would gladly go out of her way to please and entertain, two boys whom she had also raised but was beginning to avoid because of their growing rudeness toward her, a mother who was easy enough to get along with in general but needed to be avoided after fights with her husband and whenever she started complaining about her in-laws, a spoiled and selfish daughter, and a man who treated her respectfully enough but refused to consider a raise. She also saw herself in relation to them, a person whom they often claimed to love but who, she never let herself forget, could be dismissed at a moment's notice. She was not one of

them, certainly not part of the family, and formed only an occasional part of the circle of love that they wrapped around one another.

If she had her own children, she might think of them when she saw her white charges. Perhaps her daughter was the same age as the scholar. If so, she had almost certainly by now stopped her own education to start work. Her mother's main concern might be that she not follow her to the city, but stay in the rural areas where morals were stricter and she was less likely to fall into trouble, including becoming pregnant. If the worker had any children who were still in school, fees and books paid for largely by her monthly remittances back to her own parents, she might become cross when she saw the white boys not taking their studies seriously, considering how her own children had to walk miles each day to get an education. Or she might be envious at the thought that white education was free, provided by the government for all children until the age of sixteen, while she had to pay for her children's from her meager salary.

We can enlarge the picture. The white family members could look over the back hedge and see the Barrys' and Forests' houses. Father wished that the latter would take better care maintaining their garden, and the boys would wonder if Jimmy and Frank were home and if they might come out to play. A worker might look in the same direction and see the back gate through which she expected her boyfriend to pass in a few hours time. She would have to remember to oil it later, to stop its creaking hinges, and to make sure that she pulled the drapes that provided too clear a view into the backyard. She knew that the tall hedges would hide him until she could send the right signal, a double flash from the kitchen light, visible from the rear of the house, which would indicate to him that it was safe to sneak onto the property. Beyond that gate, she knew, he was wandering now, having no job to attend on a Saturday, and her heart went out to where he might be waiting for the appointed time, hoping he was safe.

The existence of multiple perspectives does not suggest clean division into "African" and "white" spheres. While whites and Africans did have different social, visual, and emotional experiences on suburban properties, this produced a complex whole, not a collection of cleanly and neatly delineated parts. People shared one another's worlds and in so doing fused them together. For instance, the worker described above is engaged now

in genuine and affectionate interaction with the smallest child. They are present to each other as two individuals, each loved by the other and each recognizing the space that the other fills. This will not last, though, and in a few hours' time the worker may to this same little girl be barely noticeable as she serves her dinner plate. The worker will slip in and out of whites' fields of vision and awareness all day, alternating between states of virtual invisibility, to being the most important and dear feature in a little girl's eyes, and occupying various positions in between.

After pulling apart the layers of behavior and perception that constitute any given site, then, it is good to try to see the whole or, at least, to sketch its complexity. This means that our journey through the Northern Suburbs is not complete with a fine-grained analysis of the nooks and corners of the houses and yards. We have to come up from under the beds, close the lids of the hampers, and stop peering in the bushes and try to bring back into focus whole neighborhoods. What do we see that we did not see before?

To start, where we might have perceived white neighborhoods within a white city, we now recognize these places to have been highly integrated. What we might previously have seen as domestic zones now contain mixed uses. Middle-class suburbia, the supposed fount of white domesticity, also served as employment center, transit stop, hiding place, and police raiding ground. Given all the activity that we know was centered in the backyard, it is no longer clear what should be considered the "front" of a house or street. Houses and apartments no longer appear as settings of serene and gracious family living, but simultaneously as sites of race and class conflict and ideological struggle.

The back rooms in each yard, once we pull our lens further back, do not correspond neatly to the houses on whose property they sit. Some workers took their meals in neighboring yards where more generous food was offered. Others slept in their friends' beds where they could have greater comfort. Many rooms accommodated men, women, and children who had no connection to the main house but that they partook of leftovers from its kitchen. The streets and sidewalks that supposedly marked boundaries and paths, we now know, imposed only a partial order on these districts. Other lines of communication and travel existed beyond these. Spaces between bushes and back alleys assume a new significance, and we can trace

FIGURE 35. Houses and back rooms cling to the hills throughout the Northern
Suburbs. (Photograph by the author)

routes along them with our eyes that shadow the larger network of paved
by-ways. New details stand out—the servants' entrance to apartment
buildings, the paths between back room and kitchen, black bus stops,
curbs that serve as seats, and public toilets that doubled as beds.

There is a saying popular in South Africa: *umuntu ngumuntu ngabantu.*
Translated from the Zulu, it means, roughly, that a person is a person
by virtue of her connections to other people. The same might be said of
places. All sites are tied to other sites through acts of perception and pat-
terns of use. If our reading of the Northern Suburbs is to be complete, it
must include identifying and deciphering not only patterns that existed
within the suburbs, but also the overlapping sets of external relations that
created and sustained them. So we broaden our gaze. The names of the
various suburbs, we note, reveal whites' sense of connection to the British
Isles—Killarney, Montgomery Park, Saxonwold, and Blairgowrie—and
house and landscape design reinforces this impression, for their houses re-
flect historical and contemporary North American and Western European
domestic architecture traditions. The people who inhabited them called

themselves European, and many carried dual passports, available through family connections.

Back rooms and rooftop rooms were part of the same design tradition, and accordingly, they resembled, on the outside, tiny country cottages in England, Ireland, or Massachusetts. However, the women who inhabited them traced no personal connections to the West. Very few considered the Witwatersrand home either, though it had once held a small indigenous population. Instead, workers belonged to peoples and lands further afield, but still well within the subcontinent. They traced their roots to townships and locations throughout South Africa; African homesteads on white farms; African reserves; and neighboring territories like Mozambique, Swaziland, and Rhodesia. These ties, never far from women's hearts or minds, grew in importance as they contemplated retirement for, after all, they could not remain in the back rooms forever. Retired domestics were expected to move out to make room for new workers. For many, retirement represented a new set of challenges.

Some workers had met and married location men during their years in Johannesburg, and this qualified them for housing in Soweto or Alexandra. These three- and four-room brick houses provided workers a measure of independence and security, even if they were able to visit them only once or twice a month. However, by law, Africans had to vacate their township houses once the male heads-of-household stopped working, so a woman could not count on long-term residence there. Many women with township rights did not want to stay anyway. Urban African areas never lost their aura of danger for many migrant women. Several women I interviewed in the 1990s expressed surprise that I knew Soweto so well, as they themselves never ventured there. Kagiso, for instance, married a Soweto resident in 1965 but decided not to try to stay in the township after his death in 1970. She objected to the barking dogs, the fighting in the streets, and the long distances she had to travel to visit loved ones. In Soweto, she said, "You take buses and taxis to go see your family. You don't stay together." In Soweto, too, one had to pay rent, while rural lands were presented freely by the chief. "I'm from homelands," Kagiso said simply. She vacated her township house, sent the furniture back to the homelands, and got another live-in domestic job.[3]

Nakopele also married a township man. Her husband lived in their

Soweto house while she slept in her employer's backyard in Johannesburg. "Home," though, was neither of those places. She built a house in rural Zululand and purchased furniture periodically that she sent there, with the intention of following upon her retirement.[4]

Most workers intended to return to the districts from which they had come. Rifts that might have been precipitated by their original, unapproved flights to the city were usually long healed. Parents who had frowned on a daughter's earlier unbecoming assertions of independence had come to see that, for many women, employment in the kitchens of Johannesburg was an economic necessity. Children who had cried to wake up one morning on the floor of the *rondavel* and find their mother gone had learned over the years to understand why she left and had moved beyond childhood resentment to, often, respect for her choices.

Domestic workers had many reasons to leave the city once their working years were finished. Apartheid legislation, of course, required that a woman return to her designated homeland when she was no longer employed in Johannesburg, but that in itself was insufficient reason to pack one's bags. As we have seen, few people based their life decisions solely on South African legislators' pronouncements. Had a woman wanted to stay in Johannesburg, she would have found a way. However, few sought such opportunities. As one worker explained, women "did not come to the city to live, but to work."[5] When the work was finished, it was time to leave. Indeed, most were eager to get out.

Johannesburg was the largest city in Southern Africa and a busy, vibrant, crowded, polluted place. Prices were high, and for many workers on meager or nonexistent pensions, life would be less expensive in the rural areas. Many never became accustomed, anyway, to the necessity of having constantly to consume in Johannesburg. "You have to pay even to use the toilet," one complained, "where back home we just dug a hole."[6] Fiscal prudence argued strongly for a return to a place where a person could grow her own vegetables and raise her own meat.

In addition, Johannesburg was unlikely to hold particularly fond memories for the women. They disliked their work, resented their lodgings, and, by the time they retired, were often emotionally exhausted by the demands of their caregiver roles. Many attributed the aches in their bones

and stiffness in their backs to many years of long manual labor. The associations they had with the city were largely negative, and the countryside beckoned as a forgiving place of rest.

Possibly the rural areas' strongest attractions, though, were the people closest to a worker's heart. That remains true today. Sinethemba moved to Johannesburg in 1949, but her parents continue to live in the region where she was born, and so that remains home: "When it's bad here and it's time to run, I know where to go."[7] When Sibongile goes to her children's village on visits, people often ask who she is. She has lived in Johannesburg for almost thirty-five years, and many of the younger generation do not know her. But the older ones tell them, "That's Thokozile's mother," and she immediately earns a place in the social order.[8] In Johannesburg she is just another anonymous and interchangeable worker in a depersonalizing cotton uniform. At home she becomes a village mother.

When they returned to the rural areas, whether to their parents', husband's, children's, grandchildren's, or, in a few cases, their own homes, often paid for with funds that conscientious employers put aside expressly for the purpose, many took a bit of Johannesburg back with them. The layout and material culture of white suburban houses, which in the beginning seemed so foreign and strange to the women, after some time developed certain attractions. "European" things had status appeal in South Africa's racialized hierarchy of values, as did "white" ways of doing things. While neighbors might exercise social control by calling a woman whose house outdid the others in approximation of the fashionable white standards of decor a "madam," these piques of jealousy stopped few women from acquiring what they could for their houses back home and instructing husbands, parents, and children how to arrange and use the new things.

"You get ideas from the white people," explained one worker, who over the years bought both a sofa and a dining room suite for her rural home, although she knew her family would initially find the idea of sitting around a table in matching chairs to eat a meal a strange one.[9] On the roofs of taxis and buses headed back to the former homelands on any given weekend, but especially at month's end, tables, chairs, and beds lay attached by ropes, to be delivered to country households.

Workers were usually more discriminating in their adaptation of white

decor than those whites who tried to exploit a growing market gave them credit for being. A contemporary marketing textbook noted that "the African deliberately imitates the buying habits of whites because he thinks they are superior."[10] To the contrary, Africans appreciated only that many whites were wealthy. They observed carefully their habits, but restricted themselves to borrowing those elements that complimented their own ideals of what constituted a clean, healthy, and attractive environment. For instance, they observed the plants and flowers that their employers kept inside the house and often tended them, but were not keen on the idea of putting living things inside their own homes. That practice would have violated the African convention of treating one's home as a refuge from nature, not an extension of it. Employers often provided their workers with clippings of house plants. They placed them outside their doors, and when they returned home on holiday, they transplanted the cuttings into their outdoor gardens.[11]

Chipiwa did not like the narrow passages that connected bedrooms in white homes because she suspected they would make it more difficult to carry a coffin out in the event of a death, as African custom demanded.[12] Beds were an improvement, especially for elderly parents, over sleeping on mats on the floor. But the separate single beds popular among white couples in the 1960s compromised African understandings of marital obligations. Many wondered at white people's odd ways and opted for double beds instead. Most approved of technologies like indoor plumbing and electricity, and some arranged to have such improvements made to their families' homes, where possible, or made a point of installing such conveniences in new places that they built. Thembi had a particularly discerning eye. She saw that material goods were certainly more plentiful in Johannesburg and that whites in particular had many fancy things, but she was not blinded by the flashiness of urban life: "You can just see that they *attract* you, those nice things. But they were not *better.*"[13]

The retirement houses of domestic workers represented the continuation of a centuries'-old process. Beginning with the missionaries who had once lived among them, Africans had been exposed to Western material goods and adopted them for use inside their own homes. From the beginning, some whites looked approvingly on this as a sign of the "civilizing" process, while others read it as a dangerous sign that the natives were for-

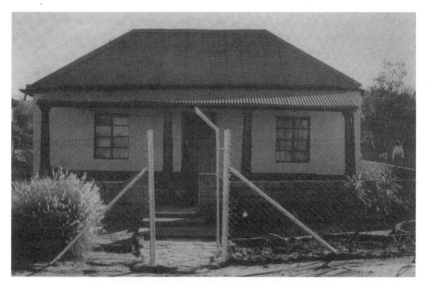

FIGURE 36. This former worker's homeland house in Bophuthatswana is in the vernacular style typical of Johannesburg, constructed of bricks and having a *stoep*, a porch roof supported by columns, and a hipped roof. It bears little resemblance to traditional Tswana dwellings. (Photograph by Santu Mofokeng)

getting their proper places. To yet others, there is a certain poignancy to these places. The "best" house in a village may be furnished with the old throwaways of wealthy Johannesburg families. One suburban white father claimed that the most emotional day of his life was when his children's nanny retired after twenty-five years of service. He loaded her boxes and bags into the family van and drove her some sixty miles to the house in the homelands that she had bought, with his assistance, many years earlier. It was his first visit. When she proudly opened the door to the house that she had been patiently furnishing for decades, he saw with something akin to horror that it was filled with furniture that his family had discarded over the years. His former worker offered him tea and served it to him in one of his own old china cups. He drank, and as he drank he wept.[14]

We can best appreciate the little houses that populate South Africa's rural and small-town landscape not as crude reproductions of the suburban mansions of white Johannesburg, but on their own terms. From years of intimate exposure to suburban white houses, each worker came to her own

conclusions about what was attractive and what ugly, about what would work in her own household, and about which features would help meet the aspirations and interests of her family. No one tried simply to reproduce the house she had once worked in. These are not miniature "white houses"; they are domestic workers' homes.

Workers who labored for years in the houses of others tried to surround themselves with environments of their own making, and they included in and around their houses what they found beautiful, useful, and good. Some objects had happy associations. With others, associations were best forgotten, and they took on new meanings in the new contexts. It is as an assemblage that the pieces, collected gradually over the years, have their strongest meaning. They speak to their owners of a life of struggles well paid off, of good taste and fashion sense acquired in long years of service, of having something tangible to show for the sleepless nights and weary days, and of the satisfaction of leaving a place for one's children.

They differ from white houses, too, in their terms of use. The former worker who lives in her own home can enter through the front door, sit down on the sofa, and raise her feet onto the ottoman. She is not obligated to account for her use of time and so feels no compulsion, unless by force of habit, to rush through these spaces in "busy" mode. Nor must she make herself invisible. Instead, she can assert her presence and control over her domain by lounging on the furniture, speaking loudly, even giving orders to those dependents who might live with her.

It is not the case that there are no layers of use creating divisible layers within these rural retirement homes, only that the former domestic worker is not disadvantaged by them. Perhaps her grandchildren sneak their lovers into the house behind her back, or the daughter-in-law, resentful of being watched as she performs her chores, finds ways of escaping the matriarch's gaze. She may be irritated by their behaviors and find ways of responding to them, but on the whole conducts her daily life on her own terms, much like a white madam, within a home that reflects her person and whose spaces open themselves up to her.

The comparison ends there, however. Unlike her former employer, whose domestic habits were conditioned in large part by the fact of her having to share space with an African, the former worker in her new home has few, if any, racial or class dynamics to negotiate. Families, of course,

FIGURE 37. Another former worker's homeland house, also in Bophuthatswana, contains the same elements as that in figure 36. Note the potted and hanging plants that decorate the front of the house, evoking a rooftop hallway. The detached room to the right, though it resembles a servant's back room, is almost certainly sleeping quarters, perhaps for a married child, according to traditions. (Photograph by Santu Mofokeng)

have their own tensions, and the outside world cannot be left on the doorstep of any home. But to the extent that the political becomes personal in domestic workers' homes, it is a different set of politics than that of the city, infused with a different set of values and interests. These small country homes, then, are no less complex spatially than city mansions. However, for no inhabitant is the color of his or her skin a determinant of rights or privileges of use.

Perhaps most important for these women, these houses represent places from which they cannot be removed. Whether they retire to property purchased from their earnings or family land protected by customary law, it is theirs. After years of living in another person's backyard or on the rooftop, dependent entirely on another's inclination to suffer their presence, having a home of one's own on land that cannot be taken away is an almost indescribable pleasure. "You must have a place where you can be settled and happy and do whatever you like to do," insisted one worker.[15] Another reflected on the sense of continuity this can provide and the importance,

especially in African religious traditions, of this connection to place: "Our graves are at the back of the house. My father's mother is buried there. His three brothers are buried there. Our cousins are there. Our *amadhlozi* are there. Sometimes, when we are worried or we need help, we go to our graves."[16]

During my discussion with her on the rooftop overlooking Johannesburg's skyline, Mkhateko anticipated with great delight her eventual retirement. "You know, this room"—she gestured with her arm to draw my attention to the small, cramped space in which we were seated—"is only when you are working. When you are finished with the job, you out of the room. . . . It's just a sleeping place." She explained that she visits as often as she can the house she built in the northern Transvaal, where her parents live: "It's sad to be living in a small room like this all your life." We both glanced at the paint tins that supported the legs of her narrow iron bed, the piles of stuffed bags on top of her plywood board wardrobe, and her pillowcase covered with beautiful needlework that spoke to many lonely hours. Her room was dim and small. Then her face broke into a smile. "When I go home, I feel really pleased. I have a big yard and trees, and I go and walk outside."[17]

Notes

A *note on interview sources:* Because I assured my informants of anonymity, I identify them by number only. Please refer to the bibliography for a complete listing.

INTRODUCTION

1. See, e.g., Rose, "Geography as a Science of Observation," and Deutsche, "Boys Town," on geographers' gaze; Bachelard, *Poetics of Space;* and Foucault, on Bachelard, in "On Other Spaces." For examples of treatments of multiple landscapes or multidimensional spaces, though they are called by various terms, see Rhys, "Traveling through the Landscape," in *Transformation of Virginia,* 52–57; Upton, "White and Black Landscapes"; Camp, *Closer to Freedom,* 6–7; Vlach, "The Plantation Landscape," in *Back of the Big House,* 1–17.

2. For new scholarship on American suburbs, see Kruse and Sugrue, *New Suburban History;* Nicolaides and Wiese, *Suburb Reader.*

3. Drury, "Very Strange Society," 6.

4. Swaisland, *Servants and Gentlewomen to the Golden Land;* "Dadge," n.d., n.p, Manuscript Collection, Strange Library.

5. House plans suggest such arrangements, as does the *Report of the Commission . . . into Assaults on Women,* 28.

6. *Report of the Johannesburg Housing Commission.*

7. House plans suggest such arrangements, as do contemporary accounts; see, e.g., Flora Behrman, "My Fifty-Odd Years in Johannesburg, 1906–1960," n.d., 13, Manuscript Collection, Strange Library; Aldehlm Slater, "The Recollections of a Johannesburg Man," n.d., MSA 446, 8, Manuscript Collection, Strange Library. See also Van Onselen, "Witches of Suburbia," 32 n. 16, citing contemporary newspaper descriptions.

8. Van Onselen, "Witches of Suburbia"; *Report of the Commission . . . into Assaults on Women,* 26–27.

9. Swaisland, *Servants and Gentlewomen to the Golden Land,* 96.

10. Cited in Gaitskell, "'Christian Compounds for Girls,'" 45.

11. Van Onselen, "Witches of Suburbia," 17.

12. *Population of South Africa, 1904–1970*, 19, 196, 237, 348. Indian population figures from the census by the Gezondheids Committee of Johannesburg are cited in Dinath, "Asiatic Population in the Transvaal."

13. "Dadge"; "Lady Pioneers: Life in the Eighties," *Rand Daily Mail*, 22 Sept. 1906; Gaitskell et al., "Class, Race and Gender," 100.

14. Minutes of Meeting of Special Committee Appointed to Deal with Housing of Natives, 16 Mar. 1916, MJB 1/13/12, 2, Pretoria Central Archives; *Report of the Johannesburg Housing Commission* (esp. the evidence tendered on 2, 7, 42).

15. Town Planning Scheme No. 1, 1946, City of Johannesburg, Clause 16 (b) (i), (iii). This scheme remained in effect until 1979.

16. I relied heavily on the literature on oral historical methods and excellent examples of such work. See esp. Grele, *Envelopes of Sound*; Gluck and Patai, *Women's Words*; Perks and Thomson, *Oral History Reader*; Bozzoli, "Introduction: Oral History, Consciousness, and Gender," in *Women of Phokeng*. Those works (not necessarily histories) based on interviews that I took as models of sensitivity toward both fieldwork and informants' words include L. B. Rubin, *Worlds of Pain*; Sennett and Cobb, *Hidden Injuries of Class*; Abu-Lughod, *Writing Women's Worlds*; Oakley, *Sociology of Housework*; Scheper-Hughes, *Death without Weeping*; Van Onselen, *Seed Is Mine*; Wolf, *Factory Daughters*; G. Clark, *Onions Are My Husband*.

17. J. Scott, *Weapons of the Weak*; M. Kaplan, *Between Dignity and Despair*, 34.

18. D. M. Smith, "Introduction," 1.

19. See Hollander and Einwohner, "Conceptualizing Resistance."

20. Kelley, "We Are Not What We Seem," 112.

21. Collins, *Fighting Words*, 5–8.

22. Nussbaum, *Cultivating Humanity*.

23. Hollander and Einwohner, "Conceptualizing Resistance."

1. GETTING TO KNOW THE CORNERS

1. 13, 18 July 1995.

2. On early migrancy and urbanization patterns in the Transvaal, see Mayer, *Townsmen or Tribesmen*; Schapera, *Migrant Labour and Tribal Life*; Bonner, "African Urbanisation on the Rand."

3. 20, 19 July 1995.

4. 68, 21 Jan. 1998, 28 Jan. 1998.

5. Yawich, "African Female Employment and Influx Control," 211–12.

6. Christopher, *Atlas of Apartheid*, 35, citing 1960 figures.

7. Platzky and Walker, *Surplus People*, is the best contemporary source of information about homeland conditions.

8. 27, 22 July 1995.

9. 43, 25 July 1996.

10. 38, 29 June 1996, 13 Feb. 1998.

11. Van der Vleit, "Black Marriage," 133.

12. Walker, "Gender and the Development of the Migrant Labour System," 191–94; Van der Vleit, "Black Marriage," 66–67; Ramphele and Boonzaier, "Position of African Women," 166; Preston-Whyte, "Between Two Worlds," 48–62; Eales; "Gender Politics," 26–28, 182–83; Longmore, *Dispossessed*, esp. 69–70, 73–74, 84, 140; Janisch, "Some Administrative Aspects of Native Marriage Problems," 3–4.

13. 38, 29 June 1996, 13 Feb. 1998.

14. 41, 6 July 1996.

15. 63, 13 Jan. 1998.

16. 16, 19 July 1995.

17. Pamphlet quoted by H. F. Verwoerd in his speech to Parliament, "The Policy of Apartheid," 3 Sept. 1948, cited in Pelzer, *Verwoerd Speaks*, 9.

18. Posel, *Making of Apartheid*.

19. Broome, "Individual and the Community," 170.

20. Republic of South Africa, Bureau of Statistics, *Population Census 1970*.

21. 39, 29 June 1996.

22. Bozzoli, *Women of Phokeng*, 94.

23. 79, 28 Feb. 1998.

24. Sharon MacKay, *Holiday* 13, no. 1 (1953): 11.

25. Lipworth, "Application of Concepts of Urban Morphology," 45–50.

26. Park, *Race and Culture*; Simmel, "Metropolis and Mental Life"; Grossman, *Land of Hope*; Griffin, "Who Set You Flowing?"; Lemann, *Promised Land*.

27. 39, 29 June 1996.

28. 6, 15 July 1995.

29. Epsie Mtomkulu Zondo, in Suzanne Gordon, *Talent for Tomorrow*, 23.

30. 16, 19 July 1995.

31. 26, 22 July 1995.

32. 6, 15 July 1995.

33. *Star*, 18 June 1963; *Rand Daily Mail*, 18 June 1963.

34. 17, 19 July 1995.

35. Magona, *To My Children's Children*, 123.

36. 27, 22 July 1995.

37. Clark-Lewis, *Living In, Living Out*, 140–45.

38. S. Kaplan, "Cognitive Maps in Perception and Thought"; S. Kaplan and Kaplan, *Cognition and Environment*, esp. 77.

39. 6, 15 July 1995.

40. 39, 29 June 1996.

41. Anonymous, *Street Sheet*, Johannesburg, Dec. 1997.

42. 39, 29 June 1996.

43. Ibid.

44. For comparative examples of established city folks helping newcomers to

adapt to urban ways, there is a sizeable literature, but see esp. Borchert, *Alley Life in Washington*; Stack, *All Our Kin*.

45. 41, 6 July 1996.

46. 39, 29 June 1996.

47. 41, 6 July 1996.

48. Kagan, "African Settlements," 13, citing Report of the Director of Census, 1896.

49. Cock, *Maids and Madams*, 145.

50. 5, 13 July 1995.

51. Goffman, *Presentation of Self in Everyday Life*.

52. 5, 13 July 1995 (emphasis mine).

2. THE TEMPO OF KITCHEN LIFE

1. Leah Tutu, in Lipman, *We Make Freedom*, 31.

2. Cock, "Deference and Dependence," 11.

3. Ibid.

4. Ibid.

5. 63, 13 Jan. 1998.

6. Magona, *Living, Loving*, 40.

7. 6, 15 July 1995.

8. 11, 17 July 1995.

9. 32, 25 July 1995.

10. 24, 21 July 1995.

11. 28, 22 July 1995.

12. On marketing to African consumers in the 1960s, see Manoim, "Black Press."

13. Sibongile Mkhabela, in Bonner and Segal, *Soweto: A History*, 60.

14. 7, 15 July 1995.

15. Unnamed source, in Robert Manson Myers, ed., *The Children of Pride: A True Story of Georgia and the Civil War* (New Haven: Yale University Press, 1972), 427, cited in Litwack, *Been in the Storm so Long*, 158.

16. Ezekial Mphahlele, *African Image*, 165. See also 160.

17. 39, 29 June 1996.

18. Unidentified worker, in Cock, *Maids and Madams*, 69.

19. 68, 21 Jan. 1998.

20. Ernestina Mekgwe, in Bozolli, *Women of Phokeng*, 96.

21. On changes to American domestic architecture and new ideas about sanitation and decoration during this period, see Volz, "Modern Look"; Sutherland, "Modernizing Domestic Service"; Wright, "Progressive Housewife and the Bungalow," in *Building the American Dream*; C. E. Clark, "Modernizing the House and

Family"; Richards, *Sanitation in Daily Life*; Talbot, *House Sanitation*; Keeler, *Simple Home*. On declining numbers of servants, see Katzman, *Seven Days a Week*, 228.

22. Cock, *Maids and Madams*, 76.

23. Wilcox, *So You Want a House!* 54.

24. 63, 13 Jan. 1998.

25. Unidentified worker, in Cock, *Maids and Madams*, 24.

26. 16, 19 Aug. 1996.

27. 70, 24 Jan. 1998.

28. 65, 15 Jan. 1998.

29. 63, 13 Jan. 1998.

30. 68, 28 Jan. 1998.

31. Miriam Sindiwe Ngulube, in Suzanne Gordon, *Talent for Tomorrow*, 166.

32. 71, 26 Jan. 1998.

33. Elizabeth Nomkhita Siphika, in Suzanne Gordon, *Talent for Tomorrow*, 251.

34. Unidentified worker, in Cock, *Maids and Madams*, 54.

35. Unidentified worker, in Cock, *Maids and Madams*, 53.

36. Unidentified worker, in Cock, *Maids and Madams*, 27.

37. Unidentified worker, in Cock, *Maids and Madams*, 26.

38. Ngulube, in Suzanne Gordon, *Talent for Tomorrow*, 167.

39. Ibid.

40. 63, 13 Jan. 1998.

41. 68, 28 Jan. 1998.

42. 60, 18 Aug. 1996.

43. Martha Mpelelapi Masina, in Suzanne Gordon, *Talent for Tomorrow*, 91.

44. Unidentified worker, in Cock, *Maids and Madams*, 54.

45. Unidentified worker, in Cock, *Maids and Madams*, 96.

46. Unidentified worker, in Cock, *Maids and Madams*, 18.

47. Es'kia Mphahele, "Mrs. Plum," 34.

48. Ibid., 32–33.

49. Unidentified worker, in Cock, *Maids and Madams*, 20.

50. Magona, *Living, Loving*, 45.

51. Christine Mashadi Kgapola, in Suzanne Gordon, *Talent for Tomorrow*, 218.

52. Thokozile Virginia Mngoma, in Suzanne Gordon, *Talent for Tomorrow*, 98.

53. 6, 15 July 1995.

54. 63, 13 Jan. 1998.

55. Unidentified worker, in Cock, *Maids and Madams*, 20.

56. Ibid., 19.

57. Mngoma, in Suzanne Gordon, *Talent for Tomorrow*, 98.

58. Catherine Kebuile Kelokilwe, in Suzanne Gordon, *Talent for Tomorrow*, 177.

59. Muriel Margaret Stella Mlebuka, in Suzanne Gordon, *Talent for Tomorrow*, 147.

60. 72, 6 Feb. 1998.

61. Unidentified worker, in Cock, *Maids and Madams,* 56.

62. 63, 13 Jan. 1998.

63. Ibid.

64. Eunice Tholakele Dhladhla, in Suzanne Gordon, *Talent for Tomorrow,* 242–43.

65. 1.6 percent of Pretoria domestics used the recreational facilities available in that city's townships. See Kingsley, "Presidential Address."

66. Magona, *To My Children's Children,* 139ff. See Griffin, *"Who Set You Flowing?,"* on "safe places"—sites of sustenance where black women can speak freely.

67. 4, 10 July 1995.

68. 1, 6 July 1995.

69. 40, 6 July 1996.

70. 4, 10 July 1995.

71. Margaret Mazonyeni Sithole, in Suzanne Gordon, *Talent for Tomorrow,* 271.

72. 23, 20 July 1995.

73. 24, 21 July 1995.

74. Kelokilwe, in Suzanne Gordon, *Talent for Tomorrow,* 212–13.

75. 68, 21 Jan. 1998.

76. Ngulube, in Suzanne Gordon, *Talent for Tomorrow,* 167.

77. Mrs. T. P., letter to the editor, *Personality,* 14 Nov. 1963.

78. 63, 13 Jan. 1998.

79. Ibid.

80. Mngoma, in Suzanne Gordon, *Talent for Tomorrow,* 97.

81. Ibid.

82. 23, July 20, 1995.

83. Mlebuka, in Suzanne Gordon, *Talent for Tomorrow,* 146.

84. 78, 28 Feb. 1998.

85. Sipika, in Suzanne Gordon, *Talent for Tomorrow,* 251.

86. 63, 13 Jan. 1998.

87. 75, 14 Feb. 2004.

88. Magona, *Living, Loving,* 56.

89. Rachel Lydia Mdabezitha, in Suzanne Gordon, *Talent for Tomorrow,* 126.

90. Magona, *Living, Loving,* 44.

91. 75, 14 Feb. 2004.

3. CHILDREN AND LEAVING

1. Preston-Whyte, "Between Two Worlds."

2. Magona, *Living, Loving,* 55.

3. 38, 29 June 1996.

4. Unidentified worker, in Jane Barrett et al., *Vukkani Makhosikazi: South African Women Speak* (London: Institute for International Relations, 1985), 28, cited in Wulfsohn, "Impact of the South African Nanny," 26.

5. Unterhalter, "Some Aspects of Family Life," 211 (emphasis mine).

6. Unidentified white mother, in Wulfsohn, "Impact of the South African Nanny," 186.

7. Unidentified white mother, in Wulfsohn, "Impact of the South African Nanny," 186.

8. Account of Victoria Mmamokgadi Mogumuti's life from "You Can't Throw God Away," in Suzanne Gordon, *Talent for Tomorrow*.

9. Ibid., 186–87.

10. Ibid., 188.

11. Ibid., 187.

12. Mlebuka, in Suzanne Gordon, *Talent for Tomorrow*, 143.

13. Suzanne Gordon, *Talent for Tomorrow*, xxiii.

14. Mlebuka, in Suzanne Gordon, *Talent for Tomorrow*, 143.

15. Rachel Lydia Ndabezitha, in Suzanne Gordon, *Talent for Tomorrow*, 121.

16. 55, 8 Aug. 1996.

17. 52, 5 Aug. 1996.

18. Straker, "Violence against Children"; Whisson and Weil, *Domestic Servants*, 46; Bernstein, *For Their Triumphs*, 187; Cock, "Deference and Dependence," 9; Ginsburg, "View from the Back Step."

19. Unidentified white mother, in Wulfsohn, "Impact of the South African Nanny," 170.

20. Nadine Gordimer, in Lipman, *We Make Freedom*, 108–9.

21. Wulfsohn, "Impact of the South African Nanny," 160–87.

22. On the pain some white children felt in breaking with their nannies, see Crapanzano, *Waiting*, 41.

23. Unidentified white mother, in Wulfsohn, "Impact of the South African Nanny," 166.

24. Unidentified white mother, in Wulfsohn, "Impact of the South African Nanny," 167.

25. Unidentified white child, in Wulfsohn, "Impact of the South African Nanny," 168.

26. Tucker, *Telling Memories among Southern Women*, 61.

27. Unidentified worker, in Cock, *Maids and Madams*, 19.

28. Unidentified worker, in Cock, *Maids and Madams*, 54.

29. 39, 29 June 1996.

30. 57, 12 Aug. 1996.

31. Abie Begwapi Socatsha, in Suzanne Gordon, *Talent for Tomorrow*, 133.

32. Unidentified worker, in Cock, *Maids and Madams*, 10.

33. Bertana Malebone Mabena, in Suzanne Gordon, *Talent for Tomorrow*, 149.

34. Unidentified source, in Yawich, "African Female Employment and Influx Control," 298–99.

35. Unidentified source, in Yawich, "African Female Employment and Influx Control," 299.

36. Unidentified source, in Yawich, "African Female Employment and Influx Control," 299.

37. 82, 14 Dec. 2004.

38. Margaret Nomgcibelo Nhlapo, in Suzanne Gordon, *Talent for Tomorrow*, 224.

39. 43, 18 July 1996.

40. Zondo, in Suzanne Gordon, *Talent for Tomorrow*, 24.

41. Socotsha, in Suzanne Gordon, *Talent for Tomorrow*, 137.

42. Ibid., 135–36.

43. Magona, *Living, Loving*, 56

44. Ngulube, in Suzanne Gordon, *Talent for Tomorrow*, 165–6.

45. Kelokilwe, in Suzanne Gordon, *Talent for Tomorrow*, 177.

46. Kgopola, in Suzanne Gordon, *Talent for Tomorrow*, 249.

47. 36, 27 July 1995.

48. 61, 19 Aug. 1996.

49. 38, 29 June 1996.

50. Zondo, in Suzanne Gordon, *Talent for Tomorrow*, 30.

51. 36, 27 July 1995.

52. 22, 19 July 1995.

53. 45, 28 July 1996.

54. 22, 19 July 1995.

55. 55, 8 Aug. 1996.

56. Siphika, in Suzanne Gordon, *Talent for Tomorrow*, 249.

57. 60, 18 Aug. 1996.

58. 51, 5 Aug. 1996.

59. 58, 12 Aug. 1996.

60. Ibid.

61. Mlebuka, in Suzanne Gordon, *Talent for Tomorrow*, 147.

62. Ibid., 144.

63. Dhladhla, in Suzanne Gordon, *Talent for Tomorrow*, 241.

64. Christine Mashadi Kgapola, in Suzanne Gordon, *Talent for Tomorrow*, 211.

65. Sithole, in Suzanne Gordon, *Talent for Tomorrow*, 272.

66. Magona, *Living, Loving*, 48–49.

67. 40, 6 July 1996.

68. Ndabezitha, in Suzanne Gordon, *Talent for Tomorrow*, 119.

69. Ibid.

70. Kgapola, in Suzanne Gordon, *Talent for Tomorrow*, 207–10.

71. Ibid., 208.
72. Ngulube, in Suzanne Gordon, *Talent for Tomorrow*, 169.
73. Tutu, in Lipman, *We Make Freedom*, 31.
74. 23, 20 July 1995.
75. 31, 25 July 1995.
76. 2, 8 July 1995.
77. 16, 19 July 1995.

4. COME IN THE DARK

1. Sue Gordon, *Domestic Workers*, 26.
2. Zondo, in Suzanne Gordon, *Talent for Tomorrow*, 21.
3. 11, 17 July 1995.
4. 12, 17 July 1995.
5. 38, 29 June 1996.
6. 63, 13 Jan. 1998.
7. 23, 20 July 1995.
8. 23, 20 July 1995.
9. 34, 26 July 1995.
10. 22, 19 July 1995.
11. 38, 29 June 1996.
12. Unnamed source, in McNamara, "Social Life, Ethnicity and Conflict," 106.
13. McNamara, "Social Life, Ethnicity and Conflict," 106.
14. Unnamed source, in Van der Vleit, "Black Marriage," 198–99.
15. Longmore, *Dispossessed*, 69.
16. 24, 21 July 1995.
17. 6, 15 July 1995.
18. 23, 20 July 1995.
19. 23, 20 July 1995.
20. 73, 14 Feb. 1998. See also Berger, *Where's the Madam?* 211. The white author of this first-person account of life in the Johannesburg suburbs describes her confusion over her garden boy's request that she present him with one of her old dresses for Christmas.
21. 37, 29 June 1996.
22. Socatsha, in Suzanne Gordon, *Talent for Tomorrow*, 137–38.
23. Whisson and Weil, *Domestic Servants*, 22–23.
24. 12, 17 July 1995.
25. 12, 17 July 1995.
26. 16, 19 July 1995.
27. 40, 6 July 1996.
28. Sithole, in Suzanne Gordon, *Talent for Tomorrow*, 264.
29. Mhlophe, "Toilet," 120–21.

30. Ibid.

31. Mlangeni, "Curtailed Lives." This article cites the recent case of a nine-year-old who fell off a rooftop while playing soccer.

32. 26, 22 July 1995. Other women also said they were aware of accidents and deaths of this nature.

33. 27, 22 July 1995

34. 8, 15 July 1995.

35. 11, 17 July 1995.

36. 26, 22 July 1995.

37. 11, 17 July 1995.

38. 13, 18 July 1995.

39. Dubb, "Impact of the City," 146–47.

40. See, e.g., "Husband's Cruel Trick," *Star,* 7 Nov. 1966; "Divorcees Face Life on Streets," *Star,* 3 Apr. 1966.

41. Mthinkulu, Posel, "Marriage at the Drop of a Hat," 23.

42. Mrs. Z, in Posel, "Marriage at the Drop of a Hat," 23.

43. Janisch, "Some Administrative Aspects of Native Marriage Problems," 4–5.

44. Mapumulo, "Back-Room Love Affairs."

45. 12, 17 July 1995.

46. Unnamed source, in Van der Vleit, "Black Marriage," 193.

47. 36, 27 July 1995.

48. See also Van der Vleit, "Staying Single," which argues that many African women during this period acquired a new sense of freedom and that single womanhood acquired a new respectability (228–47).

49. 68, 28 Jan. 1998.

50. Sithole, in Suzanne Gordon, *Talent for Tomorrow,* 264.

51. Ngulube, in Suzanne Gordon, *Talent for Tomorrow,* 165.

52. 21, 19 July 1995.

53. "Motherless—by Order," *Star,* 12 Feb. 1973.

54. 50, 3 Aug. 1996.

55. 12, 17 July 1995.

56. 56, 12 Aug. 1996.

5. HOUSE RULES

1. Ndabezitha, in Suzanne Gordon, *Talent for Tomorrow,* 119.

2. Clark-Lewis, *Living In, Living Out;* Constable, *Maid to Order in Hong Kong;* Glenn, *Issei, Nisei, War;* Hansen, *Distant Companions;* Chang, *Disposable Domestics;* Rollins, *Between Women,* esp. 201–12; Chaney and Castro, *Muchachas No More;* Romero, *Maid in the USA;* Graham, *House and Street;* Katzman, *Seven Days a Week,* esp. 188; Jones, *Labor of Love;* Palmer, *Domesticity and Dirt;* Tucker, *Telling Memories among Southern Women.*

3. Anonymous housewife, in Cock, *Maids and Madams*, 137.

4. In her study of African American domestics in literature, Harris finds that they, too, experienced the kitchen as "the most comfortable realm" within the white house. See *From Mammies to Militants*, 15.

5. Uniforms served similar purposes elsewhere. See Constable, *Maid to Order in Hong Kong*, 95–96; Clark-Lewis, *Living In, Living Out*, 113–17.

6. Behrman, "My Fifty-Odd Years in Johannesburg," 13.

7. Velma Davis, in Clark-Lewis, *Living In, Living Out*, 114. For other comparative examples of maids' critical responses to uniforms, see Constable, *Maid to Order in Hong Kong*, 95–96; Tucker, *Telling Memories among Southern Women*, 268.

8. Unidentified housewife, in Cock, *Maids and Madams*, 140.

9. Unidentified housewife, in Cock, *Maids and Madams*.

10. Unidentified housewife, in Cock, *Maids and Madams*.

11. See esp. the many interviews cited in Cock, *Maids and Madams*, which provide a strong sense of white people's anxieties over black germs.

12. 23, 20 July 1995.

13. Whisson and Weil, *Domestic Servants*, 22–23; Preston-Whyte, "Race Attitudes and Behaviour," 71–89; Sue Gordon, *Domestic Workers*, 8.

14. Preston-Whyte, "Race Attitudes and Behaviour."

15. Dagut, "Domestic Racial Interaction."

16. See, e.g., Whisson and Weil, *Domestic Servants*, 27; 72, 6 Feb. 1998.

17. On U.S. paternalism, see, e.g. Genovese, *Roll Jordan Roll*, esp. 4–7. For examples of Southerners' beliefs that they made better employers than Northerners, and Black servants' confirmation of this, see Tucker, *Telling Memories among Southern Women*, 13; Rollins, *Between Women*, 219–22.

18. "Yes, But . . . ," letter to the editor, *Femina*, 16 Nov. 1997.

19. "House Proud," letter to the editor, *Femina*, 11 May 1961. But see also a South African's response to such attitudes by Mrs. Winifred Miles ("I am sick of reading articles by immigrants and others on how lazy and work-shy South African women are"), *Personality*, 6 Apr. 1961.

20. 38, Johannesburg, 29 June 1996.

21. Ibid.

22. Ibid.

23. Gordon notes the disagreements among servants about which employers, English, Afrikaners, or Jewish, are best. See Suzanne Gordon, *Talent for Tomorrow*, xii.

24. Mnguma, in Suzanne Gordon, *Talent for Tomorrow*, 97.

25. Socatsha, in Suzanne Gordon, *Talent for Tomorrow*, 133.

26. 58, 12 Aug. 1996.

27. 59, 13 Aug. 1996.

28. Francis, Dugmore, and Rico, *Madam and Eve's Greatest Hits*, 34.

29. On the central role of surveillance in white American homes that employed Black workers, see Collins, *Fighting Words*, 20–22.

30. Sue Gordon, *Domestic Workers*, 14–15; Whisson and Weil, *Domestic Servants*, 28.

31. Cock, *Maids and Madams*, 133–34.

32. Unidentified housewife, in Cock, *Maids and Madams*, 134.

33. Cock, *Maids and Madams*, 137.

34. "Single Clerk," letter to the editor, *Femina*, 13 Apr. 1961.

35. For a sample of contemporary opinion, see, e.g., letters to the editors from "Ann," *Femina*, 4 Apr. 1963; "Conscientious," *Femina*, 25 May 1961; Betty Bassett, *Femina*, 27 Apr. 1961; "Be Feminine," *Personality*, 30 Apr. 1964; "M.M.B.," *Femina*, 12 Sept. 1963.

36. But also see Cowan, *More Work for Mother*, which argues that the development of new technologies raised standards of cleanliness and therefore increased women's workloads.

37. "Patricia," quoted in *Femina*, 23 Aug. 1968, 73 (emphasis mine).

38. This seems to have been a common tactic among American madams as well, according to Harris, *From Mammies to Militants*, 18–19.

39. Anton Murray, "The Future of English-Speaking South Africa," *New Nation*, May 1968, 4.

40. Peter Gross, "Prize-Winning Essays," *New Nation*, July 1968, 10.

41. Andriola, *White South African*, 147.

42. DeVilliers, *South Africa*, 10.

43. Beinart and Dubow, introduction, 6–7; Welsh, *Roots of Segregation*; Legassick, "British Hegemony"; Swanson, "'Sanitation Syndrome'"; Johnstone, "White Prosperity and White Supremacy." See also contemporary popular publications that reveal support for the principles of the National Party, if not its actual tactics, e.g., Peter Gross, "English-Speaking South Africa—What's to Be Done?" *New Nation*, July 1968, 11; Andrew Duminy, "The Role of the English Speaker," *New Nation*, June 1968, 8–9.

44. 60, 18 Aug. 1996.

45. See Whisson and Weil, *Domestic Workers*, 40–45, for a similar argument. But while Whisson and Weil suggest that the housewife's psychological needs to find Africans inferior were given support by the fact that the servant class was composed of the least ambitious and competent of the nonwhite classes, I am not ready to concede that she was in fact exposed to the lowest rungs of African society. I believe housewives saw what they needed to see in their servants, many of whom showed remarkable independence, determination, and courage in making their way to the city for employment. See also Rollins's argument that American whites' ideas of unequal human worth were confirmed by the presence of "inferior" black servants, in *Between Women*, 202–3.

46. There are dozens of examples of these, but see, e.g., letters from Mrs. T. B. Beeton on her worker inadvertently eating the family's supper, from "Employer" on his servant's loyalty, and from Miss P. Hood on her faithful former char, in *Personality*, 14 May 1964, *Personality*, 15 Dec. 1960, and *Femina*, 8 Oct. 1964, respectively.

47. Blassingame, *Slave Community.*

48. For contemporary commentaries on employer paternalism, see, e.g., Cock, "Deference and Dependence", 11; Whisson and Weil, *Domestic Workers,* 20–21.

49. Gabrielle Pienaar, "For Women Only," *Pro Veritate* 9, no. 1 (1970): 15.

50. 67, 19 Jan. 1998.

51. 74, Johannesburg, 14 Feb. 1998. See also Cock, "Deference and Dependence," 11.

52. 74, 14 Feb. 1998.

53. 68, 28 Jan. 1998.

54. Magona, *Living, Loving,* 22.

55. Ramatohka Robert Seise, in Suzanne Gordon, *Talent for Tomorrow,* 63.

56. 71, 26 Jan. 1998.

57. 3, 10 July 1995.

58. 73, 14 Feb. 1998. In this African domestics appear to have behaved differently from the African American servants whom Dill interviewed, for whom one form of resistance was "talking back." One reason for the difference was likely that Dill's informants were living out and therefore had less to fear from employer retaliation. While an African worker who quit a position could be fairly sure, during the 1960s, at any rate, of finding another one reasonably soon, a woman who was fired for insubordination might be locked out of her room and so lose her possessions there.

59. Magona, *Living, Loving,* 56.

60. 74, 14 Feb. 1998.

61. 68, 21 Jan. 1998.

62. Ibid.

63. 70, 24 Jan. 1998.

64. 78, 28 Feb. 1998.

65. Cock, *Maids and Madams,* 29.

66. Ramathoka Seise, in Suzanne Gordon, *Talent for Tomorrow,* 58.

67. 40, 6 July 1996.

68. Mngoma, in Suzanne Gordon, *Talent for Tomorrow,* 97.

69. Dill, "'Making Your Job Good Yourself,'" 33.

70. 66, 19 Jan. 1998.

71. 73, 14 Feb. 1998.

72. Cock, "Deference and Dependence." The expression "take back their bodies" comes from Kelley's discussion of African American workers in the Southern United States: "'We Are Not What We Seem,'" 85–86.

6. FROM HOMES WITH APARTHEID

1. Ehrenreich, "Maid to Order," 70.

2. Ibid.

3. 27, 22 July 1995.

4. 37, 29 June 1996.

5. 36, 27 July 1995

6. Ibid. See also Van der Vleit, "Black Marriage," 67; Bonner, "'Great Migration,'" 4.

7. 10, 17 July 1995.

8. 37, 29 June 1996.

9. 26, 22 July 1995.

10. H. J. D. Weiss, et al., *A Survey of the Retail Trade in South Africa* (Johannesburg: Statsinform, 1967), 33–35, cited in Manoim, "Black Press," 24.

11. 21, 19 July 1995.

12. 26, 22 July 1995.

13. 37, 29 June 1996.

14. 60, 18 Aug. 1996.

15. Christine Kgapola, in Suzanne Gordon, *Talent for Tomorrow*, 218.

16. Thoko Ngoco, in Suzanne Gordon, *Talent for Tomorrow*, 283.

17. 10, 17 July 1995.

Bibliography

PRIMARY SOURCES

INTERVIEWS

Because I assured my informants of anonymity, I identify them by number only. Except where indicated, all informants are African. PT stands for Peggy Twala, my research assistant.

1. 6 July 1995, Soweto
2. 8 July 1995, Soweto
3. 10 July 1995, Soweto
4. 10 July 1995, Soweto, with PT
5. 13 July 1995, Soweto, with PT
6. 15 July 1995, Johannesburg
7. 15 July 1995, Johannesburg
8. 15 July 1995, Johannesburg
9. 15 July 1995, Johannesburg
10. 17 July 1995, Johannesburg
11. 17 July 1995, Johannesburg
12. 17 July 1995, Johannesburg
13. 18 July 1995, Johannesburg
14. 18 July 1995, Johannesburg
15. 19 July 1995, Johannesburg
16. 19 July 1995, Johannesburg
17. 19 July 1995, Johannesburg
18. 19 July 1995, Johannesburg
19. 19 July 1995, Johannesburg
20. 19 July 1995, Johannesburg
21. 19 July 1995, Johannesburg
22. 19 July 1995, Johannesburg
23. 20 July 1995, Johannesburg
24. 21 July 1995, 12 August 1996, Johannesburg
25. 21 July 1995, Johannesburg
26. 22 July 1995, Johannesburg
27. 22 July 1995, Johannesburg
28. 22 July 1995, Johannesburg
29. 22 July 1995, Johannesburg
30. 22 July 1995, Johannesburg
31. 25 July 1995, Soweto, with PT
32. 25 July 1995, Soweto, with PT
33. 26 July 1995, 13 August 1996, Johannesburg
34. 26 July 1995, Johannesburg
35. 26 July 1995, Johannesburg
36. 27 July 1995, Johannesburg
37. 29 June 1996, Johannesburg
38. 29 June 1996, 13 February 1996, Johannesburg
39. 29 June 1996, Johannesburg
40. 6 July 1996, Johannesburg
41. 6 July 1996, Johannesburg
42. 6 July 1996, Johannesburg
43. 18 July 1996, Johannesburg

44. 26 July 1996, Soweto, with PT
45. 28 July 1996, Soweto, with PT
46. 29 July 1996, Soweto, with PT
47. 30 July 1996, Soweto, with PT
48. 31 July 1996, Daveyton
49. 31 July 1996, Johannesburg
50. 3 August 1996, Johannesburg
51. 5 August 1996, Johannesburg
52. 5 August 1996, Johannesburg
53. 8 August 1996, Johannesburg
54. 8 August 1996, Johannesburg
55. 8 August 1996, Johannesburg
 (white)
56. 9 August 1996, Johannesburg
 (white)
57. 12 August 1996, Johannesburg
 (white)
58. 12 August 1996, Johannesburg
 (white)
59. 13 August 1996, Johannesburg
 (white)
60. 18 August 1996, Johannesburg
 (white)
61. 19 August 1996, Johannesburg
62. 8 January 1998, Johannesburg
 (white)
63. 13 January 1998, Soweto, with PT
64. 15 January 1998, Soweto, with PT,
 and 7 February 1998, Hekpoort,
 with PT

65. 15 January 1998, Soweto, with PT
66. 19 January 1998, Johannesburg
 (white)
67. 19 January 1998, Johannesburg
 (white)
68. 21 January 1998, 28 January 1998,
 Soweto, with PT
69. 23 January 1998, Johannesburg
 (white)
70. 24 January 1998, Soweto, with PT
71. 26 January 1998, Soweto, with PT
72. 6 February 1998, Johannesburg
73. 14 February 1998, Johannesburg,
 PT alone
74. 14 February 1998, Johannesburg,
 PT alone
75. 14 February 1998, Johannesburg
76. 24 February 1998, Johannesburg
77. 25 February 1998, Johannesburg
 (white)
78. 28 February 1998, Johannesburg,
 PT alone
79. 28 February 1998, Johannesburg,
 PT alone
80. 28 February 1998, Johannesburg
81. 1 May 1998, Johannesburg (white)
82. 14 December 2004, Johannesburg
83. 14 December 2004, Johannesburg

MANUSCRIPT COLLECTIONS

Bailey's African History Archive (BAHA), Johannesburg
Council for Scientific and Industrial Research Archives (CSIR), Pretoria
Johannesburg Deeds Office
Johannesburg Local Government Library
Johannesburg Planning Department
Pretoria Central Archives
Randburg Municipality Annex
Roodepoort Planning Department
South African Institute of Race Relations Library (SAIRR), Johannesburg

Star Photographic Library, Johannesburg
State Archives, Pretoria
Strange Library, Johannesburg Public Library
 Manuscript Collection
 Photographic Archives. Housed at Museum Africa, Johannesburg
University of the Witwatersrand Archives, Johannesburg
 Ballinger Papers Johannesburg Historical Foundation
 Black Sash Papers Papers
 End Conscription Campaign Papers J. Rheinhalt Jones Papers
 Fisher Papers SAIRR Clippings
 Goodman Papers SAIRR Papers
 Lewis Papers

GOVERNMENT PUBLICATIONS

Census Data

City Engineer's Department. *Greater Johannesburg Area Population Report, January 1970.*
Republic of South Africa, Bureau of Statistics. *Population of South Africa, 1904– 1970.* Report no. 02-05-12.
———. *Population Census 1960.* Vols. 1, 2, no. 9; vol. 8, nos. 1–2; vol. 5.
———. *Population Census 1970.* Report nos. 2, 02-05-04, 02-05-07, 02-01-06, 02-05-11, 02-01-08.
———. *Statistics of Houses and Domestic Servants.* Report no. 11-03-01–10 (1938–74).
———. *Survey of Family Expenditure, November 1966.* Report no. 11-06-01.

Building and Planning Regulations

Interim Johannesburg Town Planning Amendment Scheme I/860, 1976.
Johannesburg Town Planning Scheme, 1979.
Municipality of Johannesburg Building By-Laws. Government Notice 564 of 1903.
Northern Johannesburg Region Town Planning Scheme, 1952.
Reef Uniform Building and Cinematograph By-Laws. Administrator's Notice No. 455 of the 29th September 1941.
Town Planning Scheme No. 1 of 1946.

Commission Reports

Report of the Commission Appointed to Enquire into Assaults on Women. U.G.39/1913.
Report of Departmental Commission Appointed to Enquire into and Report upon the Question of Residence of Natives in Urban Areas and Certain Proposed Amendments of the Native Urban Areas. Act No. 21 of 1923.

Report of the Johannesburg Housing Commission. 1903.
Report on Investigation into Begging in Johannesburg. 1948.

Legislation

Act to Consolidate and Amend the Laws Related to Brothels and Unlawful Carnal Intercourse and Other Acts in Relations Thereto. Act no. 23 of 1957 ("Immorality Act").
Act to Make Better Provision for the Elimination of Slums within the Areas of Jurisdiction of Certain Local Authorities. Act no. 53 of 1934 ("Slums Act") and Amendments.
Act to Provide for the Removal of Natives from Any Area in the Magisterial District of Johannesburg or Any Adjoining Magisterial District and Their Settlement Elsewhere, and for That Purpose to Establish a Board to Define Its Functions; and to Provide for Other Incidental Matters. Act. no. 19 of 1954 ("Natives Resettlement Act").

Other Government Publications

Vade Mecum (Report of the Treasurer's Department, Johannesburg City Council), 1960–76.

NEWSPAPERS AND MAGAZINES

Femina and Women's Life (later *Darling*), Johannesburg, 1960–64, 1967–68, 1972–73, 1976.
New Nation, Johannesburg, 1968.
Personality, Johannesburg, 1960–64, 1967, 1973.
Rand Daily Mail, Johannesburg, 1971.
South African Architectural Record, 1950–59, 1967–68.
Star, Johannesburg, 1959–78.

OTHER SOURCES

Aboud, Frances. *Children and Prejudice.* London: Basil Blackwell, 1988.
Abu-Lughod, Lila. *Writing Women's Worlds: Bedouin Stories.* Berkeley: University of California Press, 1993.
Adams, Annmarie. "The Eichler Home: Intention and Experience in Postwar Suburbia." In *Gender, Class and Shelter, Perspectives in Vernacular Architecture V,* ed. Elizabeth Collins Cromley and Carter Hudgins, 164–78. Knoxville: University of Tennessee Press, 1995.
Adams, Herbert, and Hermann Giliomee, eds. *The Rise and Crisis of Afrikaner Power.* Cape Town: David Philip, 1979.

AlSayyad, Nezar. "Culture, Identity, and Urbanism in a Changing World: A Historical Perspective on Colonialism, Nationalism, and Globalism." In *Preparing for the Urban Future: Global Pressures and Local Forces*, ed. Michael A. Cohen and Blair A. Ruble, et al., 108–22. Washington, D.C.: Woodrow Wilson Center, 1996.

AlSayyad, Nezar, ed. *Hybrid Urbanism: On the Identity Discourse and the Built Environment*. Westport, Conn.: Praeger, 2001.

Ames, Kenneth. *Death in the Dining Room and Other Tales of Victorian Culture*. Philadelphia: Temple University Press, 1992.

Andriola, Joseph. *The White South African: An Endangered Species*. Cape Town: Howard Timmins, 1976.

Anonymous. "The Surrogates." *Leadership South Africa* 6, no. 5 (1987): 126–27.

Atkins, Keletso E. *The Moon Is Dead! Give Us Our Money! The Cultural Origins of an African Work Ethic*. Portsmouth, N.H.: Heinemann, 1993.

Atwood, Margaret. *Alias Grace*. London: Virago Press, 1997.

Bachelard, Gaston. *The Poetics of Space*. Trans. Maria Jolas. Boston: Beacon Press, 1994.

Baddeley, Alan. "The Psychology of Remembering and Forgetting." In *Memory, History, Culture and the Mind*, ed. Thomas Butler, 33–60. Oxford: Basil Blackwell, 1989.

Beavon, K. S. O. "Black Townships in South Africa: Terra Incognita for Urban Geographers." *South African Geographical Society* 64, no. 1 (1982): 3–20.

Beinart, William. *Hidden Struggles in Rural South Africa: Politics and Popular Movements in the Transkei and Eastern Cape*. London: Currey, 1987.

Beinart, William, and Peter Delius, eds. *Putting a Plow to the Ground: Accumulation and Dispossession in Rural South Africa, 1850–1930*. Johannesurg: Ravan Press, 1986.

Beinart, William, and Saul Dubow. Introduction. In *Segregation and Apartheid in Twentieth-Century South Africa*, ed. William Beinart and Saul Dubow, 1–24. London: Routledge, 1995.

Berger, Lucy Gough. *Where's the Madam?* Cape Town: Howard Timmins, 1966.

Bernstein, Hilda. *For Their Triumphs and Their Tears: Women in Apartheid South Africa*. London: International Defence and Aid Fund for Southern Africa, 1985.

Best, Laura. "Not More Than Forty-Six Hours per Week . . ." *SASH* 35, no. 3 (1994): 20–23.

Blassingame, John W. *The Slave Community: Plantation Life in the Antebellum South*. New York: Oxford University Press, 1979.

Bloch, Graeme. "Sounds in the Silence: Painting a Picture of the 1960s." *African Perspective*, no. 25 (1984): 3–23.

Bloomer, Kent, and Charles Moore. *Body, Memory, and Architecture*. New Haven: Yale University Press, 1977.

Bonner, Philip. "African Urbanisation on the Rand between the 1930s and 1960s:

Its Social Character and Political Consequences." *Journal of Southern African Studies* 21, no. 1 (1995): 115–29.

———. "'Desirable or Undesirable Basotho Women?' Liquor, Prostitution and the Migration of Basotho Women to the Rand, 1920–1945." In *Women and Gender in Southern Africa*, ed. Cherryl Walker, 221–50. Cape Town: David Philip, 1990.

———. "'The Great Migration' and 'The Greatest Trek' in Comparative Perspective." Paper presented at Racializing Class, Classifying Race—A Conference on Labour and Difference in Africa, USA, and Britain, St. Antony's College, Oxford University, 1997.

Bonner, Philip, and Lauren Segal. *Soweto: A History*. Cape Town: Maskew Miller Longman, 1998.

Borchert, James. *Alley Life in Washington: Family, Community, Religion, and Folklife in the City, 1850–1970*. Urbana: University of Illinois Press, 1980.

Bourdieu, Pierre. "The Berber House." In *Rules and Meanings: The Anthropology of Everyday Knowledge*, ed. Mary Douglas, 98–110. Harmondswroth, UK: Penguin Books, 1973.

Bozzoli, Belinda, with the assistance of Mmantho Nkotsoe. *Women of Phokeng: Consciousness, Life Strategy, and Migrancy in South Africa, 1900–1983*. Portsmouth, N.H.: Heinemann, 1991.

Brandel-Syrier, Mia. *Reeftown Elite: A Study of Social Mobility in a Modern African Community on the Reef*. London: Routledge and Keegan Paul, 1971.

Broome, The Hon. Frank. "The Individual and the Community." In *White Africans Are Also People*, by Sarah Gertrude Millin et al., 154–72. Cape Town: Howard Timmins, 1966.

Brown, Norman, et al. "Public Memories and Their Personal Context." In *Autobiographical Memory*, ed. D. C. Rubin, 137–58. Cambridge: Cambridge University Press, 1986.

Bundy, Colin. *Families Divided: The Impact of Migrant Labour in Lesotho*. Cambridge: Cambridge University Press, 1981.

———. *The Rise and Fall of the South African Peasantry*. Berkeley: University of California Press, 1979.

Bunting, Brian. *The Rise of the South African Reich*. Harmondsworth, UK: Penguin, 1964.

Butterfield, Herbert. *The Whig Interpretation of History*. New York: Scribner, 1951.

Camp, Stephanie. *Closer to Freedom: Enslaved Women and Everyday Resistance in the Plantation South*. Chapel Hill: University of North Carolina Press, 2004.

Cardy, Linda Gillian. "The Historic Grid Towns of the Transvaal: Cultural and Cadastral Influences on Planning (1838–1860)." MA thesis, University of the Witwatersrand, 1990.

Chaney, Elsa M., and Mary Garcia Castro, eds. *Muchachas No More: Household*

Workers in Latin America and the Caribbean. Philadelphia: Temple University Press, 1989.

Chang, Grace. *Disposable Domestics: Immigrant Women Workers in the Global Economy.* Cambridge, Mass.: South End Press, 2000.

Chipkin, Clive. *Johannesburg Style: Architecture and Society, 1880s–1960s.* Cape Town: David Philip, 1993.

Christopher, A. J. *Atlas of Apartheid.* Johannesburg: Witwatersrand University Press, 1994.

Clark, Clifford Edward. *The American Family Home, 1800–1960.* Chapel Hill: University of North Carolina Press, 1986.

Clark, Gracia. *Onions Are My Husband: Survival and Accumulation by West African Market Women.* Chicago: University of Chicago Press, 1994.

Clark-Lewis, Elizabeth. *Living In, Living Out: African American Domestics in Washington D.C.* Washington, D.C.: Smithsonian Institution Press, 1994.

Classen, Constance. *Worlds of Sense: Exploring the Senses in History and across Cultures.* London: Routledge, 1993.

Cock, Jacklyn. "Deference and Dependence: A Note on the Self Imagery of Domestic Workers." *South African Labour Bulletin* 6, no. 1 (1980): 9–21.

———. "Domestic Service: Apartheid's Deep South." *South African Outlook* (November 1979):165–68.

———. *Maids and Madams: Domestic Workers under Apartheid.* Johannesburg: Ravan Press, 1980.

Cohen, Lizabeth. "Embellishing a Life of Labor: An Interpretation of the Material Culture of American Working-Class Homes, 1885–1915." In *Common Places: Readings in American Vernacular Architecture,* 273–76. Athens: University of Georgia Press, 1986.

Coles, Robert. *The Moral Life of Children.* Boston: Atlantic Monthly Press, 1986.

Collins, Patricia Hill. *Fighting Words: Black Women and the Search for Justice.* Minneapolis: University of Minnesota Press, 1998.

Connerton, Paul. *How Societies Remember.* Cambridge: Cambridge University Press, 1989.

Constable, Nicole. *Maid to Order in Hong Kong: Stories of Filipina Workers.* Ithaca: Cornell University Press, 1997.

Conway, Martin A., and David Rubin. "The Structure of Autobiographical Memory." In *Theories of Memory,* ed. Alan Collins et al., 103–37. Hove, UK: Lawrence Erlbaum, 1993.

Cowan, Ruth Schwartz. *More Work for Mother: The Ironies of Household Technology from the Open Hearth to the Microwave.* New York: Basic Books, 1983.

Crapanzano, Vincent. *Waiting: The Whites of South Africa.* London: Granada Press, 1985.

Dagut, Simon. "Domestic Racial Interaction in Later Nineteenth Century South

Africa." Paper presented at the Institute for Advanced Social Research, University of the Witwatersrand, February 1996.

Davenport, Rodney. "Historical Background of the Apartheid City to 1948." In *Apartheid City in Transition*, ed. M. Swilling, R. Humphries, and K. Shubane, 1–18. Oxford: Oxford University Press, 1991.

Davey, Alfred. *Learning to Be Prejudiced: Growing Up in Multi-Ethnic Britain*. London: Edward Arnold, 1983.

Deecker, Mrs. "Young Johannesburg: A Pioneer's Story." *S.A. Railways and Harbours Magazine* (December 1923): 1225–31.

De Kiewiet, C. W. *A History of South Africa, Social and Economic*. 2nd ed. London: Oxford University Press, 1957.

Desmond, Cosmos. *The Discarded People: An Account of African Resettlement in South Africa*. Harmondsworth, UK: Penguin, 1970.

Deutsche, Rosalyn. "Boys Town." *Environment and Planning D: Society and Space* 9, no. 1 (1991): 5–30.

DeVilliers, Les. *South Africa: A Skunk among Nations*. London: International Books, 1975.

Dewey, John. *Art as Experience*. New York: Minton, Balch, 1934.

Dinath, M. Y. D. "Asiatic Population in the Transvaal (1881–1960), with Special Reference to Johannesburg Municipality." BA Hons., University of the Witwatersrand, 1963.

Douglas, Mary, and Baron Isherwood. *The World of Goods*. New York: Basic Books, 1979.

Downs, Roger, and David Stea. "Cognitive Maps and Spatial Behavior." In *Cognitive Mapping and Spatial Behavior*, ed. Roger Downs and David Stea, 8–26. Chicago: Aldine Publishing, 1973, 2006.

Drury, Allen. *"A Very Strange Society": A Journey to the Heart of South Africa*. London: Michael Joseph, 1967.

Dubb, Alice. "Impact of the City." In *South Africa: Sociological Analyses*, ed. A. Paul Hare, Gerd Wiendieck, and Max H. von Broembsen, 145–51. Cape Town: Oxford University Press, 1979.

Eales, Katherine Anne. "Gender Politics and the Administration of African Women in Johannesburg, 1903–1939." MA thesis, University of the Wiwatersrand, 1991.

Ehrenreich, Barbara. "Maid to Order: The Politics of Other Women's Work." *Harper's Magazine* 300, no 1799 (2000): 59–70.

Elders, Glen. *Hostels, Sexuality, and the Apartheid Legacy: Malevolent Geographies*. Athens: Ohio University Press, 2003.

Foster, Don. "The Development of Racial Orientation in Children." In *Growing Up in a Divided Society: The Contexts of Childhood in South Africa*, ed. Sandra Burman and Pamela Reynolds, 158–83. Johannesburg: Ravan Press, 1986.

Foster, Jeremy. *Washed with Sun: Landscape and the Making of White South Africa*. Pittsburgh: University of Pittsburgh Press, 2008.

Foucault, Michel. "On Other Spaces." *Diacritics* 16 (Spring 1986): 22–27.

Fox-Genovese, Elizabeth. *Within the Plantation Household*. Chapel Hill: University of North Carolina Press, 1988.

Francis, S., H. Dugmore, and Rico. *Madam and Eve's Greatest Hits*. Sandton, South Africa: Penguin Books, 1997.

Fredrickson, George M. *White Supremacy: A Comparative Study in American and South African History*. New York: Oxford University Press, 1981.

Frescura, Franco. *Rural Shelter in Southern Africa*. Johannesburg: Ravan Press, 1981.

Frescura, Franco, and Dennis Radford. "The Physical Growth of Johannesburg: A Brief Survey of Its Development from 1886 to Date." Outline of a paper to be presented at the Urbanization Conference, South African Institute of Race Relations, October 1982. Housed in University of Witwatersrand Architectural Library.

Friend, Margaret. *Without Fear or Favour*. Cape Town: Howard Timmins, 1958.

Frisch, Michael. "Oral History and *Hard Times*: A Review Essay." In *The Oral History Reader*, ed. Robert Perks and Alistair Thomson, 29–37. London: Routledge, 1998.

Gaitskell, Deborah. "'Christian Compounds for Girls': Church Hostels for African Women in Johannesburg, 1907–1970." *Journal of South African Studies* 6 (1979): 44–69.

Gaitskell, Deborah, et al. "Class, Race and Gender: Domestic Workers in South Africa." *Review of African Political Economy* 27–28 (1983): 86–108.

Gartrell, Beverley. "Colonial Wives: Villains or Victims?" In *The Incorporated Wife*, ed. Hilary Callan and Shirley Ardener, 165–85. London: Croon Helm, 1984.

Genovese, Eugene. *Roll Jordan Roll: The World the Slaves Made*. New York: Vintage, 1972.

Ginsburg, Rebecca. "View from the Back Step: White Children Learn about Race in Johannesburg's Suburban Homes." In *Designing Modern Childhoods: History, Space and the Material Culture of Children*, ed. Marta Gutman and Ning de Coninck-Smith, 193–212. New Brunswick, N.J.: Rutgers University Press, 2008.

Girouard, Mark. *Life in the English Country House: A Social and Architectural History*. New Haven: Yale University Press, 1978.

Glassie, Henry. *Folk Housing in Middle Virginia*. Knoxville: University of Tennessee Press, 1977.

Glenn, Evelyn Nakano. *Issei, Nisei, War Bride*. Philadelphia: Temple University Press, 1986.

Gluck, Sherna Berger, and Daphne Patai, eds. *Women's Words: The Feminist Practice of Oral History*. London: Routledge, 1998.

Goffman, Erving. *The Presentation of Self in Everyday Life*. Garden City, N.Y.: Doubleday, 1959.

Gordon, Sue. *Domestic Workers: A Handbook for Housewives.* Johannesburg: South African Institute of Race Relations, 1973.

Gordon, Suzanne. *A Talent for Tomorrow: Life Stories of South African Servants.* Johannesburg: Ravan Press, 1985.

Gould, Peter, and Rodney White. *Mental Maps.* New York: Penguin Books, 1974.

Graham, Sandra Lauderdale. *House and Street: The Domestic World of Servants and Masters in Nineteenth-Century Rio de Janiero.* Austin: University of Texas Press, 1988.

Greig, Doreen. *A Guide to Architecture in South Africa.* Cape Town: Howard Timmins, 1971.

Grele, R. J. *Envelopes of Sound: The Art of Oral History.* Chicago: Precedent Publishing, 1985.

Griffin, Farah Jasmine. *"Who Set You Flowin'?" The African-American Migration Narrative.* New York: Oxford University Press, 1995.

Grossman, James R. *Land of Hope: Chicago, Black Southerners, and the Great Migration.* Chicago: University of Chicago Press, 1989.

Hall, Edward T. *The Hidden Dimension.* New York: Anchor Books, 1966.

Hansen, Karen. *Distant Companions: Servants and Employers in Zambia, 1900–1985.* Ithaca: Cornell University Press, 1980.

Harris, Trudier. *From Mammies to Militants: Domestics in Black American Literature.* Philadelphia: Temple University Press, 1982.

Hellman, Ellen. *Rooiyard: A Sociological Survey of an Urban Native Slum Yard.* Cape Town: Oxford University Press, 1948.

Herman, N. *My Kleinian Home.* London: Quartet Books, 1985.

Hindson, Mark Richard. "The Transition between the Late Victorian and Edwardian Speculative House in Johannesburg from 1890–1920." M Arch. thesis, University of the Witwatersrand, 1987.

Hodder, Ian. *Reading the Past: Current Approaches to Interpretation in Archaeology.* Cambridge: Cambridge University Press, 1986.

Hollander, Jocelyn A., and Rachel L Einwohner. "Conceptualizing Resistance." In *Sociological Forum* 19, no. 4 (2004): 533–54.

Horrell, Muriel. *Laws Affecting Race Relations in South Africa.* Johannesburg: South African Institute of Race Relations, 1978.

———. *Yearbooks.* Johannesburg: South African Institute of Race Relations, 1957–78.

Hunter, Tera. *To 'Joy My Freedom: Southern Black Women's Lives and Labors after the Civil War.* Cambridge: Harvard University Press, 1997.

Isaac, Rhys. *The Transformation of Virginia, 1740–1790.* Chapel Hill: University of North Carolina Press, 1982.

Jackson, Kenneth. *Crabgrass Frontier: The Suburbanization of the United States.* New York: Oxford University Press, 1985.

Jacob, A. *White Man, Think Again!* Pretoria: Voortrekkerpers, n.d.

Janisch, Miriam. "Some Administrative Aspects of Native Marriage Problems in an Urban Area." *Bantu Studies* 15 (1941): 1–11.

Johnson, Mark. *The Body in the Mind: The Bodily Basis of Meaning, Imagination, and Reason.* Chicago: University of Chicago Press, 1987.

Johnstone, Frederick. "White Prosperity and White Supremacy in South Africa Today." *African Affairs* 69, no. 275 (1970): 124–40.

Jones, Jacqueline. *Labor of Love, Labor of Sorrow: Black Women, Work, and the Family, from Slavery to the Present.* New York: Vintage Books, 1985.

Jones, Sean. *Assaulting Childhood: Children's Experiences of Migrancy and Hostel Life in South Africa.* Johannesburg: Wits University Press, 1989.

Joubert, Elsa. *Poppie Nongena.* New York: Henry Holt, 1987.

Kadijang, Mmatshilo. "'The Best Kept Secret': Violence against Domestic Workers." Paper No. 5, presented at the Project for the Study of Violence Seminar Programme, University of the Witwatersrand, July 1990.

Kagan, Noreen. "African Settlements in the Johannesburg Area, 1903–1923." MA dissertation, University of the Witwatersrand, 1978.

Kaplan, Marion A. *Between Dignity and Despair: Jewish Life in Nazi Germany.* Oxford: Oxford University Press, 1998.

Kaplan, Stephen. "Cognitive Maps in Perception and Thought." In *Image and Environment: Cognitive Mapping and Spatial Behavior,* ed. Roger Downs and David Stea, 63–78. Chicago: Aldine Publishing, 1973.

Kaplan, Stephen, and Rachel Kaplan. *Cognition and Environment: Functioning in an Uncertain World.* New York: Praeger, 1982.

Katzman, David M. *Seven Days a Week: Women and Domestic Service in Industrializing America.* New York: Oxford University Press, 1978.

Keegan, Timothy *Colonial South Africa and the Origins of the Racial Order.* Cape Town: David Philip, 1996.

———. *Facing the Storm: Portraits of Black Lives in Rural South Africa.* Cape Town: David Philip, 1988.

Keeler, Charles. *The Simple Home.* San Francisco: P. Elder and Company, 1904.

Kelley, Robin D. G. "'We Are Not What We Seem': Rethinking Black Working-Class Opposition in the Jim Crow South." *Journal of American History* 80, no. 1 (1993): 75–112.

Kelly, Barbara. *Expanding the American Dream: Building and Rebuilding Levittown.* Albany: State University of New York, 1993.

Kemble, Frances Anne. *Journal of a Residence on a Georgian Plantation in 1838–1939.* New York: Alfred A. Knopf, 1961.

Kingsley, B. F. Presidential Address, Delivered to the Eleventh Annual Conference of the Institute of Administrators of Non-European Affairs, Mossel Bay, South Africa, 28 August 1962. Published by the Institute of Administrators of Non-European Affairs, Southern Africa, 1962.

Knox, Patricia, and Thelma Gutsche. *Do You Know Johannesburg?* Vereeniging: Unie-Volkspers, Beperk, 1947.

Koch, Edward. "Doornfontein and Its African Working Class, 1914–1935: A Study of Popular Culture in Johannesburg." MA dissertation, University of the Witwatersrand, 1983.

Kotre, John. *White Gloves: How We Create Ourselves through Memory.* New York: Free Press, 1995.

Kruse, Kevin M., and Thomas J. Sugrue, eds. *The New Suburban History.* Chicago: University of Chicago Press, 2006.

La Hausse, Paul. "Oral History and South African Historians." *Radical History Review* 46–47 (1990): 346–56.

Lee, Terrence R. "Psychology and Living Space." In *Image and Environment: Cognitive Mapping and Spatial Behavior,* ed. Roger Downs and David Stea, 87–108. Chicago: Aldine Publishing Company, 1973.

Legassick, Martin. "British Hegemony and the Origins of Segregation in South Africa, 1901–14." In *Segregation and Apartheid in Twentieth-Century South Africa,* ed. William Beinart and Saul Dubow, 43–59. London: Routledge, 1995.

Lemann, Nicholas. *The Promised Land: The Great Black Migration and How It Changed America.* New York: Alfred A. Knopf, 1991.

LeMay, G. H. L. *The Afrikaners: An Historical Interpretation.* Oxford: Blackwell, 1995.

Lemon, Anthony. "The Apartheid City." In *Homes Apart: South Africa's Segregated Cities,* ed. Anthony Lemon, 1–25. London: Paul Chapman Publishing Ltd., 1991.

Le Roux, Peter. "Growing Up an Afrikaner." In *Growing Up in a Divided Society: The Contexts of Childhood in South Africa,* ed. Sandra Burman and Pamela Reynolds, 184–207. Johannesburg: Ravan Press, 1986.

Lever, Henry. *South African Society.* Johannesburg: Jonathan Ball, 1978.

Leyds, G. A. *A History of Johannesburg.* Cape Town: Nasionale Boekhandel BPK, 1964.

Lipman, Beata. *We Make Freedom: Women in South Africa.* London: Pandora Press, 1984.

Lipton, Merle. *Capitalism and Apartheid, South Africa, 1910–1984.* Totowa, N.J.: Rowman and Allanheld, 1985.

Lipworth, M. A. "An Application of Concepts of Urban Morphology in Studying the Northern Development of Johannesburg." BA Hons. Essay, University of the Witwatersrand, 1961.

Litwack, Leon. *Been in the Storm So Long: The Aftermath of Slavery.* New York: Random House, 1999.

Longmore, Laura. *The Dispossessed: A Study of the Sex-Life of Bantu Women in Urban Areas in and around Johannesburg.* London: Jonathan Cape: 1959.

Lynch, Kevin. *The Image of the City.* Cambridge: MIT Press, 1960.

Mabin, Alan. "Conflict, Continuity and Change: Locating 'Properly Planned Na-

tive Townships' in the Forties and Fifties." Paper presented at the Symposium of the South African Planning Society, Pietermaritzburg, South Africa, September 1993.

———. "Dispossession, Exploitation, and Struggle: An Historical Overview of South African Urbanization." In *The Apartheid City and Beyond: Urbanization and Social Change in South Africa*, ed. David M. Smith, 12–24. London: Routledge, 1992.

———. "The Dynamics of Urbanization since 1960." In *Apartheid City in Transition*, ed. M. Swilling, R. Humphries, and K. Shubane, 33–47. Oxford: Oxford University Press, 1991.

Magona, Sindiwe. *Living, Loving, and Lying Awake at Night*. Brooklyn: Interlink Books, 2003.

———. *To My Children's Children*. Cape Town: David Philip, 1990.

Mandela, Nelson. *No Easy Walk to Freedom: Articles, Speeches, and Trial Addresses of Nelson Mandela*. London: Heinemann, 1965.

Mandy, Nigel. *A City Divided: Johannesburg and Soweto*. Johannesburg: MacMillan 1984.

Manoim, Irwin. "The Black Press, 1945–1963: The Growth of the Black Mass Media and Their Role as Ideological Disseminators." MA thesis, University of the Witwatersrand, 1983.

Manona, C. W. "Relying on Kin: Ex-Farm Workers' Adaptation to Life in Grahamstown." In *Tradition and Transition in Southern Africa: A Festschrift for Philip and Iona Mayer*, ed. A. D. Spiegel and P. A. McAllister, 201–18. New Brunswick, N.J.: Transaction Publishers, 1991.

Mapumulo, Dolly. "Back-Room Love Affairs Are Full of Drama, Intrigue." *Star*, 10 December 1963.

Marquard, Leo. *The Peoples and Policies of South Africa*. 4th ed. London: Oxford Paperbacks, 1969.

Massey, Douglas S., and Nancy A. Denton. *American Apartheid: Segregation and the Making of the Underclass*. Cambridge: Harvard University Press, 1993.

Mather, C. "Residential Segregation and Johannesburg's 'Locations in the Sky.'" *South African Geographical Journal* 69, no. 2 (1987): 119–28.

Matthews, M. H. *Making Sense of Place: Children's Understanding of Large-Scale Environments*. Savage, Md.: Barnes and Noble Books, 1992.

Mayer, Philip. *Townsmen or Tribesmen: Conservatism and the Process of Urbanization in a South African City*. Cape Town: Oxford University Press, 1971.

Maylam, Paul. "The Rise and Decline of Urban Apartheid in South Africa." *African Affairs* 89, no. 354 (1990): 57–84.

McDaniel, George. *Hearth and Home: Preserving a People's Culture*. Philadelphia: Temple University Press, 1982.

McNamara, John. "Social Life, Ethnicity and Conflict in a Gold Mine Hostel." MA thesis, University of the Witwatersrand, 1978.

Mercer, Kobena. "Black Hair/Style Politics." In *Out There: Marginalization and*

Contemporary Cultures, ed. Russell Ferguson, Martha Gever, Trinh T. Minh-ha, and Cornel West, 247–64. New York: New Museum of Contemporary Art, 1990.

Mhlophe, Gcina. "The Toilet." In *Being Here: Modern Short Stories from South Africa*, comp. Robin Malan, 117–23. Cape Town: David Philip, 1994.

Miller, Daniel. *Material Culture and Mass Consumption*. Oxford: Basil Blackwell, 1987.

Millin, Sarah Gertrude, et al. *White Africans Are Also People*. Cape Town: Howard Timmins, 1966.

Milner, David. *Children and Race*. Harmondsworth, UK: Penguin, 1975.

Mlangeni, Bongiwe. "The Curtailed Lives of Those Who Live atop City's Buildings." *Star*, 18 June 1997.

Moore, Gary T., and Reginald Golledge. "Environmental Knowing: Concepts and Theories." In *Environmental Knowing: Theories, Research, and Methods*, ed. Gary T. Moore and Reginald Golledge, 3–24. Stroudsburg, Penn.: Dowden, Hutchinson, and Ross, 1976.

Moore, Henrietta. *A Passion for Difference: Essays in Anthropology and Gender*. Bloomington: University of Indiana Press, 1994.

———. *Space, Text and Gender: An Anthropological Study of the Marakwet of Kenya*. Cambridge: Cambridge University Press, 1986.

Morris, Pauline. *A History of Black Housing in South Africa*. Johannesburg: South Africa Foundation, 1981.

Morrissey, Charles T. "On Oral History Interviewing." In *The Oral History Reader*, ed. Robert Perks and Alistair Thomson, 107–13. London: Routledge, 1998.

Mphahlele, Es'kia. "Mrs. Plum." In *Contending Voices in South African Fiction*, ed. Percy Mosieleng and Temba Mhambi, 20–56. Isando, South Africa: Lexicon Publishers, 1993.

Mphahlele, Ezekial. *The African Image*. Rev. ed. New York: Praeger, 1974.

Neame, L. E. *City Built on Gold*. South Africa: Central News Agency, n.d.

Nicolaides, Becky, and Andrew Wiese, eds. *The Suburb Reader*. London: Routledge, 2006.

Nussbaum, Martha. *Cultivating Humanity: A Classical Defense of Reform in Liberal Education*. Cambridge: Harvard University Press, 1998.

———. *The Literary Imagination and Public Life*. Boston: Beacon Press, 1995.

Oakley, Ann. *Sociology of Housework*. New York: Pantheon Books, 1974.

———. *Women's Work: The Housewife, Past and Present*. New York: Vintage Books, 1974.

Ockman, Joan. "Mirror Images: Technology, Consumption, and the Representation of Gender in American Architecture since World War Two." In *The Sex of Architecture*, ed. Diana Agrest, Patricia Conway, and Leslie Kanes Weisman, 191–210. New York: Harry N. Abrams, 1996.

O'Meara, Dan. *Volkskapitalisme: Class, Capital, and Ideology in the Development of Afrikaner Nationalism, 1934–1948*. Cambridge: Cambridge University Press, 1983.

Omond, Roger. *The Apartheid Handbook. A Guide to South Africa's Everyday Racial Policies*. Harmondsworth, UK: Penguin Books, 1985.

Ong, Aihwa. *Spirits of Resistance and Capitalist Discipline: Factory Women in Malaysia*. Albany: State University of New York Press, 1987.

Ornstein, Robert. *The Evolution of Consciousness: The Origins of the Way We Think*. New York: Prentice Hall Press, 1991.

———. *The Psychology of Consciousness*. New York: Penguin, 1986.

Palestrant, Ellen. *Johannesburg One Hundred. A Pictorial History*. Johannesburg: A. D. Donker (Pty), 1986.

Palmer, Phyllis. *Domesticity and Dirt: Housewives and Domestic Servants in the United States, 1920–1940*. Philadelphia: Temple University Press, 1989.

Park, Robert E. *Race and Culture*. London: Free Press of Glencoe, 1950.

Parnell, Susan. "Council Housing Provision for Whites in Johannesburg: 1920–1955." MA thesis, University of the Witwatersrand, 1987.

———. "Johannesburg Slums and Racial Segregation in South African Cities, 1910–1937." PhD thesis, University of the Witwatersrand, 1993.

Peattie, Lisa. "Aesthetic Politics: Shantytown or New Vernacular?" Ann Arbor: University of Michigan Press, 1992.

Pelzer, A. N., ed. *Verwoerd Speaks: Speeches 1948–1966*. Johannesburg: APB Publishers, 1966.

Perks, Robert, and Alistair Thomson, eds. *The Oral History Reader*. London: Routledge, 1998.

Pigott, M. J. D. "Housing for Black Workers in South Africa: A Study of State Intervention After 1945." PhD thesis, University of London, 1985.

Pirie, G. H. "Racial Segregation on Public Transportation in South Africa, 1877–1989." PhD thesis, University of the Witwatersrand, 1990.

Platzky, Laurine, and Sherryl Walker (for the Surplus People Project). *The Surplus People: Forced Removals in South Africa*. Johannesburg: Ravan Press, 1985.

Pockock, Douglas, and Ray Hudson. *Images of the Urban Environment*. London: Macmillan, 1978.

Pogrund, Benjamin. *How Can Man Die Better: Sobukwe and Apartheid*. London: Peter Halban, 1990.

Posel, Deborah. "Curbing African Urbanisation in the 1950s and 1960s." In *Apartheid City in Transition*, ed. M. Swilling, R. Humphries, and K. Shubane, 19–32. Oxford: Oxford University Press, 1991.

———. *The Making of Apartheid, 1948–1961: Conflict and Compromise*. Oxford: Oxford University Press, 1990.

———. "Marriage at the Drop of a Hat: Housing and the Politics of Gender in Urban African communities in South Africa, 1930s–1960s." Paper presented at

Africa's Urban Past, School of African and Oriental Studies, University of London, June 1996.

Preston-Whyte, Eleanor Mary. "Between Two Worlds: A Study of the Working Life, Social Ties, and Interpersonal Relationships of African Women Migrants in Domestic Service in Durban." PhD thesis, University of Natal, 1969.

———. "Race Attitudes and Behavior: The Case of Domestic Employment in White South African Homes." *African Studies* 35, no. 2 (1976): 71–89.

Ramphele, Mamphela. *A Bed Called Home: Life in the Migrant Labour Hostels of Cape Town.* Cape Town: David Philip, 1993.

Ramphele, Mamphela, and Emile Boonzaier. "The Position of African Women: Race and Gender in South Africa." In *South African Keywords: The Uses and Abuses of Political Conflict,* ed. E. Boonzaier and J. Sharp, 153–66. Cape Town: David Philips, 1988.

Rees, Robert. "Policy Memo: 'If the Union Is Not There, Nothing Is Caring for the Domestic Workers': The Feasibility of Advice Offices for Domestic Workers." Paper presented at the National Labour and Economic Development Institute, Johannesburg, October 1997.

Reports, History of Architecture IV and V, 1990. Housed, uncataloged, in the Architecture Library, University of the Witwatersrand, Johannesburg.

Rhoodie, N. J., and H. J. Venter. *Apartheid: A Socio-Historical Exposition of the Origin and Development of the Apartheid Idea.* Cape Town: Haum, n.d.

Richards, Ellen. *Sanitation in Daily Life.* Boston: Whitcomb and Barrows, 1910.

Robinson, Jennifer. *The Power of Apartheid: State, Power and Space in South African Cities.* Oxford: Butterworth-Heinemann, 1996.

Rollins, Judith. *Between Women: Domestics and Their Employers.* Philadelphia: Temple University Press, 1985.

Romero, Mary. *Maid in the U.S.A.* New York: Routledge, 1992.

Rose, Gillian. "Geography as a Science of Observation: The Landscape, the Gaze, and Masculinity." In *Human Geography: An Essential Anthology,* ed. John A. Agnew, David N. Livingstone, and Alisdair Rogers, 341–50. Oxford: Blackwell Publishing, 1996.

Ross, B. H. *Remembering the Personal Past.* Oxford: Oxford University Press, 1991.

Rubin, D. C., ed. *Autobiographical Memory.* Cambridge: Cambridge University Press, 1986.

Rubin, Lilian Breslow. *Worlds of Pain: Life in the Working-Class Family.* New York: Basic Books, 1969.

Ruskin, John. *Fors Clavigera: Letters to the Workmen and Labourers of Great Britain.* Vol. 3. Kent: George Allen, 1873.

Samela, Monde Ishmael. "The Law and the Disadvantaged, Exploited Workers with Special Focus on South African Domestic Workers." LLM thesis, University of the Witwatersrand, 1993.

Schactel, Ernest. "On Memory and Childhood Amnesia." *Psychiatry: The Journal of the Biology and Pathology of Interpersonal Relations,* no. 10 (1947): 1–26.

Schapera, I. *Migrant Labour and Tribal Life: A Study of Conditions in the Bechuana-land Protectorate*. London: Oxford University Press, 1947.

Scheper-Hughes, Nancy. *Death without Weeping: The Violence of Everyday Life in Brazil*. Berkeley: University of California, 1992.

Scott, James. *Weapons of the Weak: Everyday Forms of Peasant Resistance*. New Haven: Yale University Press, 1985.

Scott, T. W. "The Servantless House in South Africa." *Lantern* 14, no. 2 (1964): 59–65.

Segal, Lauren. "A Brutal Harvest: The Roots and Legitimation of Violence on Farms in South Africa." Seminar Paper No. 7 delivered to the Project for the Study of Violence Seminar Programme, 1990.

Sennett, Richard, and Jonathan Cobb. *The Hidden Injuries of Class*. New York: Vintage Books, 1973.

Shindler, Jennifer. "The Effects on Influx Control and Labour-Saving Appliances on Domestic Service." *South African Labour Bulletin* 6, no. 1 (1980): 22–34.

Siegel, Alexander W., Kathleen C. Kirasic, and Robert F. Kail Jr. "Stalking the Elusive Cognitive Map: The Development of Children's Representations of Geographic Space." In *Children and the Environment*, ed. Irvin Altman and Joachim F. Wohlwill, 223–58. New York: Plenum Press, 1978.

Sieverts, Thomas. "Perceptual Images of the City of Berlin." In *Urban Core and Inner City: Proceedings of the International Study Week, Amsterdam 11–17 September 1986*, ed. University of Amsterdam Sociological Department, 282–85. Leiden: E. J. Brill, 1986.

Simmel, Georg. "The Metropolis and Mental Life." In *Classic Essays on the Culture of Cities*, ed. Richard Sennett, 47–60. New York: Appleton-Century-Crofts, 1969.

Simon, H. J. *African Women: Their Legal Status in South Africa*. Evanston: Northwestern University Press, 1968.

Slim, Hugo, and Paul Thomson, with Olivia Bennett and Nigel Cross. "Ways of Listening." In *The Oral History Reader*, ed. Robert Perks and Alistair Thomson, 114–25. London: Routledge, 1998.

Smith, Adam. *The Theory of Moral Sentiments*. London: A. Millar and A. Kincaid and J. Bell, 1759.

Smith, David Marshall, ed. *The Apartheid City and Beyond: Urbanization and Social Change in South Africa*. London: Routledge, 1992.

———. "Introduction." *The Apartheid City and Beyond: Urbanization and Social Change in South Africa*, ed. David Marshall Smith, 1–10. London: Routledge, 1992.

Smythe, Nicholas Charles. "The Origins of Apartheid: Race Legislation in South Africa, 1836–1910." LLM thesis, University of the Witwatersrand, 1995.

Sommer, Robert. *Personal Space: The Behavioral Basis of Design*. Englewood Cliffs, N.J.: Prentice-Hall, 1980.

Spain, Daphne. *Gendered Spaces*. Chapel Hill: University of North Carolina Press, 1992.

Stack, Carol. *All Our Kin: Strategies for Survival in a Black Neighborhood*. New York: Harper and Row, 1974.

Steward, Alexander. *You Are Wrong, Father Huddleston*. Amsterdam: Culemborg Publishers, 1956.

Stewart, Peter Dominic Stephen. "The Social Context of Political Attitudes among Middle-Class English-Speaking Whites in Johannesburg, in a Situation of Political Polarization." PhD thesis, University of the Witwatersrand, 1994.

Stickley, Gustav. *Craftsman Homes*. New York: Craftsman Publishing Co., 1909.

Straker, G. "Violence against Children: Emotional Abuse." In *People and Violence in South Africa*, ed. B. McKendrick and W. Hoffman, 171–89. Cape Town: Oxford University Press, 1990.

Sutherland, Daniel E. "Modernizing Domestic Service." In *American Home Life, 1880–1930*, ed. Jessica H. Foy and Thomas J. Schlereth, 242–66. Knoxville: University of Tennessee Press, 1992.

Swaisland, Cecille. *Servants and Gentlewomen to the Golden Land: The Emigration of Single Women from Britain to Southern Africa, 1820–1930*. Durban: University of Natal Press, 1993.

Swanson, Maynard. "'The Sanitation Syndrome': Bubonic Plague and Urban Native Policy in the Cape Colony, 1900–1909." *Journal of African History* 18 (1977): 387–410.

Symonds, F. Addington. *The Johannesburg Story*. London: Frederick Muller, 1953.

Talbot, Marion. *House Sanitation: A Manual for Housekeepers*. Boston: Whitcomb and Barrows, 1917.

Thompson, Leonard. *A History of South Africa*. New Haven: Yale University Press, 1990.

Thornton, Bonnie Dill. "'Making Your Job Good Yourself': Domestic Service and the Construction of Personal Dignity." In *Women and the Politics of Empowerment*, ed. Ann Bookman and Sandra Morgen, 33–52. Philadelphia: Temple University Press, 1988.

Thorpe, K. L. "The Origins and Early Years of a Multicultural Reef Labour Society." *Historia* 31, no. 2 (1986): n.p.

Tolman, Edward C. "Cognitive Maps in Rats and Men." In *Image and Environment: Cognitive Mapping and Spatial Behavior*, ed. Roger M. Down and David Stea, 27–50. New Brunswick, N.J.: Aldine Transaction, 1973, 2006.

Tringham, Ruth. "Men and Women in Prehistoric Architecture." *Traditional Dwellings and Settlements Review* 3, no. 1 (1991): 9–28.

Tucker, Susan. *Telling Memories among Southern Women*. New York: Schocken Books, 1988.

Unterhalter, Beryl. "Some Aspects of Family Life in Flatland, Johannesburg." PhD thesis, University of the Witwatersrand, 1968.

Upton, Dell. "Another City: The Urban Cultural Landscape in the Early Republic." In *Everyday Life in the Early Republic*, ed. Catherine E. Hutchins, 61–117. New York: Norton, 1994.

———. "Form and User: Style, Mode, Fashion and the Artifact." In *Living in a Material World: Canadian and American Approaches to Material Culture*, ed. Gerald Pocius, 156–69. St. John's: Institute of Social and Economic Research, Memorial University of Newfoundland, 1991.

———. "White and Black Landscapes in Eighteenth Century Virginia." *Places* 2 (1985): 59–72.

Van der Vleit, Virginia Naomi Charlotte. "Black Marriage: Expectations and Aspirations in an Urban Environment." MA thesis, University of the Witwatersrand, 1982.

———. "Traditional Husbands, Modern Wives? Constructing Marriages in a South African Township." In *Tradition and Transition in Southern Africa: A Festschrift for Philip and Iona Mayer*, ed. A. D. Spiegel and P. A. McAllister, 219–41. Johannesburg: Witwatersrand University Press, 1991.

Van Onselen, Charles. "Race and Class in the South African Countryside: Cultural Osmosis and Social Relations in the Sharecropping Economy of the South-Western Transvaal, 1900–1985." *American Historical Review* 95, no. 1 (1990): 99–123.

———. *The Seed Is Mine: The Life of Kas Maine, a South African Sharecropper, 1894–1985*. New York: Hill and Wang, 1996.

———. "The Witches of Suburbia." In *Studies in the Social and Economic History of the Witwatersrand, 1886–1914*, 2: 1–73. Johannesburg: Ravan Press, 1982.

Visser, Margaret. *The Rituals of Dinner: The Origins, Evolution, Eccentricities, and Meaning of Table Manners*. New York: Grove Weidenfeld, 1991.

Vlach, John Michael. *Back of the Big House: The Architecture of Plantation Slavery*. Chapel Hill: University of North Carolina Press, 1993.

Volz, Candace M. "The Modern Look of the Early-Twentieth Century House: A Mirror of Changing Lifestyles." In *American Home Life, 1880–1930: A Social History of Spaces and Services*, ed. Jessica H. Foy and Thomas J Schlereth, 25–48. Knoxville: University of Tennessee Press, 1992.

Walker, Cherryl. "Gender and the Development of the Migrant Labour System." In *Women and Gender in Southern Africa to 1945*, ed. Cherryl Walker, 168–96. Cape Town: David Philip, 1990.

Wall, Diana diZerega. *The Archaeology of Gender: Separating the Spheres in Urban America*. New York: Plenum, 1994.

Ward, Colin. *The Child in the City*. New York: Pantheon Books, 1978.

Watts, H. L. "A Social and Demographic Portrait of English-Speaking White South Africans." In *English-Speaking South Africa Today: Proceedings of the National Conference, July 1974*, ed. Andre de Villiers, 61–73. Cape Town: Oxford University Press, 1976.

Wellman, D. T. *Portraits of White Racism.* Cambridge: Cambridge University Press, 1977.

Wells, Julia. *We Now Demand! Women's Resistance to Pass Laws in South Africa.* Johannesburg: University of the Witwatersrand Press, 1993.

Welsh, David. *The Roots of Segregation.* Cape Town: Oxford University Press, 1971.

West, Martin E. *Apartheid in a South African Town, 1968–1985.* Berkeley: Institute of International Studies, University of California, Berkeley, 1987.

Whisson, Michael, and W. Weil. *Domestic Servants: A Microcosm of "the Race Problem."* Johannesburg: South African Institute of Race Relations, 1971.

White, Naomi Rush. "Marking Absences: Holocaust Testimony and History." In *The Oral History Reader,* ed. Robert Perks and Alistair Thomson, 172–82. London: Routledge, 1998.

Wilcox, A. R. *So You Want a House! A Complete Guide to House Building and Purchase in South Africa.* Johannesburg: Hugh Keartland, 1967.

Wilkie, Laurie A. *Creating Freedom: Material Culture and African American Identity at Oakley Plantation, Louisiana, 1840–1950.* Baton Rouge: Louisiana State University Press, 2000.

Wilson, Francis. *Migrant Labour: Report to the South African Council of Churches.* Johannesburg: SACC and SPRO-CAS, 1972.

Wolf, Diane Lauren. *Factory Daughters: Gender, Household Dynamics, and Rural Industrialization in Java.* Berkeley: University of California Press, 1992.

Wright, Gwendolyn. *Building the American Dream: A Social History of Housing in America.* Cambridge: MIT Press, 1981.

———. *Moralism and the Model Home, 1873–1913.* Chicago: University of Chicago Press, 1980.

Wulfsohn, Diane Rosemary. "The Impact of the South African Nanny on the Young Child." PhD thesis, University of the Witwatersrand, 1988.

Yawich, Joanne. "The Relation between African Female Employment and Influx Control in South Africa, 1950–1983." MA thesis, University of the Witwatersrand, 1984.

Yeoh, Brenda S. A., and Shirlena Huang. "Negotiating Public Space: Strategies and Styles of Migrant Female Domestic Workers in Singapore." *Urban Studies* 35, no. 3 (1998): 583–602.

Young-Bruehl. *The Anatomy of Prejudices.* Cambridge: Harvard University Press, 1996.

Index

Italicized page numbers indicate illustrations and maps.